Advance Praise for

Tacky

"*Tacky* is a very funny book. Not just funny, I mean, SERIOUSLY FUNNY. King has the power to trick you into thinking you've got the joke all figured out, then suddenly reveals that you're going to experience a wealth of tender, thought-provoking emotions and guess what? You're gonna like it! On the sentence level, King's a wizard; she's able to wring the last drops of cool and sweet and sexy out of every moment. This isn't a book you read. It wants to be devoured. Rax King is a supremely gifted writer, and *Tacky* is a masterly ode to unfettered, unrestrained, and unrepentant joy." —Kristen Arnett, author of *With Teeth*

"Goddamn, Rax really tore this shit up. THIS BOOK IS GOOD AS HELL." —Sam Irby, author of *Wow, No Thank You*

"*Tacky* proves something to me that I've thought for a while: liking stuff that is bad actually means I'm smart. And it not only means I'm smart, but it also means I'm a complicated individual with a vast interior life who is capable of deep, lasting love. Rax King turns cultural artifacts like *Degrassi*, *America's Next Top Model*, or *Jersey Shore* into timeless poetry served on a hilarious, horny dish that you'll ugly cry while eating because you'll be thinking of the people in your life who have left, whether for a new person or the next world. Each essay burns brighter than Guy Fieri's hair. This bitch has me crying to Creed."
—Melissa Lozada-Oliva, author of *Dreaming of You*

"*Tacky* approaches all our gaudiest, clumsiest, most embarrassing cultural artifacts—and, at the same time, all our gaudiest, clumsiest, most embarrassing human emotions—with the insight they're rarely given and the compassion they deserve. A piercing, sparkling rhinestone of a book." —Jess Zimmerman, author of *Women and Other Monsters*

"Rax King is one of the sharpest and funniest essayists you'll ever read, and her debut is a bounteous feast of hilarity, tenderness, and nostalgia that will make you feel less alone in all of your own tacky joys and obsessions. Get it, read it, savor it like Guy Fieri savors the most beautiful burger you've ever seen. You deserve it."
 —Nicole Chung, author of *All You Can Ever Know*

"*Tacky* is overflowing with Cheesecake Factory portions of humor, insight, and tenderness. And you'll read the whole thing faster than the Cheesecake Factory menu." —Josh Gondelman, author of *Nice Try*

"After reading Rax King's boisterous, bighearted *Tacky*, I'll never look at Guy Fieri the same way again—but beyond that, King shifted the way I think about so many pop culture phenomena of the past two decades. Her book is like a delicious funnel cake—dusted with frosty wit, soft and chewy in the middle, and I could not stop devouring it."
 —Rachel Syme

"I am thankful for *Tacky* for how it broadens my own considerations of popular culture, of shame, and of celebration. The meditations in the book are equal parts comical, heartbreaking, and revelatory. A monument to uplifting the parts of popular culture that might otherwise be shrugged off and/or dismissed by those who don't have the imagination to celebrate what they might consider mundane. This book made me feel more at home with my obsessions, both small and large."
 —Hanif Abdurraqib, author of *A Little Devil in America*

Rax King

Tacky

Rax King is the James Beard Award–nominated writer of the columns Store-Bought Is Fine and Dirtbag Chef, as well as the host of the podcast *Low Culture Boil*. Her writing can also be found in *Glamour, MEL Magazine, Catapult,* and elsewhere. She lives in Brooklyn with her hedgehog and toothless Pekingese.

Tacky

Love Letters to the
Worst Culture We Have to Offer

Rax King

VINTAGE BOOKS
A Division of Penguin Random House LLC
New York

A VINTAGE BOOKS ORIGINAL, NOVEMBER 2021

"Love, Peace, and Taco Grease" first appeared in *Catapult* on July 29, 2019, and "It's Time to Let Meat Loaf into Your Embarrassing Little Heart" first appeared in *Electric Literature* on September 19, 2019.

Library of Congress Cataloging-in-Publication Data
Names: King, Rax, author.
Title: Tacky : love letters to the worst culture we have to offer / Rax King.
Description: New York : Vintage Books, 2021.
Identifiers: LCCN 2020052273 (print) | LCCN 2020052274 (ebook) |
 ISBN 9780593312728 (paperback) | ISBN 9780593312735 (ebook)
Subjects: LCSH: King, Rax. | Popular culture—United States—Anecdotes.
Classification: LCC PS3611.I58425 Z46 2021 (print) |
 LCC PS3611.I58425 (ebook) | DDC 814/.6 B—dc23
LC record available at https://lccn.loc.gov/2020052273
LC ebook record available at https://lccn.loc.gov/2020052274

Vintage Books Trade Paperback ISBN: 978-0-593-31272-8
eBook ISBN: 978-0-593-31273-5

www.vintagebooks.com

Printed in the United States of America
10 9 8 7 6 5 4 3 2 1

*For my dad, who is dead but hopefully taking a break
from smoking weed and eating fried chicken on the
astral plane to read his daughter's book*

Pleasure, so to speak, is nature's revenge. In it human beings divest themselves of thought, escape from civilization.

—Max Horkheimer and Theodor W. Adorno

Do every sin that you can, you know? Have sex with an old man and steal a plant and get arrested.

—Nicole "Snooki" Polizzi

Contents

Tacky

Introduction

I always thought of *tacky* as my mother's word, and at eight, I didn't quite know what it meant. In fact, at twenty-eight, I still don't really know what it means, though like Supreme Court Justice Stewart once said of the threshold for obscenity, I know it when I see it. But as a kid, I hadn't yet seen it enough to wrap the word into an appropriate context in my mind. I mostly heard my mother use it when speaking about my father's mother, a glamorous woman whom I believed was the absolute coolest. I liked watching her chain-smoke and hand my dad his ass in games of Scrabble, though I liked it less and threw occasional temper tantrums when she handed me my own ass in Scrabble. My tantrums seemed to galvanize her. She always responded to them by pointing at me and laughing, taunting me with a chant of "Aries moon, Aries moon!" until I either cried or shut up. Having been a professional astrologer for decades, she had one answer to all my most annoying behavior, be it my sore-loser tendencies or my stubborn refusal to take a joke that was made at my expense, which was that my Aries moon was responsible.

Still, I liked exploring her musty Miami condo and checking out all the badass old-lady stuff she had: piles of furs that her gangster husband had bought her, entire libraries' worth of books about tarot and palmistry, four full boxes of real jewelry that looked fake. Her jewelry alone, she'd once bragged, was so heavy that she'd had to tip her movers extra. To this day, I look back on that statement and think about how baller it is.

My mother had her issues with her mother-in-law, because this was the '90s and everybody hated their wives and mothers-in-law with all their hearts, if the era's stand-up comedy is to be believed. But when

she really wanted to cut my bubbe down to size, she'd bust out one particular insult. "Your grandi is just *tacky-tacky-tacky!*" she'd say to me, her voice jumping into its shrillest register with each *tacky*. "I mean it. Tacky-tacky-tacky-tacky-tacky!"

All that said, I wasn't worried about the central tenets of tackiness as an eight-year-old. My thoughts were firmly on the school talent show, where my then best friend, Maria, and I planned to sing and perform an Irish jig to a B*Witched song. We couldn't sing and did not know how to dance any traditional Irish dances, but we weren't about to let that hold us back. A lot was riding on this: our reputations, our love for B*Witched, our ability to wear glittery costumes. This last item was, I suspect, our primary motivator: my mother had taken us to a Michaels craft supply store once, where she'd made the mistake of letting us see the store's selection of fabric paint. My mother refused to stock a single tube of the stuff in her house, correctly believing that I would immediately turn it on all my most hated child formal wear. But now that we had an act for which we needed to costume ourselves, our desire for the fabric paint was legitimized. My mother grudgingly purchased us a couple tubes, along with some white T-shirts.

"So what are you going to paint?" she asked us, a lifelong artist herself. "Polka dots, stripes?"

Maria and I hadn't thought that far, and looked at each other.

"Princesses," I said, at the same time that Maria said, "Jewels."

My mother chuckled. "Sounds good."

At home, we promptly went apeshit, drawing vast squiggling fuckeries all over those poor white T-shirts. I do think we were making an honest effort to draw actual things, since we had developed our princesses/jewels theme a little more in postproduction and decided that we would dress as actual members of B*Witched. I would be either Edele or Keavy (they were identical twins, and my obsession with the band did not extend so far that I could tell them apart). Maria wanted to be Sinead, but I pointed out

that it wasn't fair for either of us to be blonde Sinead, since we both had dark hair. So she settled on being either Keavy or Edele, whichever one I wasn't. Clearly, we were running a tight ship.

You couldn't have told us that our shirts looked like shit, of course. It would have been roughly as effective as it ever is to tell your friend that the guy who's been giving her the best dick of her life is a jerk. We were in love with our shirts. I fell momentarily out of love when I determined that the dog had stepped on my shirt while it was drying and left a paw print. But fortunately Maria liked the paw print and switched shirts with me, so I got to fall right back in love again. As we modeled our shirts for each other, imitating the dances that we'd seen the B*Witched girls do onstage, it occurred to us that we looked *amazing*.

Then my mom came in the room and burst out cry-laughing. I'd never seen her go from zero to a hundred that quickly: one moment, she was leaning against the doorway; the next, she was losing her makeup all over her cheeks, red in the face and guffawing.

"Mom!" I said, watching her collapse.

"Oh, my God, I can't breathe!" she said. I thought, *Good. Then you'll die! And it'll serve you right!*

It took her a minute, but her laughter eventually petered out to chuckling and then aahing. "I'm sorry," she finally said, flicking a tear from her eye. That was how she thought she could save her eye makeup when she cried, though it was too late this time. "It's just. I'm sorry. You just look so tacky!"

Hearing my mother's dearest insult directed at me that day, when I knew I looked the best I could ever possibly look, I decided that I would make my life a monument to . . . to whatever the hell "tacky" was, because I still didn't know. Tacky, as far as I was concerned, was the manna of the world. The alpha, the omega. My mother only ever said it about awesome things; if I wanted to become awesome myself, tacky was the answer. Potentially high off paint fumes and unequivocally drunk off my rage at

my mother's lack of taste, I had inadvertently stumbled ass-over-elbow onto the path where I've stayed ever since.

It was the first time *tacky* was directed at me, but it wouldn't be the last. And every time I heard it, my determination was fortified. Everything worth doing, it seemed to me, was tacky-tacky-tacky: Wearing pinstriped denim overalls over a red sports bra. Shotgunning brick weed into my hot friend Adam's mouth in Bishop's Garden. Repurposing my toe rings as pinky rings during the winter months, which I sincerely believed was just smart jewelry ownership. It occurred to me that being tacky was, in some sense, the opposite of being right. And being right was hard, and thankless, and involved so much tasteful covering of the very tits that I'd prayed for throughout puberty until finally the fuckers sprang out of my chest seemingly overnight. Why should I put all that work into being right when the alternative was so much more fun?

For over a decade, I've cultivated my understanding that the rightness so many intelligent, capable people pursue does not actually matter one bit. This book is the fruit of all my research into the opposite of what is right. I mean, I call it "research," and it's true that I've read books and watched movies and whatnot, but most of that research has taken place in and around my body. The work of tackiness belongs to lived experience anyway! Would you trust someone to talk convincingly about tackiness if that person had never dated an adult man who called himself Viper and believed that showers were a conspiracy inherited from the Nazi government? If that person never passed out in a strip-club bathroom, came to, and immediately vomited on her ex-girlfriend's Pleasers to the raucous laughter of all her fellow strippers?

As far as I'm concerned, tackiness is joyfulness. To be proudly tacky, your aperture for all the too-much feelings—angst, desire, joy—must be all the way open. You've got to be so much more ready to feel everything than anyone probably wants to be. It's a brutal way to live.

What fruits will you reap? Well, you'll do a lot of stuff and be a lot of

fun at parties. Your friends will be exhausted; you'll need to make, like, six additional friends because they'll have to work in shifts to accommodate the amount of time you'll spend in emotional crisis. You'll believe that *Spice World* never did get its fair shake as a piece of effective satire. Your friend will Venmo you for the cost of replacing her curtain, into which you'd burned a cigarette hole while gesturing a little too wildly during a conversation about Puddle of Mudd. Oh, you'll be the sort of person who gestures a little too wildly with a cigarette during a conversation about Puddle of Mudd. And you'll be a relentless optimist.

Tackiness is about becoming: it's hard to access all those too-much feelings if you believe you're already done growing, but it's the easiest thing in the world when you're constantly poking your head around corners looking for what's next. Maria and I, we didn't know how to dance. We couldn't sing worth a damn. We barely knew the words to the song that we'd decided to perform. After that day, we had to admit that we were no longer even interested in fabric paint, because we hadn't counted on what a pain in the ass it would be to use. We were constantly poking our little heads around corners, full of childish thrills at the idea of the next thing and yet so young that we couldn't even predict what that thing would be.

In that moment, standing there being roasted by my mother, the next thing wasn't so great. We made asses of ourselves at the talent show. We stopped speaking in fifth grade. The last update I had on Maria's life was that she got a belly button ring, which I approve of, the belly button being the tackiest of piercings. As for me, I launched from that moment into a life of pining after unsuitable boys and surreptitiously listening to music that those boys would have scoffed at. I wanted so badly to be respectable and believed for years that I really could get there. I drank (well, drink) too much and smoked (well, smoke) too much weed in pursuit of a quiet mind. To this day, my mind is the fireworks on the Fourth of July. But who cares? I'm comfortable now.

My friend Hillel recommended that I say here what I hope people learn

from this book, because everybody wants to buy a book and then read a book report called "What I Hope People Learn from My Book by Rax King (age eight and one half)" at the beginning of that book. No, I'm just joshing. It's not a bad idea. I hope that people learn how to have a fun time with the things they love, even the silly-seeming ones, before it's too late. And in truth, I'm unqualified to teach anybody anything other than precisely that, anyway.

Six Feet from the Edge

Try though I may to eliminate snobbery from myself, I worry that I have one secret where I should be drawing the line against candor. Entire relationships have passed without my partners sniffing this out about me. I used to worry that my parents would give me away someday ("Remember when Rax was so into _____?"), but I needn't have—as shameful a secret as this has always been for *me*, it was unremarkable to them. My father might have literally taken it to his grave, but not out of any loyalty to me. More because he didn't realize he was protecting anything in particular.

My secret is that I like the band Creed. And I always have, and even now I'm tempted to hedge and say I "kinda like" or "used to like." Well, it's bullshit! I still like Creed! So there!

I'm emboldened to say this now because I think everybody feels this way, even if it's not always Creed that they feel this way about. The world is rich with pieces of pop culture that are corny, tacky, and yet balls-to-the-wall popular. We enlightened coast dwellers may sneer at Creed, Puddle of Mudd, P.O.D., Insane Clown Posse, et al., but somebody is buying up all those concert tickets, and not just in the sorts of cities we think we're better than because we no longer projectile vomit in them on spring break. Creed headlined two sold-out shows at New York City's august Beacon Theatre as recently as 2012, is what I'm trying to say. I'm merely making explicit what most of us prefer to keep under wraps, which is that I like many things in this world, not all of which have the approval of *n+1* or *Artforum*.

Grandstanding aside, I'm sensitive about my love for Creed. It doesn't feel like that long ago that I developed my first ever mega-crush, which,

fine, happened to be on Creed's lead singer, Scott Stapp. And may I remind those of you who did spit takes upon reading that how eminently crushable of a character Scott Stapp was in 2001. He had that bootleg Kurt Cobain thing going on that was so popular in the late '90s (2001 is still technically the late '90s since the 2000s didn't begin in earnest until Beyoncé and Jay-Z released "Crazy in Love"). But I always thought Scott Stapp did bootleg Cobain better than most. He was long and lean and had a chestnut shag haircut that swooped prettily off his face and pillowy lips that I wanted to kiss before I even knew for certain that I wanted to kiss boys at all.

It went like this: I heard "My Sacrifice" on the local alternative rock station, into whose tempting waters I'd just begun to dip my toes. (How alternative of a rock station could it have been if it was playing the latest Creed single? These were the sorts of philosophical questions that occupied local high school boys, creatures of the utmost sophistication as far as I was concerned, but such thoughts hadn't entered into my ken yet.) I liked the song, and at ten years old, I was only just beginning to decide whether I liked songs on my own—before that, my parents had called the shots on what we listened to in the car, and I'd been along for the ride. When the song ended, the DJ announced that we'd just heard the latest from "testosterone rockers from Tallahassee, Creed." I will never forget the lilting cadence of the phrase *testosterone rockers from Tallahassee*. It's absolutely euphonious, my version of *cellar door*.

This was 2001, meaning that further investigation wasn't as immediate as pulling out my phone and launching myself down a Google rabbit hole. Instead, I wrote *Creed* on the front of my notebook, to remind myself to check them out. Then, later, I asked my dad if he'd take me to Barnes & Noble that week, where I hoped to buy a CD.

"A CD, huh?" my father asked over dinner, his face spattered with spaghetti sauce. "Is there a new Backstreet Boys or something?"

"It's this alternative band called Creed," I said incorrectly. As a matter

of fact, there was a new Backstreet Boys, but my parents teased me so ruth-lessly over my mild attraction to Nick Carter that it felt unwise to say as much. I thought that phrases like *alternative band* would finally get me some respect around here, proving as they incontrovertibly did that I was a cool teenager who was developing good taste of her own.

"Well, sure," he said. He wiped some red sauce off his mouth with the back of his hand and looked in his calendar. "I'll take you tomorrow. We can make a date of it."

Make a date of it we did, and after hamburgers and milkshakes at our favorite place, we adjourned to Barnes & Noble, him for a book, me for my Creed. I loved to browse the music section by myself, believing that I resembled a teenager who legitimately belonged there. I was incurably shy, but in the music section, I was as close to brassy as I ever got, mean-ing I nodded to strangers as I passed them rather than looking at the floor.

I found the album with "My Sacrifice" on it, *Weathered*. Regrettably, the album cover depicts a tree with the band members' faces superimposed onto it, with a pair of hands about to hammer a nail between two of their faces. Behind the tree, light shines in such a way as to heavily suggest the presence of godliness, while a man's figure engages in some sort of general-ized toil to the tree's side. The whole tableau is composed as if by a fifth grader with a collage assignment that was supposed to be handed into his art class four days ago, and maybe the theme of the assignment was Sad-ness, or What Jesus Means to Me.

I saw none of that, though, at the time. What I saw then was a particu-larly pretty face at the base of the tree with the band's faces trapped in it. Hangdog eyes, a sweep of dark hair. The other faces loomed off to either side whereas his was central, which I recognized even then as the placement of a front man. I looked at the list of band members on the back of the CD. "Scott Stapp," I whispered.

My father returned to pay for my CD, a book in hand. "You ready?"

I hid the CD's front, believing that he'd sense something improper in the way I looked at it. "Yep."

"No parental advisory sticker," he said, taking the CD from me. "How alternative could it be?"

Creed's music was, as far as I was concerned, *very* good, but Scott Stapp's face was better. My attraction to him demonstrated for the first time that I was a little animal who would one day have erotic needs, and as with all things happening for the first time, it felt too big and too much. At ten, I was functionally still the child I'd always been. I wore glasses and braces with rubber bands that made a spit circus out of my speech, and I still played with Barbies sometimes and punched the neighbor boy in the face for asking to kiss me. (Navid, if you're reading this, I am truly sorry about that.) I wasn't crush-proof, and in fact had my eye on a boyish young teacher in my school who had a sweet smile, not to mention my aforementioned vague interest in Nick Carter. But I wept over my obsession with Scott Stapp, yearned to meet him, to smell his hair. Bite his face. Anything. None of my other incomplete attractions had ever obsessed me like that before.

I believe that the mega-crush is a formative experience in a kid's life, quite separate from the low-intensity testing the waters that constitutes most early crushes. Our earliest crushes, if they exist, are typically shy and half-assed. We've received the message that we're supposed to find each other attractive, and are just beginning to give it a shot, even if our hearts aren't in it. When Navid the neighbor boy asked me for a kiss, my sense wasn't that he actually wanted one. After all, he didn't like me—his favorite activity until that point had been to whiz past me on his bike so close that the breeze his passing generated whipped me hard in the face, laughing at my startled cries. My mother's explanation was that boys who liked me would always tease and bully me like that, but in retrospect, I think he was acting out of duty rather than feeling when he proposed that we

kiss. Tasked with the eventual kissing of girls, he figured he might as well practice and found a low-risk partner for his venture.

But no kid needs to be wheedled into kissing a mega-crush. For some of us, myself included, it's a celebrity; others are fortunate enough to find mega-crushes at school or the mall, where they can be seen regularly and even touched. The circumstances change, but what doesn't change is the absolute gut-plummeting desire. It's an adult's desire compacted into a child's body; it gnashes its teeth and howls at the moon. To see one's mega-crush is an experience of such pungent bliss that an auxiliary glow will follow the crush-haver for hours; to experience the mega-crush with some closer sense, hearing or smell or (can you imagine?) taste, is to plunge into the divine. Because this was 2001, Scott Stapp appeared occasionally in celebrity media, all of which I consumed with a hunger I hadn't known I possessed. I didn't read interviews with him, exactly. What I did was scan them for words that were relevant to my young obsession, words like *girls, women, touch, sex, kiss, hunger, love, flesh*. I tore out pictures of him for my wall, including once, memorably, from a magazine that I had not actually purchased from the grocery store. Thus did I love Scott Stapp: with a fervent, angry desperation to kiss him, scream at him, swallow him whole.

While my obsession was mostly with the face (and the body, Jesus Christ; 2001's Scott Stapp was still relatively fresh from his tenure as a college athlete and had abs you could shred a brick of Parmesan on), I never could forget the music. Every Creed song seemed to me like it was made to be heard on repeat. As gorgeous as Scott Stapp was to me, I don't think I would have become obsessed with the same face on a man who wasn't singing about abject pain. My nascent sexual urges had already tethered themselves to my fascination with emotional agony: I wanted a sensitive man to be sensitive with me. At ten, the edges of my personality were beginning to crisp up into certainty, and Stapp's anguish filled me to those

edges as much as his beauty did. I was becoming the sort of lover that I was maybe always cursed to become. Earnest, gentle, despicable.

There was something peculiarly masculine about the way in which Stapp expressed all that pain, too—not just male but adult, manly. He didn't cry or shrink into himself the way I did when I was unhappy. He didn't stamp and bully like a little boy. He didn't keep placid over a vast ocean of agony like an adult woman. As a girl, I knew plenty of men in a neutered sort of capacity. My father expressed unhappiness when he felt it, but couldn't do so with true candor while I was still so young and innocent to the problems of adult life. My male teachers would send us to the principal or give us detention if we pissed them off, but if they wailed about it in the teacher's lounge later, I certainly never knew about it. Until I began listening to Creed, I had no point of reference for what men's pain sounded like straight from the tap, before being filtered for my childish consumption.

Of course, popular entertainment has always put a high premium on expressions of male pain. I might not have seen it in pure form in the men I knew, but men's pain was all over the TV, in books, everywhere. Stapp's pain, though, was different. It was unadorned. He never took pains to transmute his sorrow into the more acceptable rage before letting audiences experience it; as such, his pain couldn't be cool. His project was never to interpret his pain for listeners, but to express it, diary-like. He was honest in a disquieting way. When his voice lacerates through the lyrics "Hold me now / I'm six feet from the edge and I'm thinking / maybe six feet ain't so far down" on "One Last Breath," there's no question of how to understand what he's saying.

Creed is despised now, but the evidence doesn't bear out people's assertions that they hated Creed from the start. For one thing, Creed's first three albums all went multiplatinum. Somehow, despite Creed's success, which was quantifiable and proven many times over, nobody I know admits to

having owned their albums. Who, then, was buying all those copies of *Weathered* and *Human Clay*? Ask people to explain that, and prepare to hear some ugly, telling answers: The slobbering masses! Dads in garage bands! Spring break cokeheads! In other words, flyover people, country idiots, anybody too buffoonish to know better.

I had a version of this argument with my friend Mike once, though I was still an undercover fan when we had it, a double agent. "Why do you think everyone who likes this music is stupid?" I asked him after he'd mercilessly roasted the Creed song that had just played on the radio.

"You're right," he said. "People who like to hear the same three power chords and the same constipated yelling guy over and over are really smart, actually."

"These guys are singing about the same stuff as anybody else. Loneliness, heartbreak, suffering. Why is it so awful when they do it and so great when Lou Reed does it?"

I'd meant it as a sincere question, but Mike rolled his eyes, sick of my shit.

"Because Lou Reed is a genius," he said. "And Scott Stapp is cockrocking bullshit."

I couldn't fight that battle further without giving myself away as a Creed enthusiast. I'd ventured too far into enemy territory as it was. But my point was that, while people say they hate Creed, it's never primarily about the music. At the forefront of that hate is the band's aesthetic: its white-bread Florida machismo, its dad-friendliness. As Mike might say, its cock-rocking bullshit.

Sure, those simple guitar riffs and Scott Stapp's yowl could have all come from the Prefab Dad Rock Band Supply Store. But the same was true of Journey, and as writer Jonah Weiner put it in his defense of Creed, "'Higher' might turn out to be the nu-grunge 'Don't Stop Believin'': dismissed by cognoscenti on arrival as bludgeoning and gauche but destined for rehabilitation down the road as a triumphant slab of ersatz inspira-

tionalism." And even that *ersatz* strikes me as a little unfair. If it's genuinely inspirational to somebody, is it ersatz inspirationalism, or is it just simple? Simply packaged, easy on the way down? And if it's just simple, must we dislike it for its accessibility to people who don't have the time or, hell, the inclination to study music and develop their taste for it on more "legitimate" grounds? Three chords served the Ramones just fine, didn't they?

An interesting thing about anti-Creed critical writing is that critics are in agreement about the fact that Creed's music is bad, but struggle to identify its badness more intelligibly than that. Forced to pinpoint that badness beyond the point of tautology ("Creed is bad because the lyrics are bad and the guitar riffs are bad"), critics flounder. Part of this is no doubt a result of how difficult it is to relate to a reader what music sounds like in one's writing, a difficulty that's always plagued writing about music. Still, truly invested music critics have always found a way to capture readers' imaginations beyond the point of telling them whether to buy a certain album or not.

Most writing about Creed is not careful like this. It's negative, but it doesn't *inspire* hate so much as it *confirms* hate. It's repetitive. It convinces the reader that the writer was bored more than anything, and what could be more boring than reading about a time when someone else was bored? Adjectives, even the positive-ish ones, convey that the people who wrote these songs must have been powerfully stupid: *straightforward*; *without pretension*; *turgid, lumbering*; *heavy* (this last one's used often, even multiple times in a single review). Some people who were tasked with writing about these albums loathed them, and others thought they could have been worse. Good luck finding any raves. But even negative reviews all point to Creed's massive popularity, with a mystified shoulder-shrugging: *Whatever we say, you're still going to throw your panties at them onstage when they roll into town, dummy.*

What strikes me about these reviews isn't that critics disliked Creed. That would have been fine—criticism should be allowed to be critical, and I don't love Creed so much that I can't imagine feeling any other way. It's that critics found Creed's music so singularly dull and without merit that

it wasn't even worth tearing to shreds. It's as if they all knew that no matter what they said, the sniveling masses were going to buy this stuff, and so why bother offering in-depth criticism instead of simple sneering? Squint at it from a certain angle, and the era's critics become the embattled soldiers at Thermopylae huddled together against Creed's unstoppable Persian army. Except, you know, less noble, less strategic, more nihilistic by half, much heavier on the despair, etc. I think about John Updike's rules for writing constructive criticism—assess what the creator meant to do and not what you want him to do; if the creator has failed, try to understand where the failure happened rather than just point fingers—and then I read reviews of Creed that ignore all those rules. This is not constructive criticism.

You'd better believe that the lack of critical approval chafed Scott Stapp like crazy. At the peak of Creed's popularity, Stapp didn't like reading anything about his band, even when it was written with sympathy. According to Gavin Edwards's 2000 *Spin* profile of Stapp, he found the sympathy condescending, the harshness of the criticism invalidating, and the whole project of being scrutinized demoralizing. He wrote a whole song, "What If," about confronting his haters, maybe physically—the lyrics are just vague enough to keep Stapp on this side of a restraining order.

Critics might have refused to take Creed seriously because Scott Stapp obviously took Creed *so* seriously. As popular as Creed has always been, that self-seriousness was their downfall: critics hesitated to confirm Stapp's God complex by hating his music with critical rigor. A rigorous treatment of Creed would have legitimized Creed too much. Gavin Edwards's profile of Stapp was kinder to him than similar profiles from the same era, but Stapp still managed to pistol-whip that kindness regularly with his heavy-handed philosophizing. Even I, a confirmed Creed stan, am tempted to roll my eyes when Stapp said of his son Jagger, "I just don't want him to have the same demons that I have. I don't want him always thinking about the grand scheme of things—life and death and heaven and hell and good and bad. That's the cross I bear daily."

But I don't roll my eyes, and I don't stop reading, and I don't go out and

call Scott Stapp a tool and make fun of his gravelly singing voice and all the rest. Unlike the people who snicker about Stapp's cross-bearing ways, I suppose I believe that this is a perfectly legitimate way for him to relate to the world. Look—why not? Why is it inherently funny to be serious, to be afraid, to borrow the language of the Bible (a language in which I'm sure Stapp is fluent, as the son of terrifyingly devout Pentecostal parents) when putting that anxiety into words? How is Stapp less intelligent for speaking about the struggle of staying alive as if it's *really, really important*? A person who looks at every earthly trauma and recognizes them as traumas, and wants to write in earnest about the fact that trauma is harmful and causes pain . . . That's not an idiot; that's a fucking philosopher.

Now, is this the position I would have taken at ten years old, my veins bubbling over with the heat of Scott Stapp's physical beauty? Absolutely not. But—and this is a crucial *but*—it's not because I didn't believe in the severity and grimness of Creed's mien. It's because I believed in them more deeply than I'm capable of now, so deeply that I didn't even think it was worth identifying as a stand that I was taking. Of course the world is dog-shit and should be sung about as such. What ten-year-old doesn't feel that way? Actually, what thirty-year-old doesn't feel that way? Just because we've built protective insulation over the rawness of those baby nerves doesn't mean they're not still there. It's saddening to me that if I'm going to feel earnest and sincere rage at the state of the world, I have to either wink and sneer at myself preemptively, or I have to be comfortable mounting a soapbox and opening myself to mockery. Honest, pointed sincerity lacks style. It isn't chic.

Would I have spent twenty years consumed by shame over an obsession with Justin Timberlake, or Nick Lachey, or poor jilted Nick Carter? These were, after all, the era's most eligible teen bachelors. Perhaps the primary issue with my fixation on Scott Stapp was the strangeness of it. People listened to Creed, sure. You may hate Creed now (that is, if you do hate Creed), but you couldn't not listen to Creed in 2001, whether you liked

them or not. But Scott Stapp wasn't a sex symbol, at least not for young girls. He was too *adult*, somehow. If he'd, say, married a Mickey Mouse Club alum or a Disney Channel star, it would have been appalling in its incongruousness. But when a sex tape was released that showed him and Kid Rock receiving blow jobs from a couple of unnamed women, nobody was surprised, even if they were supremely bummed out by the trashiness of the whole scene. (To my mind, trashiness is distinct from tackiness; it's closed off and uninviting. It's unpleasant. If tackiness is about joyfully becoming, trashiness has already become, and there's not one joyful thing about the thing it has become.)

Anti-Creed-ists rightly point out Scott Stapp's troubling tendency to behave like a drunk teenager on spring break at Daytona Beach. As far as we were concerned, Scott Stapp hadn't earned the right to cut loose and misbehave. He wasn't a visionary. He was just some guy from Florida, shit-housed and slurring for stadium audiences despite the fact that he wasn't good enough at his chosen craft for that shit. Scott Stapp chose to burn himself alive rather than fizzle out or fade away, unable to achieve either the dignity of martyrdom or the steady lifestyle of the popular working musician.

After Creed's wild success, Stapp sank into one of the most dismal low periods in recent collective memory. In 2014, he posted an exceptionally creepy Facebook video that was rife with conspiracy theories. He claims in this video to be clean and sober, appearing to be anything but, and also says that "they" are stealing money from him, resulting in the IRS putting repeated freezes on his bank accounts. The video has since been cleared from the Internet, but was posted within the same month that Stapp's wife, Jaclyn, called the cops on him because he wouldn't stop claiming to be a CIA operative sent to kill then president Obama. Ultimately, Stapp's psychiatrist determined that he was in the middle of a psychotic break, likely related to undiagnosed bipolar disorder. Diagnosis in hand, Stapp really did get clean and sober, and his psychiatrist fixed his medication, and

now "whatever happened to Scott Stapp" is one of the top auto-suggested results when one Googles his name.

Now, I repeat: I didn't see any of that as a kid. You don't, when you have a mega-crush. All I saw were miles of muscular arms, hundreds of trillions of chestnut hairs, a cubic ton of collagen bound by acres of soft pink lips. But then, I heard that voice, too, like so many other voices but not, shot through with lacerating pain that turned out to be so much more real than any of us recognized. It's easy to laugh at such a voice and call it dilettante, poseur, dollar store Eddie Vedder. It's not so easy to laugh at the pain itself. Not when it's destructive like that. And as a kid, riddled with phantom pains that I didn't understand, the pain of a crush, the pain of an adult's brain and body forcing their way to the surface, I was drawn to him. I appreciated how unsubtle he was. It was what I needed.

Look again at "One Last Breath." Nobody likes it anymore, because this is 2020 and Creed has been a joke for a cool twenty years. But when it was released, it was a powerhouse, one of those songs you'd turn the radio dial to escape because you were sick of it, only to run smack into it on the next radio station. One of their greatest hits, that song, and from start to finish it's about the speaker's desire to *die violently and immediately*.

We laughed—that is, if we did laugh. But it would have been so much kinder to listen.

The day I started high school, I learned I wasn't allowed to like Creed anymore. I was developing my snob instincts at that point, but they hadn't come for Creed yet. Mostly, I belittled the various preps and poseurs that ruled my class, believing (correctly) that they were a more imminent threat to my social standing than were the nuances of dueling alternative rock sects. I believed that my marching orders were to hate the Black Eyed Peas and my once-beloved Britney Spears, not Creed, and I was all too happy to obey them.

So *Weathered* was still in my portable CD player when I got onto the

bus that day and sat beside a good-looking junior. But when I ejected it at the next bus stop, my handsome seatmate snickered. "Creed?" he said. "Really?"

I like to think that today, I'd respond with the piss and vinegar that such sneering deserves. Like, what difference did it make to him whether I was listening to Creed? But I was brittle then, and desperate for approval, and so I absorbed those two words and the entire cruel landscape of implication that stretched beneath them, and I learned the appropriate relationship for me to have with Creed, which was one of low-grade superiority over them. Not a superiority to be asserted or defended, but simply low-wattage smirking at the very fact of them, as dull and unchangeable as the turning of the earth. I stopped listening to them. I cleared my walls of Scott Stapp paraphernalia. By then, the sharpness of my attraction to him had begun to blunt, anyway. Boys at school had soft lips and well-defined arms, too, and they had the advantage of being in my orbit. Banishing Creed from my life was an early effort at padding my young feelings, dulling the severity and sincerity of them in an effort to make them more palatable. At ten, I fell in love with anguish for the first time; at fourteen, I realized that unblunted anguish was unattractive to the people that I very much wanted to attract.

It wasn't until a chance relistening of "One Last Breath" that I realized I'd allowed certain muscles to atrophy unnecessarily. Who cares whether the band was derivative? What isn't derivative in this day and age? Creed cribbed from their idols with hard-nosed, unornamental skill. Their music sounds so simple that it's easy to lose sight of the song craft in it. Plus, of course, to look back on Stapp's lyrics is to engage with earnest empathy in its most unpolished form. He wrote from the perspectives of rape victims, fathers holding their newborns, the suicidal. And fine, what he wrote may never win any MacArthur "genius" grants, but name a single other songwriter who was as prominent in those days and working his empathy muscles even half as hard.

I realized, in other words, that I'd waved goodbye to sincerity too early. It's a common evolution, I think, but it's one that I'm ready to reverse. When I was a teenager, my peers' approval could not have mattered to me more, to the point that I was willing to learn how to sneer, how to mock, how to experience emotions almost sarcastically; if I dared to cry about pain that I was experiencing, I needed to then laugh at myself, apologize for my embarrassing behavior. In retrospect, it was a shame that we learned to blunt ourselves before we learned to be kind, but I get why we had to do it in that order. The hugeness of adolescent emotions would have crushed us if we hadn't learned to at least act like our feelings didn't matter. Now that I'm older, and can recognize that not every pain is a death knell, I'd like to revisit that time in my life when I was equipped to give the hideousness of human emotion its respectful due. I'd like to groan, and wail, and squeeze my eyes shut when I sing a particularly meaningful chorus. And I'd like to do all those things without worrying that people are making fun of me for it, even though they will be.

So, in case the message was remotely unclear: I like Creed. I liked Creed seventeen years ago, I like Creed now, and I don't think I'll ever stop liking them. They lacked style. Fine. So what? I embrace Creed, in fact, with arms wide open. And I invite anybody else who's sick of smirking behind the general public's back to do the same. We have so little time to engage with the art that our fellow humans have created, and of course nobody is obligated to like all of it. But to decide that someone's work has no merit because that person is drunk, or sick, or unhappy, that is a judgment call that none of us should feel qualified to make.

Ode to Warm Vanilla Sugar

You are unctuous light, you are brown and golden smell, you are the density of pound cake still steaming from the oven. Some people think that brown-and-golden is no smell at all. Some people, cowards, philistines, enemies of all that is subtle in the world, some people *ice* their pound cake. Drown sugar in butter and spoil the whole thing sweet-rotten. They don't know what you and I know.

What I know is that you are the smell of frightened girlhood just as it teeters over the precipice of *the change*. You were a pheromonal ideal for us because we did not yet know how to smell like ourselves. What did we know about the earthy odor of unwashed hair, about getting drunk off the right person's neck sweat? What did we, who until recently had played cheerfully enough in dirt, know about what the dirt and grit of being human actually was?

Because listen carefully and you can hear unfamiliar sounds: the scritch-scritching of hair sprouting against gym-class pinnies; the whisper of training bras under shirts that once covered only the nothing that had always been there before. Before, before, before. And of course there is still the cacophony that attends all children everywhere, tiny bones tumbling skin-first onto sidewalk, singsongy speech feeding into tears, the squelching of fat bugs under shoes that may still even have Velcro and not laces. Velcro, for God's sake! What could be more little-girl than that? And yet we were changing, and we knew it, and we could look at our mothers and sisters and think, *That's coming for me, too.*

We hadn't met you just yet, Warm Vanilla Sugar, though we'd met others like you. Some of us had been licking berry-flavored Wet N Wild off

our lips for years. Some of the bolder girls even wore 28AAA facsimiles of bras, complete with lace rosettes or bows between the "cups." The bras supported nothing, but made their wearers feel womanly. That was the game: to feel womanly. To put on all the same ridiculous feather boas and fascinator hats that had always filled our dress-up trunks, but have them look *real* on us.

Perfumes, body spray, body glitter—these were all extensions of those same girlish impulses to look like women before we'd bothered to take a good look at women. We all missed the subtlety in grown women's performances, the earth-toned makeup palettes without a glitter or green in sight, the sleekness of a woman's pelt fresh from the blow dryer, the necklines that inexplicably didn't always show the maximum amount of cleavage even though they *had* cleavage, these women, and could have shown it off all day long if they'd wanted to. We little girls understood none of this. "When *I* have boobs," my friend Maria (whom you may remember from my ill-fated B*Witched tribute performance) once said confidently, "*everyone* will see them."

So we threw ourselves into the world of substitutes, even as we knew they could only ever be substitutes—if they'd been the adult versions of the things they imitated, then forget it, our parents would never have let us have them. We painted our eyelids blue and our mouths pink. We stuffed our training bras with tissues and socks. Unable to be women yet, we built woman-golems from ourselves, fearsome and ugly. We clip-clopped around the house in our mothers' heels, our feet pooling at the shoes' bottoms. We attended closely to every word we could hear our parents saying so that our speech was a monstrous blend of slangy playground insults and grown ladies' kaffeeklatsch talk. At nine, I might have described the rude neighbor boy as a "little shit." At eleven, I chuckled at his antics, dodging his water balloons and wryly saying, "Oh, he thinks he's *such* a card." My woman's ear was untrained and couldn't pick the mild from the profane; I'd become a prepubescent grandma.

You were a key part of that performance, you and your sisters. But for me, once I had you, I needed nothing else. Other girls might favor Cucumber Melon or Sweet Pea, and good luck to them. Me, I found holiness in your smell, beguiling as it was. You baked a cake out of me every time I rubbed you into my skin. You turned me into dessert. What could Cucumber Melon do? Turn its acolytes into cocktails or salad? What could Sweet Pea do? I'd found all the sweetness I thought I'd ever need.

The funny thing about dessert is that nobody needs it. I never order a slice of cake to satisfy a need, but rather to fulfill some craving, succumb to an impulse. I am tempted, constantly, by dessert, which does little to sustain my body but does wonders for my soul. At diners, I can't help but genuflect at the cases of elderly-looking apple turnovers and stiff old cannolis. I pause, every time, at the glittering lazy susan overburdened by pies upon pies upon pies. Whenever I make eye contact with the blueberry muffins at coffee shops, suddenly I am one blueberry muffin richer, without even realizing that I've ordered one, propelled by pure impulse. I can know that the lemon pound cake at Starbucks has seen better days and still long for it, just as I long for one more line of coke when I know I've had enough, just as I long for the love of men who don't think about me when I've gone. As a woman, I succumb constantly to the lure of dessert, in any form. As a kid, I was content just to become it.

Don't get me wrong: I am still, typically, dessert. I am dessert when I get a text at one in the morning, *miss you*, from a man I haven't seen since 2016. I am dessert when I listen to a married man telling his wife on the phone that he's alone, totally alone, yes, he promises, no, he's not lying, and the phone call ends, and he doesn't even pretend it's a struggle to make eye contact with me—after all, what about dessert could ever be a struggle? And when I let myself be folded into that lying man's arms, when I let it feel good, I am as dessert as I'll ever be. I am egg whites folded into black batter. A wisp of whipped cream cresting off a mocha, a bead of ice cream

melting down a pretty chin, a speck of vanilla bean in a pastry-cream tun-
dra, dessert. I imagine men receiving a menu with me on it, and shutting
that menu after the most cursory glance: *No, thank you, it's very tempting, but I
couldn't possibly.*

The more ornamental a person becomes, the less they are able to relax.
I'm thinking of dessert, and also of Vargas girls, the wildly popular pinups
from the 1940s who couldn't have been more dessert if they'd tried. They
dressed (inasmuch as they did dress) not for style but for sex. Their faces
showed unmitigated exuberance at the prospect of being eye candy. Their
bodies were pinched into corsetry and punishingly tight shorts, but they
still arched their backs and pointed their toes with ease, like no human
woman in the same getup would be able to.

For the boys at the front during World War II, that was arguably the
point. These were not the ladies back home in their unflattering factory
wear, smeared with motor oil and sweat and punching time cards. The
Vargas girls existed far away from even the suggestion of a workday. Their
panties all had matching bras. They were forever reclining on California
king–sized beds in some distant, inaccessible hotel room, waiting to be
activated. I took them, and not any real women, for my role models. If
the Vargas girls had been able to speak, it would have been exclusively
in murmurs and purrs. If we could have smelled them, we would have
encountered none of the pungency of womanhood, but violets, melting
chocolate, strawberry shortcake. Or, maybe, warm vanilla sugar.

You made the whole mess so much more straightforward: I could be des-
sert in the most immediate way, without bothering to mold myself into
something more tempting on any other level. I could make the room smell
like cake without worrying about whether I was, sexually, metaphysically,
the cake. I was content to let my skin be dessert because I hadn't yet learned
about the ways a woman might torch the crème brûlée of her psyche until
she was barely recognizable as human. At eleven, I was plank-flat and shrill

and hadn't figured out how to talk around the formidable architecture of my rubber-banded braces. Nothing about me was tempting but my smell, which was really your smell. It belonged, still belongs, to you.

Yes, it belongs to you, and I could argue something similar about so many things that are delectable about me now. This body belongs not to me but to youth; this voice belongs to all the cigarettes I haven't yet smoked; this mouth has been annexed by the men who claim to worship it. I'm not going to be an intoxicating beauty in fifteen years. Other women have the patience for that sort of upkeep, but I freely admit that my plan is to let it all go to hell. Where will it go when it's gone? What will this body be when the last licks of caramelized sugar have been swallowed off its surface?

I don't remember precisely when I stopped wearing you, but I do know why. Some of your coevals were discontinued, but you seem to still be going strong, baking treats out of a whole new generation of raw-batter girls. As a kid, doused in so much of you that I was regularly sent to the bathroom to rinse, I believed that you would be my signature scent forever. But then I sprouted, really sprouted, not just those half-growths of budding breasts and single-digit armpit hair counts that plagued us in the middle school locker rooms with how goddamn slowly they seemed to be proceeding. Once I sprouted, I counted on your magic less. I quickly grew cocky about the magic of my own body after watching the way it drew stares and whispers. I didn't think I needed something like you anymore. I believed I'd outgrown dessert and didn't yet realize that as a woman, my ideal role was to be dessert forever, unnecessary but so delicious that one couldn't help but desire it.

I remember all the men who have ever appreciated my body and, more pointedly, all the men who have failed to, despite the Vargas girl–like theatrics I've long incorporated into its upkeep. Because frankly, at the end of the day, I don't want to work so hard to look and smell and taste good. I

don't want to eat as much pineapple as I currently eat because I read somewhere that it makes one's pussy taste sweeter. I don't want to have a panic attack because I've begun my period two days early while wearing a pair of panties that cost fifty dollars and are the only ones I own that match this bra. I hate leaving the house realizing I've forgotten to spritz myself with perfume and going back home to fix it. I don't want to work so hard for an only occasionally appreciative audience, especially when that audience comprises men I'm attracted to—a demographic that is historically not worth making any special effort for.

I particularly remember one man from Tinder, Drew, who had just graduated medical school and was one of those exhausting postgrad drug users who has nothing to say about anything except the exceptional quality and unquestionably fine provenance of his psychedelics. I had sex with him because I'd met him at his apartment and it seemed a waste of a perfectly good lace bodysuit not to have sex with him. I did everything right. Arched my back, pointed my toes, everything Vargas girl perfect, choreographed down to the last detail because I couldn't relax. And afterwards, he reviewed my performance with the same daffy good cheer that he used to speak about his last DMT trip. "That was fun!" he said. "Do you ever think about maybe trying to tone your butt more?" All that effort, costuming, preparation, and in the end he noticed nothing but one glaring defect.

I wish I'd cussed him out, slapped his face, stormed out of his apartment—in fact, I wish I'd stormed out of his apartment before we had sex, when I'd already decided I didn't really like him. But, caught off guard and pathologically frightened of the ways men react when challenged, I only smiled and said no, I never had, how interesting. And now I hear Drew in my head asking whether I would tone my butt more every time I examine the full length of my naked body in the mirror, which I do often. Looking, as Drew looked, for defects.

As a teenager, I kept thinking I was done becoming. I found my first boyfriend and checked "find life partner" off my internal list. I grew breasts and got my period and checked off "become entire woman." I was realistic,

of course—I knew that my becoming wouldn't be worth much until I went to college, at which point, free from my parents, all my wanting would be over at last. Between the years of fourteen and, well, the present day, I've felt constantly as if I've finally learned my lesson. When my first boyfriend dumped me, I figured I'd learned how to keep the next one around forever. And I figured it after every instance of a man's cruelty or disrespect: that I'd learned what to do differently. Now I'm twenty-eight, a decade and a half into having "learned what to do differently." What am I actually doing differently? Nothing. Still the same hoarfrost-hearted secret romantic, but with the beginnings of a beer belly; that's something, even if the optimistic teen that I once was would never have put it on a wish list for her life.

When I grew from sweet-tempered girlhood into the glowering sluttiness of my adolescence, I had no place for you anymore. An adult woman's signature aesthetic was meant to be darker and woodsier. I knew the score and spent my first ever paycheck on my first ever bottle of perfume (not the Daisy by Marc Jacobs that I wear now, but something cheap and nostril-choking). I mean, let's face it, I bought everything. A floor-length nylon gown with crotch-high slits, an ill-fitting Victoria's Secret teddy, a pair of pumps that I didn't bother to practice walking in before I wore them for the first and only time and got only a wreckage of blisters for my trouble. If I'd seen some better variant of the thing on a grown woman, I needed it.

Now I am grown myself, no longer enough of a fool to believe that I'm done becoming, but enough of a fool to believe that the worst is over. I am not quite finished baking, but by now, one can smell the dessert that I'll be when the oven door opens and the toothpick comes out of me clean. I no longer storm about in my mother's heels; I have heels of my own, heels that fit, and I have makeup without any glitter in it, and a lingerie collection that makes a certain sort of man believe in God. I pay my own rent in an apartment where my mother does not live. All of this is what I cling to when men remind me that they will always think of me as the dessert they consume when they're really too stuffed to eat another bite.

———

I could return to you if I wanted to. You're still available for purchase, and I'm sure you smell more or less the same, albeit in a less revelatory way now that I can never again smell you for the first time. Forgive me for choosing not to then, especially because I miss you—not in the way that a man misses a woman he texts at one in the morning, but in a truer and simultaneously more fantastical way, because you represent something that I once was and can never be again (so actually, maybe exactly the way a man misses a woman he texts at one in the morning). I am tempted, often, by the desire to go backwards. To return to a silly and optimistic mode that should no longer be available to me, a mode from before I knew every cruel way that I would be treated on my journey towards adulthood. I'd feel pathetic chasing the bite-sized tea cake magic that you once bestowed on my skin, now that I am no tea cake at all but something heavier and more sinister, something with Valrhona and no flour. I do nothing the way that I did it when I was eleven. Why should I make an exception for you? So as easy as it'd be to reunite with you, it'd be a false reunion. We'd have nothing to do together anymore, you and I.

So I no longer own you. Fair enough! I hope, though, that you'll still permit me my nostalgia for you. I hold you in the highest esteem for what you did for me, allowing me to spray something on my neck and then on one wrist, and mash my wrists together to spread the smell, like I'd watched my mother do at her vanity every day. You bought me time. Like a training bra, you let me play my last games of dress-up before I knew what kind of woman I even wanted to dress up as, before I knew that there were different kinds.

As for the things that haven't changed, I could never hold you responsible for that. I was always destined to be consumable. I was never going to become the sort of person who commands respect. And that's fine. Some days, it's even preferable. I pass through men's lives like the taste of cherry kirsch syrup down the throat. What would I do if I were something meaty and substantive? Grow old with somebody I met in high school, like I once believed I would? Miss out on all this? I'd sooner miss out on the sun.

So I salute you for the grown-up games you allowed me to play without ever calling attention to the indignity of the truth that I was, in fact, still playing games. I salute your smell, rich as bread but sickly as sugar syrup, somehow heavy and fairy-light all at once. Every time I saw you being deployed in a locker room, I failed to salute, and so now I must make up for lost time. You introduced me, fleetingly, to the woman I was going to be. And now that I am her, I remember you with the greatest fondness, confident that, in a way, I couldn't have done it without you.

Vignettes from Hot Topic

The first time I saw a Hot Topic was just before my eleventh birthday, which was itself just before my entry into middle school. I remember passing by the store hand in hand with my mom as we headed to Limited Too. All my clothes were still pastel, floral, girlhood bundled into every pleat. I planned that day, as I often did, to pester my mother into buying me a baby blue velour jacket with *Varsity* loopily scripted across the zip-up front, one of Limited Too's signature items. She never wanted to blow her money on such a frivolous thing, but I optimistically believed I was making headway every time I harassed her for it. My usual argument was that these jackets were cornerstone statement pieces of such fifth grade successes as Faith O'Daniel and Kelsey Barber, names that failed to inspire in my mother the awe intended. But, I argued, how could I be as pretty and popular as they were if I didn't share their uniform?

It's amazing to look back on my girlhood and remember how tormented I was over my inability to fit in. In retrospect, it feels like it can't have mattered so much, but of course I'm looking back on it all as an adult with a job, romantic partners, money troubles, deadlines, drugs, episodes of *The Sopranos* to catch up on . . . At the time, there was only school. My mother was consumed by pain at how I suffered at the popular girls' hands, and racked with guilt at her inability to provide me with the Limited Too camouflage that I believed would save me. It probably wouldn't have. A food chain had long ago been established, and I'd been at its bottom for years already. It was too late for me to catch up unless I started anew at a different school, which I frequently begged my parents to allow. (At a different school, I *would* have the varsity jacket, and nobody would know

there was a time when I hadn't.) I must have understood on some level that I couldn't change the behavior of the girls who despised me for my glasses and braces and asthmatic wheeze and, it must be said, pronounced teacher's pet tendencies. But changing what I wore while they mocked me, that was easy.

All this weighed on me as we shuffled past the new store occupying the space left behind by the seasonal Christmas store, deep in the mall's bowels where few people would see it. But as I peeked inside the new store, called Hot Topic, I realized I'd been chasing the wrong prize. It was livelier in there than Limited Too ever was, full of orange- and green-dyed heads as richly hued as Truffula trees, with liberty spikes of perfect, prismatic integrity poking out from racks of clothes like sharks' dorsal fins. The pants that I saw draped from lower bodies were all massive and appeared to weigh about eighty pounds apiece, after factoring in all the chains and pockets. Boots, too, were blocky and looked hard to lift from one step to the next. Most fascinating of all, there wasn't a mom in sight. (I later learned that the fashionable thing was to part ways with one's mom at the start of a shopping trip, head straight to Hot Topic, and then catch up with her later with the store's plasticky vegan-leather scent still trailing behind.)

I was a myopic little thing, and it had simply never occurred to me that there was a second way to dress. As far as I'd always been concerned, it was varsity jacket or bust—I attended a public school that had no administratively mandated uniform, but that was the uniform all the same. And I studied the rules of this uniform with the obsessive dedication of an anthropology scholar doing research for a field report, putting myself in a masochistic situation in which I knew every incorrect thing about the way I was dressed, but was powerless to fix it. My mother thought I looked awfully cute in my corduroy overalls and oxfords, but I knew better. I knew with a child's intense rage that I already stuck out, which was the worst thing to do as a kid. But now, I was looking at a burning bush. The people

in Hot Topic stuck out, too, but they did so with such care that it could be nothing but intentional. For the first time, I realized that I was totally allowed to thumb my nose at Faith O'Daniel and Kelsey Barber when they started in on my fucking glasses again. I didn't need to agree with their assessments of me. Another standard had made itself available to me with which I could assess myself, and if those little bitches didn't even know that standard existed, all the better. I'd never considered the possibility that I could one-up them before.

After staring into the store and swallowing as much of it as those few seconds allowed, I looked quickly up at my mom again, hoping to catch in her face some understanding of the threshold we'd just crossed. But she was looking at her watch. "Whoops—we have to hustle," she said to me. "I have to get home in an hour to turn off the oven."

At that age, I'd seen punks, barely. Rather, I'd seen people wearing the Hot Topic–prescribed attire that I'd associate with punks for most of my adolescence, though the "real" punks who lived twelve to a town house in my neighborhood likely would have scoffed at them and called them poseurs or worse. And without realizing it, I'd seen plenty of those "real" punks, too. D.C. was like that: for every ten people you saw walking down the street in complementary beiges, you'd see at least one scowling mouth poking out from a Bad Brains hoodie. D.C. had long ago lost its status as a hotbed of hard-core activity, but the old-school punks who still lived there certainly didn't know it. They worked at the couple remaining leftist or "leftist" bookstores in the city, and spent their days locked in tiresome arguments about Marx and Mao and Fugazi and whether their buddy's band qualified as hard-core, and they didn't dress any particularly exciting way while they did it.

In any event, I was young then, more invested in the aesthetic of the thing than the politics that ate away at it. I hadn't yet slept with my first thirty-four-year-old secondhand record shop owner. I just liked the way

Hot Topic hit on a sensory level: the dark lights, the walls lined to their very ceilings with tchotchkes, the staff, the glass cases of Manic Panic and Special Effects hair dye, the jewelry designed for holes I couldn't even identify, the staff, the workman's boots that somehow cost $200 a pair, the staff, the staff, the staff.

For oh, the Hot Topic staff! Sing, goddess, of Ataris T-shirts and Prismacolor hair extensions and tattoos of Johnny the Homicidal Maniac! The Hot Topic staff came to me as sirens performing grand arias in the open ocean. They were salespeople, and therefore friendly, but dressed so forbiddingly that the contrast was pure enticement to me. I believed, God help me, that these mean-looking punks were being friendly to me because they identified in me a kindred spirit. How they would have done such a thing, when I still mostly dressed as if I were going to Thursday night Bible study, is beyond me. Probably my kindred-spirit status beamed so brightly out of my very spirit that they couldn't have missed it.

At the time, my family and I lived a few doors down from a notorious punk house, though I didn't know it was notorious at the time. I just thought of the earthy-smelling young adults who smoked on the porch as neighbors, the same as the guy next door who walked around the block singing loudly all day, or the woman across the street who wore only a not-quite-closed silk robe to check the mail. Years later, I'd learn that this was one of those group houses with a name and that its residents were the sorts of tiresome communists who decided on even the purchase of a new dish soap by committee. It had been in the hands of some local punk or other since the '80s.

But they were my neighbors and I addressed them with the same shy, parent-enforced politeness that characterized my interactions with all my neighbors: I spoke to them if I had to and ignored them, terrified of them as I was of all adults, if I didn't. Most of them ignored me in turn. Only one resident, Big Joe, showed any interest in befriending me, with that effortlessly cool *I'm an adult and you're a kid but aren't we both just people*

demeanor that I'm unable to affect with children to this day. He and I spoke when we ran into each other, usually while walking our respective dogs, and after a while I realized that I actually looked forward to seeing him—which was not a way that I felt about anybody in those hideous prepubescent years when all I wanted was to disappear.

Big Joe seemed ageless and perfect to me then, but in retrospect he probably wasn't even thirty yet. And he was *big*. I was a small kid (and remain a small adult), but even correcting for my little girl's understanding of how tall everybody was, I'm convinced that Big Joe was a staggeringly huge person. He had a heavy belly, but he wasn't soft fat. His beer gut seemed to be reinforced with steel and filled with fiberglass. His jeans were all patched in the same place from where his ass had torn into them during a routine sit-down, and he rarely wore sleeves, even in snowstorms; his arm bulk and his boxer, Stella, kept him plenty warm, he explained, so why waste money on a coat?

One day, I was walking my dog and listening to one of the *Now That's What I Call Music!* compilations on my portable CD player, and Big Joe asked what I was listening to while our dogs sniffed each other cordially. And when I told him, he nodded and asked me, did I like the Sex Pistols? The Clash? Nirvana? I'm not sure what motivated him and am no longer able to ask him now that he's died. Maybe it's something of an adult punk's mitzvah, taking a kid under your wing and sharing the building blocks of what you believe to be good taste. Or, hell, maybe *he* was lonely. I certainly was, but it was an anxious person's loneliness, one that needled me constantly about how I must have been the only lonely person on earth; again, a myopic kid, too frightened of my own motivations to even begin to tackle anybody else's.

Now, as an adult woman, I don't take kindly to recommendations of music from strange men. If we aren't already close friends, you're not selling me anything I especially need to buy. But at the time, I was thrilled for the guidance from an adult whom I understood to be some kind of cool—not Faith O'Daniel and Kelsey Barber cool, no, but an identifiable

breed of cool all the same. I told him that I'd buy (well, beg my mother to buy) *Never Mind the Bollocks* on my very next trip to Barnes & Noble, and he laughed.

"Hold off on that, bud," he said. "How about I just burn you the CD?"

Later, I learned what *bollocks* meant, and was grateful to Big Joe for sparing me the conversation with my mother. But at the time, I don't think I'd ever felt so cool. I was having my very first CD burned for me, which I understood to be a rite of passage between friends. I thought about listening to the CD, nodding my head to the music, and when someone inevitably asked me what I was listening to, I would say, "The Sex Pistols. My friend Big Joe burned it for me."

The next time I went to Hot Topic, I saw a Sex Pistols T-shirt and knew I had to have it. For one thing, it said *Sex* on it, and when people saw me wearing a T-shirt with *Sex* written on it, they would have to accept that I was cool. Plus, the Sex Pistols were themselves cool. It was an inarguable double whammy of cool.

"Absolutely not," my mother said. "That Sid Vicious murdered his poor girlfriend."

"Who's Sid Vicious?" I asked, and she laughed.

"You don't even know who Sid Vicious is and you want a Sex Pistols shirt! Come on, honey."

It stung that my mother had basically called me a poseur, and I took the dog on a long walk about it when I got home, hoping I'd run into Big Joe. I did.

"What's going on?" he asked, boisterously happy to see me. That was something I appreciated about Big Joe. No matter how I loathed myself and, indeed, no matter what isolation was inflicted on me at school, no matter how distracted my parents were when they got home, no matter how aggressively friendless the water in which I had no choice but to swim was, he was one person who was always, *always* happy to see me.

"Not much," I said. I'd wanted to tell him about the injustice of the

T-shirt, and the larger injustice of my mother's unwillingness to buy me all the gear that I needed in order to become the exciting new person that I'd decided to be. But now that he was here, I was shy.

He asked me to wait a minute so that he could grab the CD he'd burned for me and handed me Stella's leash so he could return to the house. A few minutes later, he jogged back to me, jewel case in hand. "Now, this is not the best band in the world," he warned me. "But it's a good entry point for someone your age."

"I just turned eleven," I said proudly.

"Eleven! I didn't start listening to the Sex Pistols until I was, what, thirteen, fourteen? You're already cooler than me."

He turned to leave, but I said, "Big Joe?" (I only addressed him as Big Joe, *never* Joe. So did everybody else in the neighborhood, as in "Big Joe pissed on my lawn last night" or "Big Joe bought every carton of Reds from the corner store and now I can't buy any myself unless I go to the 7-Eleven four blocks away.")

He looked back at me. "What's up?"

"Who's Sid Vicious?"

Big Joe chuckled in the manner of a grandpa gearing up to share a well-worn tall tale with his grandson. "Pardon my French, but he was a fuckin' poseur. You know he didn't actually play a single lick of bass on this whole album?"

Well! Sid Vicious, a poseur! That would show my mom!

Hot Topic was fiendishly expensive, even worse than Limited Too—my poor parents couldn't catch a break. Most of my clothes came from Target, which sold inexpensive but not unsnazzy gear. But I was permitted the occasional "statement piece" from my stores of choice as a birthday present, some article of clothing which I always wore front and center and to absolute death. In fifth grade, my coveted statement piece was that damnable baby blue varsity jacket from Limited Too. By sixth, I'd become fixated

on the Sex Pistols T-shirt. I now knew who Sid Vicious was, and Johnny Rotten, and even Malcolm McLaren, kind of. I used the bulky computer in our living room to research them obsessively and had downloaded more Sex Pistols music than the Sex Pistols ever intended to be released. Our hard drive yawned under the weight of my research. Sometimes I printed out pictures of my boys, just to look at them.

In most settings, my fixation was strange and unwelcome. But at Hot Topic, it made perfect sense. I now had something to talk to the staff about. They seemed endlessly worldly, though in retrospect, none of those cashiers could have been a day over eighteen years old. They made recommendations of their own to me, which I believed was because they saw me as one of them but was in reality an effort to upsell, inspired partly by what I'm sure was the cuteness of my enthusiasm.

Hot Topic didn't just sell music and music-branded clothing, but the insiders knew that those were the only things you were allowed to buy from there. The line between punk and poseur was tough to spot, but to the best of my knowledge, it was something like: If you shop at Hot Topic, it has to be because you love the punk *music*, not because you want to look cool and stylish. And if you love the music, the cool stylishness will follow, whereas if you buy seventy-five-dollar rockabilly dresses like a tryhard bimbo, that's all you'll ever be.

You'd think that my own lifelong torment at the hands of judgmental jerks would have softened me, but I was perhaps the most judgmental jerk of all once I learned the rules. My years as a victim were like a stay in the stocks. I emerged, rubbed my wrists, cracked my neck, and learned nothing (except, of course, about how to victimize others in the same way). I'd decided on some level that, punk or prep, the important thing was to be looking down on somebody else at all times. In short, I'd missed the point something terrible.

Anyway, it wasn't like it was easy for me to be an effective judgmental jerk. To me, the first step was to look the part, and I hadn't quite gotten

there yet. I still dressed the same as I ever had, albeit with the addition of two shirts that had already faded from overuse despite having been in my rotation for less than a year: a men's Nirvana T-shirt, and one of my father's old flannels, which I wore in an effort to look grunge. (He was six foot two and two hundred pounds. I was a prepubescent kid. You can imagine the effect.) I maintained this look throughout middle school, until one day in October the same Kelsey Barber that I'd so longed to emulate cornered me in the locker room. At this point, she'd graduated from the Limited Too varsity jacket to the pubescent equivalent: a velour Juicy Couture tracksuit. "You know," she said, looking at my body swimming in my father's flannel button-down, "Halloween is *tomorrow*."

Her friends tittered, and I thought: *What would Big Joe do?* I still didn't see him as the kindhearted man who'd taken me under his wing; I saw him, when it was convenient for me to do so, as the fearsome neighborhood terror pissing on his neighbors' lawns, just like most of my neighbors did. So I scrapped the plans I'd already made for a Halloween costume and turned my old sweatpants and sweatshirt into an imitation of Kelsey's Juicy Couture tracksuit, complete with the word *JUICY* scrawled across the ass of the sweatpants in black Sharpie. The next day, when people asked what I was for Halloween, I put on Kelsey's voice, which was itself an affected Valley Girl accent that couldn't have been real, since Kelsey, like me, was from D.C. "Um, hello? I'm Kelsey Barber?" It was immature and mean, and not what Big Joe would have done at all, and she never gave me trouble again, and I demurred when Big Joe asked me what I did for Halloween— I could make him the inspiration for my unkind behavior, but I knew I couldn't make him congratulate me for it.

Still, for all my posturing with my new look, it was incomplete due to what I perceived as my parents' cheapness. One day, I bemoaned their lack of cool to Big Joe. All I wanted, all I *needed*, was this thirty-dollar T-shirt that for some reason these old squares wouldn't get for me.

"I have a bunch of old shirts you can just have," he said, looking

amused. "I'll even wash them for you. Your folks are right. Don't spend a bunch of money on mass-produced crap."

And so I ended up with a box of men's 2XL T-shirts for a few bands I'd heard of and many I hadn't. That became my new barometer of taste: if a band appeared on one of Big Joe's T-shirts, it was good and worth researching. Sometimes my parents could fill me in, but sometimes even they were stumped.

"I don't get it," my father said as we ate breakfast together one morning. "Who's this GG Allin guy, and why is he on your shirt looking like he's about to hurl?"

Big Joe and I had a real rapport in my early adolescence, but he moved out of the punk house on my block without telling me, and we never saw each other again. But I learned many years later that he died. He died, in fact, before Stella did, and Stella was already eight years old when I met the two of them, so . . . you can do the math if you'd like.

But he was kind and encouraging to me at a stage when I needed kindness and encouragement from an adult more than anything. And so I'd like to briefly eulogize him, in the limited way that I can, one that I think he'd appreciate. Big Joe, I am sorry to hear that you'll never again piss on a genteel lady's lawn. May the corner store be ever stocked with the cigarettes of your choice, in your honor. May your spirit live on in the form of some other young girl befriending some other neighborhood goofball and wearing a box of his T-shirts, the shoulder seams sitting in the crooks of her elbows.

I don't miss him, exactly. We were not close. But I miss being myself in his presence, full of wonder and receptive to learning and as yet unscarred by everything I didn't yet know was going to happen to me. And I miss the generosity he showed me, his desire to share with the next generation.

Looking back, as much as I cherished Hot Topic, I never bought much from there. Big Joe knew the place was meaningful to me and did his best

not to disparage it in my presence, but he gently steered me away from the store whenever he could; if I was gushing about a CD I'd seen there, he offered to burn it for me; if I wanted to buy one of their T-shirts, he offered me a substitute from his own closet. I don't know how aware my parents were of his limited presence in my life, not that they needed to be—he was the perfect, courteous gentleman, never invited me into the house or tried any funny business. But they were certainly aware of the massive men's T-shirts that were suddenly on my torso every day, fresh, as Big Joe had promised, from the laundry, but still bearing a stale smell, as if they'd gone into the washing machine after spending thirty years buried underground.

I do wish Big Joe and I had managed to hold onto some of that friendliness after he moved back in with his family when I started high school, though I understand why we couldn't. He was only able to be an authority to me when he was living on his own with his dog in a punk house; transfer him into a home where he was not in charge, and the authority dissipated. But I'm glad, at least, that I carried some of the spirit with me that I'd picked up from him. In fact, I picked it up from him and Hot Topic equally: It is possible to look scary and still be loving and cordial. It is, in the tritest possible terms, punk rock to be kind. Only poseurs are cruel.

Corny, yes? But then, that lesson stuck the most closely of all: nothing in the whole world is wrong with being corny. Better, always, to be a poseur than to point fingers at poseurs and laugh.

Never Fall in Love at the Jersey Shore

The rules of taste aren't written anywhere, Susan Sontag's extensive theorizing on the matter notwithstanding—what I mean is that they aren't encoded anywhere that the average person might see and obey them. But we still believe we can discern good taste from bad using our judgment. For whatever reason, I've always been a magnet for people whose taste in pop culture is unimpeachable, meaning that I spend much of my time on edge around my friends whose internal scales are always perfectly balanced. Nothing can upend them. No earworm is so catchy, no trashy gossip magazine so enthralling that these people will shrug off the mantle of correct aesthetics. They wear the right glasses, stock their home bookshelves with the right treatises, discuss the right theories (even at brunch, which as far as I'm concerned is too early in the day for any theory at all!). They're impervious to everything wonderful and silly in the world.

These are tricky friendships, given how I seethe with jealousy over these people's interior rightness. Take my friend John, for example. We've been friends for a decade, ever since I asked him out in college and he politely demurred, pointing out (correctly) that I was so drunk that I'd just spilled Natty Light down my entire front without realizing it. Somehow, this led to a friendship. John wears corduroy pants and pearl-snap button-downs and earth tones that all look good together and precisely zero pieces of jewelry with swear words written on them. On Twitter, he's restrained but funny, particularly when poking mild fun at the other people in his field, which is literature. On Twitter, I'm funny, too, but it's because I tell tens of thousands of strangers per day about my sexual misadventures with people like my ex–weed dealer who once invited me to see him play a show in an

"exciting venue" that turned out to be the Silver Spring Metro station. Oh, and my field is . . . nothing. I don't work in a job that could be described as part of a field.

All this is to say, John's taste is *too good*. It's intimidatingly spot-on, it allows no space for trash, and worst of all, he doesn't feel that he's missing out on the trash. It simply doesn't appeal to him, which is the nature of the wall that separates me from him. One night, I invited him to join me at the movies for one of those forgettable horror releases that's really fun to watch stoned. What was it called? *Murder Baby*, I think, or *Ghost Bank*—you can count on cheap horror movies to put it all out there in the title. He looked puzzled.

"You're seeing that? Like, in theaters?"

"Well, yeah," I said. "I don't anticipate remembering that *Ghoul Clinic* exists when it's time for the DVD release."

"Why are you seeing it if you don't think it's going to be good?"

Some people.

Like John, I can speak with some degree of intelligence about Heidegger and Hegel; unlike John, I don't want to. Why should those be the conversations that occupy two people's limited time with one another, those dense theoretical snarls of what *could* be the meaning of life and what *might* become of humanity and not the vivid here and now outlined in gossip rags? Why shouldn't John and I discuss, with equal enthusiasm, the various misfit toys who have ejaculated on my face (or, hell, his face, if that's what he's into)? Or romance novels? Or half-hour sitcoms with laugh tracks? I may be somewhat capable of meeting people on an intellectual plane, to a limited extent, on the right day . . . but that's not where I prefer to meet them. I prefer, instead, to call them up during a *Jersey Shore* rerun and ask them if they're seeing this shit that Ronnie just did to Sammi. I prefer what has been filmed, set against a soundtrack of late-'00s club hits, and selectively edited before airing on MTV.

I turned eighteen and went to college the year that *Jersey Shore* came out. The first few months of college were as refreshing for me as for any teenager whose libido and liver are strong. But by winter break, when the show debuted, I was feeling blue. The hot senior I'd faked orgasms for hadn't rewarded my performance by making me his girlfriend. The boy who *had* made me his girlfriend was insecure, mean, and controlling. Plus, I missed my family, my hometown friends, and D.C. itself. I missed those Legoland buildings that looked as if they'd been dropped by a clumsy architect onto the streets from a great height, the nervously fancy government buildings of sun-catching marble, the cluster of bars that never carded me.

One night over this winter break, I visited my father at his house in Rockville, a perky little suburb of the city. On the way, I stopped at his favorite deli for his signature order: half a pound of *thinly sliced* Hebrew National salami, quarter pound of corned beef, a loaf of *thinly sliced* marble rye (*not* the New York rye, marble rye), one brisket plate, a box of latkes, and whatever cheese was good that week.

When I opened my father's door, I was dismayed to find his house in worse shape even than before. He'd never been one for keeping a clean house, but the entire entryway smelled like a wet ashtray. Empty shopping bags and cigarette cartons littered the floor from moments that he'd dropped them and then been, I knew, physically unable to bend over and pick them back up. Stacks of overflowing accordion folders tumbled out of every corner, centralized at his desk, which yawned beneath a sloping mass of papers. Of late, my father had been ill and "working from home," still unusual enough at that time that it warrants being put in quotes now; he *did* work, but mostly it seemed that what he did was generate trash.

I waded through the debris and found him on his living room sofa, wearing the grubby gray tracksuit that I'd gotten him for his birthday one year (and then regretted terribly when I realized that it was all he'd ever wear again, between too-intermittent washes). He'd always been a figure with so much physical and charismatic presence that he seemed to

occupy the space of about three people wherever he went. I'd spent my life watching him double-fisting cheeseburgers and chasing steak with chicken, undoing his belt and clapping his hairy hands over his formidable gut with a belch to announce his compliments to the chef. But something was off tonight; later, I'd realize it was because he'd begun subtly and unwillingly losing weight.

He was already too sick to eat like he'd used to and had responded by locking into a mulish battle of wills with the body he'd abused for decades, maybe believing that he could convince it to reverse its progress if it saw him putting away double servings of chicken Alfredo like he'd always done. The result was that he still had the same jolly gut he'd had my entire life, but deflated; his arms were still built like tree trunks, but the skin on them was graying and sagging. Even his hair, his pride and vanity and what I'd long believed was the Samson-like source of his power, was beginning to thin. He'd ascended into his fifties and sixties with an intact mane, the lushness of which he always joked was "proof of Jewish supremacy"; now he was knocking at the door of his seventies with a pronounced bald spot that even one of his pancake-sized hands couldn't have covered.

He also had a cigarette frozen on its way to his open mouth. I followed his gaze to the TV, which was playing something I hadn't seen before.

"What's this?" I asked, but he shushed me. I dropped the grocery bags and took my spot beside him on the sofa, reaching into the crinkly bag of potato chips on the table in front of him and feeling around for a few good chips.

"*Shhhhhh!*" he said again. So I sat in perfect stillness until the program finally reached its commercial break.

"Jesus. What's so important?" I asked, after confirming that the hypnosis had broken and that my father was once again free to open and close his mouth and lift cigarettes all the way to it.

"You see this shit? *Jersey Shore*, it's called," he said. "I never saw anything like it."

My father and I had always bonded over our ability to watch absolutely anything on TV together. My mother ruled her television according to the principles of law and order, and watched the seven o'clock news, the eight o'clock *Trading Spaces* or (if *Trading Spaces* was a rerun) *Divine Design*, perhaps the last half hour of a movie if it was something she hadn't seen before but had heard good things about, and bedtime. She didn't care to rewatch, channel-surf, or partake of the rapidly growing phenomenon of soap-opera-style reality programming. Such TV-watching behaviors were unseemly, chaotic. She was a practical woman with a limited amount of attention that she preferred to dole out to only those programs that she was certain she'd like.

My father and I, however, embraced all that could be chaotic and unseemly about TV. To us, the hundred-ish channels that comprised our cable package represented sheer possibility. My mom still tells the story of the day that she walked into the living room to find my father and I transfixed by an unsubtitled German beach musical that we'd stumbled onto; she left, came back thirty minutes later, and we were still mesmerized as the German teen idols cavorted in haystacks and belted out major-key songs about adventure. Could we understand a word? Of course not. Was it engrossing on every other level? Wholly, and when I was able to track down the musical years later (*Heißer Sommer*) and purchase a used DVD of it from a German eBay wholesaler in time for my dad's birthday, he pronounced it the best gift he'd ever received.

So it wasn't surprising that he'd embraced *Jersey Shore*. The year 2009 was *Jersey Shore* the way 1991 was Nirvana; the show's eight guidos and guidettes (Italian Americans, for the uninitiated) were everywhere, they were notorious, they were adored and hated and stumbling out of clubs and getting DUIs, and while nobody I knew was emulating their style, exactly, it's still safe to say that their style was very *visible* at the time.

This was in what I believe was the golden age of reality television, its second generation. Reality TV had abandoned much of the self-seriousness

that characterized pioneering programs like *The Real World*, instead embracing the limitations of its format. No longer burdened with the lofty goal of "capturing" anything about humanity through lightly scripted gonzo filming, reality TV had thrown up its hands and said, *Fuck it.* This was the era that gave us gems like the ―――― *of Love* franchises, both *Rock* and *Flavor*; it was the apotheosis of *America's Next Top Model*'s ego-driven messiness; it no longer asked its programs to pretend that they were really going to employ the winners and stars of these shows and instead gave them permission to run wild. At the apex of this wildness was, as my father said, "this shit" called *Jersey Shore.* It was unbound by the narrative logic that had imprisoned its predecessors and, even better, populated by some of the absolute craziest characters that have appeared on any TV show, anytime.

Part of this unbinding might have been the growing importance of prestige TV. The laugh tracks were all but gone; now, the best shows were as serious as movies. HBO had proven that TV could matter. But then again, it was 2009. *Sex and the City*, *The Wire*, and *The Sopranos* had just ended; *Game of Thrones* was still two years away from consuming everybody's lives. We were all primed for some palate-cleansing insanity in the form of six Italian American gym rats with sun damage giving each other pink eye. If anything, I thought that *Jersey Shore* was a bit conventional for my father's tastes. As noisy as it was, my father could have gone noisier; he could have always gone noisier, or sillier, or worse.

He'd thrown down the gauntlet, though. Once again, I was being summoned to launch into chaos with him, to take the right-hand spot on the sofa and engage. I was eager to prove that I was up for it, as I always was when my father issued these unspoken challenges to me and my taste. I said, "I'll fix us a couple plates."

This was when my father was beginning to fail. He and my mother had been divorced for years, but she still suggested regularly that he see a doctor about his hacking cough. In 2009, the suggestions became pleas and

finally ultimatums. She and I couldn't stand to listen to him complain about his pain anymore unless he planned to do something about it.

The doctor he eventually did see diagnosed him with COPD—chronic obstructive pulmonary disease, a frequent death sentence for smokers as prolific as my father. It's an umbrella term for a handful of lung diseases, nearly all of which he had. "You happy?" he asked me when he relayed the news, unwrapping a pack of cigarettes.

"Of course not."

"Me, neither." And he lit one.

I suspect he never quite believed that the smoking was behind all his health problems. The COPD was the center of a rat king whose knotted tails numbered in the hundreds. Lung problems became heart problems became blood problems became diabetes became infections that wouldn't go away became surgeries became dependencies on post-surgery pain meds became more smoking became new lung problems. To solve all these problems would have required an amount of discipline and commitment that was not in my father's gift to provide for himself. Towards others, he was endlessly generous, available to deliver soup and turn down the covers for any acquaintance with a cold. Towards himself, he was unforgiving. He believed that he had these problems not because he smoked, exactly, but because he *was* a smoker. He considered himself a weakling, missing the willpower to be a hearty, healthy person who required no palliatives to face the world. He'd given up drinking and drugs, and could give up no more of what soothed him.

Occasionally, people who loved him would ask me—*beg* me—to "get" him to quit smoking. His coworkers, his best friend, his sister. People claimed I had a hold on him that nobody and nothing else had.

"You're the love of his life," one of his other ex-wives said to me once, not unkindly. "If he won't listen to you, who will he listen to?"

She hit me with this rather overwrought plea when I was sixteen, and I didn't have the words at sixteen to name the rage that flooded me. But if

he were still alive now and she told me the same thing, I think I'd be better equipped to explain that he wouldn't listen to me, that he wouldn't listen to anybody, that the only voice that had ever swayed him was the cruelest one that lived inside his head and turned him traitor against himself, and that was the voice that commanded him not to quit smoking even when he wanted to. And that voice, too, encouraged his addictions and made him a terrible husband to four separate wives. His love for his friends could sometimes overpower his will to betray himself, but his love for himself never had that kind of juice.

She would have asked me, I'm sure, why I believed all this to be true of my father. And I would have told her: these are the family heirlooms he's passed to me. Self-loathing, avoidance, nihilism, boundless devotion for anybody who dares to love me despite it all. I would have told her that she knew a stronger man than I did because in her fragile company, he insisted on being strong, but in my presence, identical to his own, he wasn't forced to be anything. He didn't have to wear a brave face or make small talk or disguise the abjectness of what preyed on him. He could sit beside me in upbeat quiet, eating corned beef, as sad as I was but still willing to laugh at whatever silliness we were watching on TV.

Yes, that's what I'd say now, I'm sure of it. But at the time, all I told his ex-wife was that I'd try.

My father had never favored reality TV that tried too hard for verisimilitude, which I believe was a large part of *Jersey Shore*'s appeal. It was such an over-the-top simulation of what it was like to exist in the world. Freed from the expectation that he believe in the events onscreen, he could instead engage with them on their own merit, as articles of storytelling. He could watch Mike "The Situation" Sorrentino make out with a twenty-year-old in a hot tub because he didn't need to suspend disbelief in order to do it. All he needed to do was laugh, gasp, cry. *Jersey Shore* excelled in the here and now, in events and shockers. It asked little of its audience philosophically. It required only that you absorb it.

So he and I sat on the sofa, our respective cushions indented with our respective ass marks, the dog asleep between us and the coffee table groaning under our weekly deli spread. He inhaled cigarette after cigarette, smoking indoors, which had been verboten when he'd lived with my mother but was his activity of choice in his bachelor pad. I knew better at this point than to try to wheedle him into quitting, or even taking his cigarettes outside where they could do less damage to his furnishings; instead, I smoked with him, albeit at a more modest pace. He once claimed he "only" smoked two packs a day, though as I observed it, it was really three or four.

Honestly, though, smoking occupied little of our attention. *Jersey Shore* was what mattered. We were gaga for it. We sensed something arch in other people's appreciation for *Jersey Shore*—they watched it for the same reason that we did, because it was entertaining, but needed to blanket that reason under protective layers of irony. We were proud that we didn't share this need to protect ourselves from our own taste, which we believed needed no correcting, had nothing wrong with it. An example: a couple years later, we bought matching T-shirts emblazoned with one of the show's key catchphrases, *G.T.L.: Gym—Tan—Laundry.* We wore them every chance we got, his a little too tight around the middle, mine a little too massive everywhere.

"'Gym tan laundry'?" said cashiers, servers, pharmacists, their tones bewildered. "What's that mean?"

"That's what you have to do to have a good night," one of us would respond, paraphrasing Mike Sorrentino's explanation of the daily G.T.L. ritual. "Otherwise, you'll feel off, and you're not gonna have a good night. But if you feel great *and* look great, bam, awesome night."

Hard to imagine two more implausible people to take these words into their gospel. Neither my father nor I had set foot inside a gym or tanning salon, like, ever, in our lives. As for laundry, that was best done every month or two, the better to wallow in one's depression at maximum capacity for the maximum amount of time.

I should say at this point that I loved my father. Lord, I loved my father! He was cool, man—everybody fell for him; everybody craved his attention. He was a tall, schlubby Jew with a beard and glasses and a permanent food stain sitting atop the belly of all his shirts, and my friends wanted him to be their father and my boyfriends hesitated to break up with me because it would have meant breaking up with him, too. Pinpointing his appeal is as impossible as explaining what's good about the rain. He was funny, but not every funny person is warm; not every warm person is a great listener; not every great listener gives good advice; not every giver of good advice is selectively unavailable in such a way as to promote obsession. For every time that he was present and charismatic, he'd be a shell of unhappiness three other times. But, crucially, the first hit of his attention was free.

I never understood the appeal even as I was more in thrall to him than anybody. He was just some guy. But he had, pound for pound, more inter-social gravitational pull than anybody else I've ever known.

And he loved me, he loved *me*, I was the object of his focus. As soon as I was born, forget about it—there was nobody else. Sure, his combination of extroversion and self-hatred left me reeling in his wake just as often as it delighted me. He was a difficult master to serve. But I served him because nothing could have been more important than his approval.

I had that approval more often than not. But he was who he was, and I was who I was, and that meant that any individual approval only ever necessitated some greater approval down the line. If I wrote a poem that he praised, it needed to win a prize. If I got an A on a test, I needed an A-plus on the next one. This was not pressure that he applied to me. I built it on myself, brick by brick, until I was bricked up behind it, always certain that I was the one who could do something so wonderful that it fixed him, made him the happy man I thought he could be. It never happened because that's not something that one person can do for another. Inasmuch as I wish he'd done anything differently, I wish he'd known to tell me that.

Point being: my father loved *Jersey Shore* in 2009, so Rax loved *Jersey Shore* in 2009. It was our ritual for the three weeks that winter break lasted. He scooped me from my mother's apartment in his convertible, and we drove to the local deli for half a pound of *thinly sliced* Hebrew National salami, quarter pound of corned beef, a loaf of *thinly sliced* marble rye (*not* the New York rye, marble rye), one brisket plate, a box of latkes, and whatever cheese was good that week. And then on to his house, his dog, *Jersey Shore*. Plus, of course, our intensive post–*Jersey Shore* analysis.

Season one, episode one of *Jersey Shore* contains more action per second than either of the two world wars. It simultaneously adheres to and oversteps the existing conventions of the reality show genre. For example, we meet the cast, which is pretty standard for any reality show of the hot-youths-sharing-a-house type. But we meet each person in a not-quite-minute-long blur—there are commercials that are longer than the glimpses we get into these people's lives, worldviews, and characters. Why? Because *Jersey Shore* barely cares who these people are; what it cares about, instead, is how they will hurt each other, and the sooner the viewer gets to that, the better.

For comparison's sake, on the first ever episode of MTV's *The Real World* (the standard by which many of these shows are still judged), we're still meeting the first character five minutes in. We've met her family, developed opinions about her overbearing father, decided whether we want her to pursue her dance career or learn computer programming—and the intro still isn't over! But on *Jersey Shore*, the first character we meet is one DJ Pauly D (Paul DelVecchio). We learn that he's a DJ who hopes for "the guidettes to come in their pants" after listening to his music, that he has an in-home tanning bed, and that it takes him twenty-five minutes to style his hair every day into what can only be described as a modified Bride of Frankenstein. As soon as our interest is piqued, *ding*, next! *Jersey Shore* understood the maxim that the people must be left wanting more, at all costs.

Because *Jersey Shore* took its plotting cues from soap operas, forcing the

plot forward with a frontiersman's aggression every week so that the plots were unrecognizable from one week to the next, one felt adrift after missing an episode. Sure, the "previously on *Jersey Shore*" tags reminded viewers of what we'd seen, but those tags only covered so much ground and *Jersey Shore* was too thrilling to miss a moment. So as winter break drew to a close and I packed my bags to return to college, I grew despondent. I had no TV at college with which to keep up with the guidos and guidettes. By the time I returned home again, my father would surely have moved on.

He called me the first Thursday I returned to college at eleven p.m. and I answered in a panic, certain that at such an hour, it could only be an emergency. But he was bubbly.

"Okay. So. The replay is starting and I'm going to walk you through it," he said. "So remember how Snooki got socked in the face last week? Well . . ."

That was how we went for the remainder of the season. He called me every Thursday at eleven, so that he could annotate the replay of the episode for me, having already seen it air at ten. He was always happy to clarify when I needed to stop him for going too fast, which was an occupational hazard of *Jersey Shore* fandom—sometimes, the universe simply moved too fast for us mere mortals to keep up. At midnight, we would engage in our analysis, make our projections for the following week. And then we'd say our goodbyes.

I don't like to play the game of What I Would Tell My Father If He Were Still Alive. For one thing, I play it all the time against my will and derive no joy from reckoning with everything I didn't have the mojo to do for him. I never told him I loved him until the week he died—how fucked up is that? I could not, for years upon years, shift my mouth into those shapes, and I could feel it hurting him every time we hung up the phone and his "I love you" went unanswered, and still I couldn't do it and I couldn't explain why. And now he's dead and my back is weighted everywhere I walk with ten tons of unsaid I-love-yous.

Still, stuck as I often am in an internal feedback loop of things I didn't tell my father and how I feel about them, one thing often occurs to me: I wish I'd told him how much it meant to me that he loved this stupid show with me, and for me, and to me. I wish I'd thanked him every week for staying up until midnight singing its silly gospels to me. And okay, sure, I wish I'd told him I loved him, not just in general, but because he was a sixty-six-year-old man who adored *Jersey Shore*, and wanted to share it with me like he always wanted to share his toys with me.

My father's collection of curiosities indicated strange taste, but spoke to greater passions than whatever drives people with "good taste"—he loved what he loved, to anybody who would listen. He sought to be entertained at random. He went to the movies not when a movie was out that he wanted to see, but because he loved going to the movies; he invited me to performances by bands he'd never heard of, just because they were happening that day. He believed with perfect faith that he'd be entertained by any entertainment, regardless of type or quality. And because I loved just the same way he did, indiscriminately and at large, I was the thing he loved best.

I would never be so cruel as to suggest that good taste overrides human emotion. My friend John's father is alive, but someday he will die and John will feel all the same hideous ways about it that I felt when my father died. And I'm sure, too, that people are capable of truly bonding over their good taste. I never appreciate the suggestion that I'm somehow a shallower person because my aesthetics are as hodgepodge as they are, and I don't believe the opposite is true, either. We are all equally people, crammed full of the same wretchedness and chugging the same daily poison.

What I would rather say is that I can't imagine bonding with my father over, say, the pure theory of Kant or the prettiness of Byron's poetry. I believe that my father was capable of reading and understanding theory, and of wearing clothes that fit perfectly and carrying a leather satchel, but that wasn't who he was. He was a man obsessed by other people, desperate to hear stories of love that overcame all odds and unlikely friendships

blossoming despite themselves. He loved schlock. And I am his child, and I love schlock, and I, too, am desperately obsessed by other people to the detriment of both my sanity and my taste. As ever, I want stories of the here and now, verbs, action, gossip.

At the end of *Jersey Shore*'s first season, things seem copacetic with the gang. Ronnie and Sammi, the house's on-again, off-again John and Jackie Kennedy, are on again. Mike, Pauly, and Vinny are as homoerotically intertwined in their friendship as ever. Snooki and JWoww are inseparable. Angelina is, well, gone. The same faint sadness that attends any summer's ending is in full effect during the season finale of *Jersey Shore*.

And aside from all that, a whole era is entering its twilight. An era of sweatpants with the waistbands rolled over, pierced belly buttons, my father's ability to breathe on his own, backwards baseball caps, fake tans, my father's smile unencumbered by the quotidian fatigue of living his life inside his body, glamour muscles, super-straightened black hair with blonde extensions, my father's life. From 2009 onward, *Jersey Shore* lasted six years and my father lasted nine. During season one, he was still able to walk; by season three, he could hobble; the year he died, he was confined to a wheelchair with a portable oxygen tank. Shallow though it may be, it's hard for me not to look at his life on a parallel with the world circumscribed by *Jersey Shore*, which was little and petty and self-important and dear to him till the end. I miss him, and then I feel little and petty and self-important, drowning in my grief while all of humanity teems around me. *Jersey Shore* isn't just my favorite trash TV franchise. It's something that allows me to locate my impish, flitting feelings for my father in a moment in time, gives me a firmer set of arms to grasp his memory with. When I remember *Jersey Shore*, I remember the man my father was before he realized that his life was really over, after all his decades of wrecking himself in the hopes that he could make his life be over.

Well, I can't help but wallow. My father was the sun. But I'd prefer to

wallow in memories of him as he was during those *Jersey Shore* recap calls, younger and more excitable than ever because of the goings-on of a reality show that was light-years removed from his life. And I'd happily wrap myself, too, in the memory of half a pound of *thinly sliced* Hebrew National salami, quarter pound of corned beef, a loaf of *thinly sliced* marble rye (*not* the New York rye, marble rye), one brisket plate, a box of latkes, and whatever cheese was good that week—food that was special not because it was special, but because it was his, which made it mine, which made it ours.

You Wanna Be on Top?

I thought the best piece of jewelry she was wearing was the spider-shaped black ring that connected to her bracelet by means of a spiderweb of chains, and so I decided that this was the piece I would compliment. It was the first day of school. We'd been paired together for the assignment on *Of Mice and Men*, and I wanted to put a good foot forward. It was hard to pick just one thing to compliment when what I really wanted was to congratulate her on the overall impression she made. She was forbidding and impressive.

I gathered up my binder and notebook and sat next to her. There was no question of which of us would move to accommodate the other in this group assignment. "Hi," I said. "I like your bracelet."

She blinked up at me. Her eyes were fishbowl-sized and bright blue. "Thanks," she said in her vague tone. Over the years, I would become accustomed to that voice, which always sounded as if it were considering a hundred things at once when it spoke. "I like your Libertines shirt."

I hadn't intended to challenge her with my compliment, but I saw that I had, and moreover, that she'd cleared my challenge with aplomb. A girl complimenting another girl's outfit or accessories is always the throwing of a gauntlet. She liked my Libertines shirt. She could hang.

I sneaked a look at her handwriting, a pretty script looping neatly along the rows of her notebook. I'd expected her to have illegible doctor's handwriting, or to write in the Rancid font, maybe. But then, it was even more punk rock for her to have such prim penmanship, somehow. It was subversive. "It's nice to meet you. We're working on this assignment together."

"I'm Trixie."

Trixie, I thought.

It's an unfashionable thing to believe, out of touch, too romantic, but I still think that you know it right away when you meet the love of your life. A curtain lifts and floods your dim brain with daylight; something simply changes. Trixie and I ate lunch together that day in excited quiet, which we punctured occasionally with chitchat.

"I like your eyeliner. My mom won't let me wear any."

"Mine, neither. But I wear it anyway. I like your hoodie."

"Thanks. It's from Commander Salamander. Do you know Commander Salamander?"

"I don't," she confessed, and I was giddy: I now had a place I could introduce her to. As far as Trixie was concerned, I was the exclusive owner of something that she would like, which was a commanding place for a fourteen-year-old girl to be. She, in turn, reached into the black crossbody bag that she never took off and produced a fat crayon of eyeliner for me.

"I don't know how to use this," I said.

"That's okay. I'll show you."

She showed me by applying the eyeliner to my lids for me, ringing it around and around each eye until I'd been fully raccooned. After lunch, she led me to the bathroom so we could examine her handiwork together. We both blinked into the bathroom mirror. Our eyes were now identical.

"We look like sisters," I said boldly. It was a risky thing to say to someone I'd only met one class period before, but she nodded.

"I thought the same thing," she said.

At fourteen, you have nowhere to go, nothing to do, and not much money to do it with. Trixie and I developed a routine: meet up after school, walk to the supermarket near my house, and load up on provisions (potato chips, tubes of cookie dough) to the tune of ten dollars or less. However hard we tried, we could only ever scrape together ten dollars or less. Then we'd retire to my room to devour our snacks and watch *America's Next Top*

Model. It was the best thing we could find on my TV, which didn't get cable, but it probably would've been the best thing we could find anyway.

America's Next Top Model was an enchantingly deranged celebration of femininity. When people talk about celebrating femininity, I find that they mostly want to celebrate the good parts. Women are, it's said, so much more emotionally intelligent than men are, deeper, more intuitive, less cruel, less thoughtless, more in tune with their hearts and spirits and the very planet that gives us all life. I challenge anybody to continue deifying women after even one episode of *America's Next Top Model.*

The show's contestants represented a vast array of backgrounds, ethnicities, and classes, so that medical school students fought cheek by jowl with pageant winners and single mothers to become America's next "top" model—"top" in quotes because winning the show was never actually a launchpad for a career as a jet-setting supermodel. Even *ANTM's* earliest contestants knew that certain behavior was expected of them as female reality show entertainers, but the blueprint for that behavior was still crude. This was before every city had its own *Real Housewives* franchise, so early contestants never seemed quite sure of their catfights.

Hesitant to really tear each other's hair out, they turned instead to acts of psychological warfare. One cycle one contestant, Robin, was a devout Christian who didn't understand the "militant atheism" of her fellow contestant Elyse. Some of the show's funniest and most appalling conflicts come as a result of Robin's determination to proselytize to Elyse by reading her pointed excerpts about the sin of nonbelieving from the Bible and forcing her to join prayer circles. But instead of exploding into a predictable slap fight, it just sort of . . . fizzles. In its early days, *ANTM* knew that conflicts can bubble and brew under the surface forever without ever exploding into real altercations—particularly conflicts between women, who have less latitude to express interpersonal anger openly. Robin and Elyse snipped and gossiped and parted as enemies, just like they almost certainly would have done in the "real world."

The show would eventually find its sea legs and gain more confidence in its catfights over the years, such that it wound up looking a lot like every other reality show everywhere. But I'm drawn to the relative subtlety of these early seasons. The show grew up during the same years that I did, so watching it feels like hanging out with someone from my senior class who never stops talking about the glory days of high school. And, of course, I'm partly drawn to those subtle early seasons because I appreciate the wickedness of the femininity that they contain. These ladies were uniformly tall and skinny and beautiful and desperately, pathologically insecure as *ANTM*'s judges calmly delineated their faults. They partook, maybe without knowing it, of femininity's peculiar witchcraft: they transformed every week into competent models, only to transform right away back into silly little girls who liked to stick their heads out limousine sunroofs and scream at the barest hint of excitement. They didn't hesitate to weep on camera. The second they were overwhelmed in any direction, you knew it. They were life, in all its pain and ugliness and joy.

I didn't have siblings, and Trixie had one brother whom we treated (and, frankly, still treat) with cordial detachment. We recognized that we were each other's true siblings. Brothers were no use to us. Boys in general, fascinated as we were by them, were really of no use to us: they didn't understand our games. We could pass an entire afternoon transfixed by *America's Next Top Model*, while coloring each other's faces with makeup and taking pictures of each other, inspired by the show's modeling challenges. Everything we did felt pleasantly illicit, even though it rarely was. These were the games of little witches testing their powers. If a game was particularly successful—if my crush liked a photo of me that Trixie had posted on MySpace, say, or if we managed to hector the cute barista at Starbucks into giving us a free passion tea lemonade—we cackled and mounted our brooms and flew away, semi-literally. We often departed rooms by dissolving into feral cackles and bolting. Still do.

Our world was the sizzle of the busted fluorescent light in the cafeteria and a note-passing technique so refined and clandestine that our teachers never discovered it and an endless exchanging of furtive looks that were their own lingua franca, uninterpretable by outsiders, but instinctive to us. It was small, felt big. It was as big as it needed to be to promote the fungal growth of our friendship, which bewitched other people. Cashiers, teachers, other kids—everyone stared into our eyes and said the magic words, "You two look like sisters." We began telling them yes, we were. It was true in the ways it needed to be true.

Rules bent around us everywhere we went. I kept Trixie's stolen-from-CVS eyeliner, which I treated like a talisman: masking my eyes within those fat black rings was a charmed and protective act. My mother didn't even bother to scold me, even though I wasn't technically allowed to wear makeup (maybe she realized that this was no mere cosmetic). The one hour per day of computer time allotted to both of us became two became three became "please get off the Internet for a few minutes so I can make a phone call," as we whiled away entire afternoons on AIM together. Every time I signed off, my father would peevishly ask what the hell we were talking about all damn day, and I'd be unable to remember a word. We didn't "talk about" discrete things. We cantillated, we hexed, we wove the unwitting denizens of the world into our complex daily spell work, which naturally centered around the furthering of each other's personal plots (money, romance, a passing grade in algebra). When an *ANTM* marathon ended for the day, we stepped outside the magic circle and forgot everything. Whenever we resumed the show, it all came rushing back.

The women of *America's Next Top Model* were taller than we were, but seemed in every other way identical, despite their more advanced age. They were as excitable, with as little regard for the world around them. They screamed as often, sometimes in delight, sometimes in distaste. They were just as annoying as we knew we were, cared as little as we did. To my mind, every tacky loudmouth of a girl is behaving strategically. For all the tiresome gender essentialism that leads people to mock girls for the obnox-

ious way they scream, nobody seems to acknowledge that a screaming girl knows exactly how annoying she's being. She simply doesn't care, whether she's a twenty-year-old college student opening a piece of Tyra Mail or a high school freshman open-throatedly delighting in the company of her best friend. For a girl, a scream is a potent reclamation of space that cannot be claimed any other way. Everybody wants to sidle up to a pretty young girl all the time unless she's screaming.

On each episode, the women of *America's Next Top Model* must first learn a new modeling skill together from a seasoned industry professional, and then they show off what they learned in a photo shoot, and sometimes also a runway challenge. Then, the show's panel of judges eliminates one contestant. Tyra gives her a pep talk, emphasizes how *amazing* the loser is and how *hard* this decision was. As with all elimination-type reality shows, we get a brief exit interview with the forsaken contestant. Sometimes she's able to summon up the usual graceful platitudes about how honored she is to have made it this far, but *ANTM*'s losers aren't afraid to show that they're upset to be sent home or that they think they deserve to stay. "That's crazy," says cycle nineteen's Leila through her sobs as she's eliminated. "I'm beyond, beyond, beyond surprised." Then, eerily, a group photo of all the remaining contestants appears onscreen and the woman who's just been sent home is erased from the photo. The reason for this melodramatic, too-literal erasure is clear: once a woman leaves *ANTM*, she's dead to them.

We don't spend much time with the eliminated contestant after that. Why would we? Someone just lost, but that just means that several other people did not lose, and we must celebrate our winners with vigor. So the camera, our eye, returns to the women who didn't lose, and watches them happily as they hug, and kiss each other's cheeks, and jump in place, and, yes, scream, and generally behave like teenage girls in the presence of their favorite boy band—except there's no boy band. There are no boys, period. There are only other women, sharing in each other's girlish joy and pain.

America's Next Top Model follows in the tradition of shows like *Star Search*,

where the professed goal is to find the next superstar, but in reality, these programs mostly excel at expanding the rosters of their own internal galaxies and boosting their hosts' profiles. *ANTM* winners and runners-up did go on to modest industry successes, but at the end of the day, the person who was able to triumph via *America's Next Top Model* was Tyra Banks and Tyra Banks alone. The show didn't have a deep enough bench of support to accommodate success for Tyra *and* her contestants. So Tyra parlayed *ANTM* into a talk show and a production company, and *ANTM*'s actual winners graduated to walk-on roles on other UPN programs, the occasional runway show, and covers of such venerable fashion publications as . . . *Psychology Today*.

Free from the implicit expectation that it provide professional support for its contestants, *ANTM* was permitted to become a cipher of femininity for its viewers. Nothing else on the air has ever been as unapologetically girly. Long stretches of airtime are given over to gaggles of women gossiping about sex shops and the mysterious behavior of their bodies, taking frequent breaks to scream-laugh. They don't necessarily like each other, but probably. They don't necessarily despise each other or feel searing jealousy for each other, either, but probably. The women of *America's Next Top Model* have no reservations about the multitudes they contain. And to be a woman anywhere, you've got to be comfortable being a mess— you'll get trampled otherwise.

One day in eleventh grade, Trixie announced that she'd gotten a job at Panera.

"I see," I said, blisteringly jealous. I'd applied at Panera myself, but hadn't been hired.

"We'll still see each other all the time. I'll only be working weekends," she promised. It felt like a breakup conversation.

I resolved to get an only-weekends job myself. For one thing, I really did need the money. Mainly, though, I refused to be left alone by my

sister in any capacity. Anything she did, I also needed to do. She already had numerous after-school activities (traditional Irish step dance, learning to drive) that I didn't share. And now that my parents had divorced, I attended a different high school, which was an activity that she couldn't share with me. It was important to me that our lives remain bound up in each other as much as possible.

Ideally, I would have gotten a job at the same Panera as Trixie, but I wasn't keen to apply and be rejected again. So I turned to the stores and cafés in the neighborhood where I now lived with my mother, as well as those near my bus stop. At Starbucks, I was lucky enough to hand in my completed application to a bright-eyed young man who turned out to be the manager, which is the only way to have a hope of getting your job application looked at anywhere: make sure you hand it to the manager. He hired me on the spot and instructed me to buy two white or black polos and two pairs of black or khaki pants.

On AIM that day, I gave Trixie the good news: now we would both work on weekends. She promised to supply me with lots of leftover treats from Panera, and I promised her lots of free drinks at Starbucks. I was relieved that the balance had been restored. Something had changed, and I had corrected for it; now, nothing had changed.

Much has been made of the supposedly natural, competitive deficiencies that occur in friendships between girls. An entire self-help industry of sorts was once devoted to deconstructing and correcting those deficiencies. Books like *Odd Girl Out* and *Queen Bees and Wannabes* (the source of much of the material that would eventually become 2004 comedy powerhouse *Mean Girls*) told mothers that their daughters were the victims of special girls-only bullying. Regular bullying could be almost anything cruel, but now we had to account for the specificities of girl-on-girl crime as well. When tormenting each other, we were told, girls rarely resorted to blunt instruments like swirlies and wedgies. Instead, girls gossiped, decimated other girls' social standing via rumor and insinuation. They were crafty,

sneaky. They were competitive to the point of neurosis, but only with other girls. It's no wonder that these books were so popular at the same time as *America's Next Top Model*. For whatever reason, it was the golden age of inter-girl cruelty. Petty gossip's stock was up.

And yet I've felt uninterrupted magic in all my important friendships with girls. Sure, I felt competitive with Trixie when she got a job and I didn't—her piece had advanced ahead of mine on the board. But it didn't drive me to despair. It propelled me forward. Trixie was the person I loved most in the world. If she was working, I was working. I hadn't been able to land a job before, but something about her job charged me like a magnet. Realigned and powerful, I was able to get what I wanted now.

One night in 2017, we were in the bathroom with a man we'd never met before, who had tipped a vial of coke onto what looked like a compact mirror and was diligently chopping it up. It was, I don't know, two in the morning, maybe later. We'd come from a drag show, and from work before that. Our bodies were swaying after a few too many cups of the drag show's cocktail special, which claimed to be a humble vodka cranberry but hit like codeine and cost only three dollars. This was our routine now. We'd adopted this experience firmly into our ken and named it "Wednesdays," for the day of the week on which it happened, obviously—but "Wednesdays" signified much more than just Wednesdays. "Wednesdays" were late nights in Hell's Kitchen, of all places, and Trixie writing to my Tinder matches for me and the smell of sticky well liquor tracking into Trixie's apartment on both our shoes at six in the morning. That's if we even made it to Trixie's apartment. More than once, I had to go straight from "Wednesdays" to work on a Thursday morning, woozy and desperate for sleep, the disgraceful flotsam of shredded false eyelashes stuck to my cheeks (the glue having proven somehow too weak to keep the lashes on my eyes, but just strong enough to adhere them to my cheeks for the rest of the day).

These trips to the bathroom were critical to the success of "Wednesdays": strange men's coke kept us awake and, more importantly, fun. But there were risks. I noticed now that Trixie was staring at our benefactor warily. "What's that?" she asked him.

"What's what?"

"That thing that you're cutting lines on."

He held it out for her examination, and I leaned over, curious now. It wasn't a compact mirror like I'd thought. It was a black-and-white photo of a severe-faced woman with two stoic toddlers, both of whom were wearing overalls—not farmers' casual overalls, but fancy ones with ornate embroidery on the pockets. I did not like the look of that photo. It looked like the sort of thing that, had we been living in a horror movie, would have absolutely been haunted.

Trixie seemed to agree with me. "Who is that?"

"My mother, me, and my twin brother."

It was hard to reconcile the chubby-cheeked rug rat in the photo with the gaunt fellow who was now squatting down and balancing the photo on his thigh, the better to roll up a twenty-dollar bill. Trixie and I exchanged looks. We could not, and still can't, explain why the photo had us so ill at ease. But then, this was the case anytime one of us was ill at ease: the other absorbed that uneasiness about the same thing, which was always something that could not be explained. Some feeling of incompatible sorceries afoot. Trixie and I had been tethered to one another by impenetrable sympathetic magic for so long that we often found ourselves at odds with other people who had power of their own, and we both recognized it and could never explain why.

We accepted the man's coke and made our excuses quickly, even though it was still early (well, "early"). As we walked to the train together, we tried to analyze what we were feeling.

"That was creepy, right?" I said.

"Dude. So creepy. That photo looked, like, two hundred years old."

"Oh, my God, it *did*. The outfits . . . !"

"The frame," Trixie said, "why did the frame make me so uncomfortable? It looked like something I would see in my grandma's house."

"That dude was a dracula."

"He was *such* a dracula."

We laughed, but we also believed it, really believed it, with a devoted childish superstition that neither of us had ever really outgrown. Maybe we would have outgrown it if we had ever grown apart, the way that so many other girls' weird impulses and fantasies die out as their childhood friendships do. But Trixie and Rax had never died out, remained a potent union of souls, and so our superstitious minds had managed to shed skins and grow as we did. Or, to put it another way: that guy was probably fine, but he had the misfortune of doing something that we simultaneously disliked, and so he found himself shouldering the burden of the outsized suspicions and rituals of a fifteen-year friendship. The sheer longevity of our shared weirdness simply had more magnetism than anything he would have been able to offer us, and we knew it, and he knew it.

As we settled in for what we knew would be at least a twenty-minute wait for our train, Trixie tapped my shoulder. "Who am I?" she said, and then put on a Hollywood Nosferatu accent. "I vant to suck your blood!"

I screamed, and she screamed, and a young man a few benches down looked up in annoyance as we collapsed into laughter. We had never stopped being sixteen years old, not really.

Fifteen years our friendship has survived, and yet I always find myself so drawn to the early years when I think about Trixie. Our wildness was still untrammeled, our feet still so unused to walking in heels that we often took them off and scampered barefoot along D.C.'s grimy sidewalks. Men were still pleasantly mysterious. We hadn't yet become fluent in the cruel, quotidian rhythms of men's disregard for women, so that when Trixie's coworker Brent never called me again after a hookup, we were able to spend

four thrilling months trying to figure out why. We were able to find the world exciting rather than dreary.

And yet we're in most meaningful ways the same feral girls we were back in ninth grade. We speak the same impossible dialect, two parts inside jokes to one part cultural references from 2005. We remember everything, every unsuitable boyfriend, every crappy job. We sure as hell remember the guy with the creepy family photo and talk about him often—he's an important figure in our mythology, as is Brent and every woman who's ever competed on *America's Next Top Model*. The people and pop culture franchises of our distant past are just as important as those that populate our lives now. Our friendship knows no sense of passing time.

Relationships between women are magical due to, I think, their sheer malleability. With men (particularly those that I've known romantically), it's hard for a relationship to shapeshift the way it needs to in order to accommodate the growth of many years. I set the terms early with men and have little wiggle room to change them. My relationships with women don't suffer the same defect. Maybe I'm lucky, or maybe the ties that bind women to one another are, for whatever reason, more secure—so that, while not every woman is going to be closest confidantes with every other woman, the ones who do have that relationship are unlikely to lose it. You see it to an extent on *America's Next Top Model*, a universe populated almost exclusively with women. The show's friendships may be shallow, but that doesn't mean they're weak. Petty grievances, too, have extraordinary sway between the show's models. They become each other's world, and the world outside is reduced to an abstraction.

If you were to ask me what Trixie and I have in common, I'd be stumped, just as I always was when my dad would ask me what we'd been talking about all damn day. What *do* we have in common? We don't share that many explicit interests or hobbies, and yet we are utterly captivated by each other's company, to the point that interests and hobbies don't matter. I have friends I write with, and friends I play music with, and friends who

love Twitter as much as I do. And then I have Trixie, a friend I don't need to [verb] with, because our time together is more precious than that. Now, as then, I couldn't say what we talk about. Just that we talk, at great length and all the time. Trixie's roommate once spent the day in our company and described the experience as exhausting. "You two talk over each other and interrupt each other constantly," she said. "But the things you're saying don't make any sense! I have no idea how you manage to finish each other's sentences."

As far as I'm concerned, Trixie is still the ninth grader wearing too much eyeliner and a spider ring/bracelet contraption. And I'm sure I'm still the bug-eyed kid in the Libertines T-shirt to her. Our friendship has stretched to accommodate the greater breadth of experience that it now has to hold, but it hasn't needed much other growth. We know so much more now and no longer need to message each other wonderingly on AIM about the mysteries of the blow job or the hard-to-read guy in Spanish class, but the tone of the friendship remains unchanged. We still make each other laugh until tears stream out of our eyes. We still share clothes and jewelry. When we're out together, strangers still ask if we're sisters, responding less to our vague physical resemblance than to the absolute sameness of our behavior. And we still blink up at them with our identical fishbowl eyes like we've always done and tell them yes, we *are* sisters, good catch.

Whenever I rode the Metro in my Starbucks visor and my syrup-stained black stretchy pants, nobody knew I was just some high school junior, or so I self-importantly believed. I was *employed*. At Starbucks, I syruped and steamed and stirred vats of lumpy Frappuccino mix until my arms ached. At Panera, Trixie did more or less the same. We liked to visit each other at the other's workplace to enjoy the star treatment, free drinks and snacks, acknowledgment and idle flirtation from the staff. We served our other classmates sometimes, too, tried not to let it sting that they were there (on the other side of the register with their friends, laughing over bagels and

mochas, smelling like Bath & Body Works products rather than the inside of a bag of coffee beans) while we were here. We crushed on each other's cute coworkers because they were cute, yes, but mainly because it gave us something fresh to plot over. My Panera boyfriend was the previously mentioned sleepy-eyed college sophomore Brent, while Trixie favored my coworker Oscar, a twenty-four-year-old Radiohead fan from Bolivia who could never be persuaded to shut the fuck up about Radiohead.

Technically, Starbucks had rules about customers being in the store after closing. But Trixie was no customer. So I gave her the best seat in the house while I kicked out all my other customers for the night, relishing the confused looks they gave her as they passed her on the way out the door. I locked up and sprinted through the store-closing procedure so that we could go out afterwards. Then, my favorite part of the night: I changed into the clothes Trixie had brought for me in the bathroom, colored in my eyelids with black eyeliner, and sashayed out the door a new woman. I loved that moment of transmutation. It was, I thought, my only chance to show coworkers my true self, even if my "true self" was wearing Trixie's clothes rather than my own half the time—still, what could be truer than that? My true self was mostly Trixie, and vice versa.

"Did you see the way Oscar was looking at you all night?" I said as I locked up the store, because it was the kind thing to say. If we were leaving Panera rather than Starbucks, it would be Trixie asking me, and she'd be asking it about Brent instead; we tried to be magnanimous about each other's crushes.

"He probably thinks I'm too young for him," Trixie demurred.

"No way! He knows you're seventeen. He asked me the other day, and I said you were seventeen, and he said: 'Perfect.'" (Which is true! He really did say that! Isn't that horrible? But at the time, of course, we thought: *Isn't that romantic?*)

In our wedge heels and cheap bodycon dresses, we could have gone to any number of places to dance and listen to music and, most importantly,

attempt to seduce adult men by pretending we were twenty-one and "forgot my ID at home, isn't that crazy, so they drew these black X's on the backs of my hands even though I'm totally of legal drinking age." This was mostly an unsuccessful gambit. We were so obviously seventeen years old in every way. But the fun was less in winning the prize than in playing the game, and we always had a good time. On this night, though, all dressed up and with any number of places to go, we were inexplicably hesitant.

I thought I knew the magic words, but wasn't certain of them. It seemed impossible, just this one time, that we could both be thinking the same thing—when there were venues to visit, DJs to dance to, bathrooms to search for generous key-bumping women who were too drunk to ask prying questions about anyone's age. Still, hesitantly, I asked it. "Want to just go home and finish out the *America's Next Top Model* marathon?"

"Oh, my God." Trixie squealed a little squeal of recognition and kinship. "Would you believe I was going to ask you the same thing? But I thought it was so lame! Like, it's a Friday!"

Fridays were sacred to us. After-Starbucks Fridays were to 2008 what Wednesdays were to 2017. We loved the sight of giggling groups of women in less-cheap versions of our own outfits, loved the '80s-themed dance night at the Black Cat. But tonight, we needed something different. A balm against the noise and chaos of the world, a powerful defensive magic to keep us safe. So we went to my apartment, where my mother never asked us to keep it down, and, still tottering in our heels, made a bowl of popcorn for our marathon. As soon as I turned on the TV, the show's vamping theme song began to play: "You wanna be on top?" And Trixie and I squealed again, tried not to scream. You know. Girl stuff.

Loss of the American Shopping Mall

Mitch worked at the Starbucks in my local shopping mall. He was pretty cute, precisely: not a bit cuter, not a bit uglier. A solid 6.5 out of 10. He was neither impressively tall nor adorably short, and I can't remember a single other trait he had other than "average height," even after looking at a picture of him—he had that sort of face, was that sort of guy. But I was sixteen years old and he was a college student who was paying attention to me, and on that basis he was a perfect 10, and my dream man, and everything else.

I hit on him in the awkward, brutal manner of the adolescent girl, putting on my strutting peacock display like I did whenever anyone cute was in my line of sight—I waggled my hips as I passed, tossed my hair so much I gave myself a neck spasm. I laughed my very loudest as often as I credibly could so that he could hear the pretty timbre of my giggle. The way he watched me gave me the impression that he wouldn't hate it if I kept this up, so I kept it up. And he didn't hate it. When I scribbled my number on a wispy Starbucks napkin for him, punctured in several places by the force of my handwriting, he texted me. He wasn't just texting for texting's sake the way boys my own age did, either; he was asking when I was free, making a plan, though he didn't seem exactly excited about it. When he set a time for us to meet, it was as if he were an assistant booking time on his executive's calendar. *See you then and there, thanks, and have a good day.*

Still, I showed up at his apartment at the designated time, still pleasantly uncertain of whether he liked me. I rang his doorbell and then picked at my tights in the winter chill while he made his ambling way to the front door to let me in. I tried to strike a pose that wouldn't look like a pose; I

wanted him to take a mental photograph of the first time he saw me that night, but I didn't want to look like that was what I wanted. The goal was to present an immediate, effortless tableau of hotness. Would he hug me hello? Kiss me, even? And why hadn't it ever occurred to me to wonder whether I liked him?

Mitch had a girlfriend, it turned out, which explained his passionless texting—she was given to reading his texts, he explained apologetically, and he had to keep things innocuous. And now, wouldn't you know it, he was feeling overcome by guilt about having invited a teenage stranger to have sex with him in their shared apartment. But, he said, that was no reason for him not to make *me* feel good after I'd come all this way to spend time with him (ten minutes on the bus, but whatever). He went down on me dispassionately, and I moaned and whimpered through it as I knew I was expected to do, wondering where this encounter fit into his monogamous relationship and no doubt eternal love with his girlfriend. Frankly, I was far less thrilled by the machinations of his clumsy mouth than I was by having lured him into this act of treason. I didn't come, but pretended I did, and had a devil of a time ever getting Mitch to respond to another text, and yet in the moment I believed I'd won something, somehow.

At that point, I'd spent years visiting the mall as dolled up as I could possibly get, looking for love and finding only the limp fries at the Philly cheesesteak stand in the food court. I watched the girls and boys of my school morph into smoldering Isoldes, debonair Tristans, as they found their improbable way to each other over Frappuccinos and Sbarro slices, and all I could do was long for a Tristan of my own to sweep me off my feet and into the mall's Employees Only closet with the faulty lock. I was forever throwing myself at people who wanted nothing to do with me; with Mitch, I'd thrown myself at someone who'd been almost willing to catch me. No wonder I genuinely believed I'd won something. Mitch represented progress. I was finally learning the societal rhythms of the mall.

———

I think most of people's quibbles with suburban life are reasonable, but I disagree when they insult the shopping mall. The gripe, as I understand it, is that malls are where culture goes to die. This gripe is a striking triumph of can't-win logic. As I understand it, a culturally enriching experience is one that has the power to tie the individual to the other members of his human tribe, reminding him of his place in the human story shared by all of us. Cultural centers are therefore sites where these enrichments are enacted, deliberately and painstakingly. Grand paintings line the walls of art museums, and groups of somewhat interested tourists trundle from one to the next in the company of a docent who explains to them exactly why Rembrandt's use of shadow and light was so revolutionary. And if fine visual art isn't to a person's liking, he may instead choose to visit a symphony hall, and surround himself on all sides with the thundering glory of Mozart's Requiem. These entertainments are the hallmarks of high culture, and we've decided that experiencing them is enriching, perhaps due in a circular way to their existing canonization, by which I mean: a person who is not necessarily stoked on the music of Mozart may still leave a performance of the requiem feeling enriched because he knows that's how he's supposed to feel about it.

Now, I don't mean to suggest that nobody is legitimately entertained by the high culture that the members of our society agree is significant. I only hope to suggest that in a shopping mall, rather than passively observing high culture (looking at it, listening to it), we were able to *create* a culture of our own. We were kids, with kids' attention spans and kids' desire for action; passive observation made us itch. Action, not contemplation, tied us to our human tribesmen, granted us access to the human story. And we couldn't have felt more tied to each other than while wandering the mall's floors, smelling each other's overzealous early efforts at perfume, coveting each other's outfits and boyfriends. We were spellbound by each other's human presence. We wrote scripts and novellas about ourselves by living them; we taught ourselves about the humanity in each other by exploit-

ing the social tension that bound us all. Entering a shopping mall was like walking onto the stage of a great opera. We knew our roles and how to play them. We played out the great love stories of the world in cruel, petty simulacra. In retrospect, I recognize something of Odysseus's triumphant return to Penelope in the way Brett Kosciusko approached Tiffany Hubachek at the water fountain after having been at juvie for a year, and in the joyful way that Tiffany launched herself into his arms, as her male hangers-on shuffled away dejectedly.

Then, there was an element of Don Giovanni's seduction of Zerlina in the way that Mitch claimed me. In Mozart's sweepingly funny opera, the great seducer Don Giovanni seduces shy peasant girl Zerlina with "Là ci darem la mano," which, it must be said, is one of the all-time panty-droppingest, dick-throbbingest seduction songs of all time. The velvet-draped hotness was necessary for the Don, though—like a timid puppy, Zerlina needed coaxing. All I needed was twenty minutes of innuendo passed over the Starbucks counter and, like, five sentences' worth of texting. I was far too desperate and willing a Zerlina. But there, that's the difference between the stories that are inscribed in the cultural memory and those that two people write to each other in real time: the base dullness of real-world seduction has no place in the gorgeous epics of the canon. The feelings themselves are still there, but need to be zoomed in and scaled up in art in order to be visible.

In the early 2000s of my adolescence, malls were electrified with this high-voltage narrative possibility, even if the reality was usually as dull as, well, reality. Malls weren't, in those days, analogues to the pickup bars where a girl merely needs to sit and wait to be claimed. They were finer, trickier sites of romance than that. Approach and timing were critical. Sloppiness was unacceptable. Malls were sites of gorgeous, humid anonymity. I say "humid" because that's what we were, less hot for one another than boiling, each of us a perfect 212 degrees Fahrenheit—and heating still, worse, redder, wetter. At any moment, we were all in danger of evaporating into steam.

The problem with places that weren't malls was their unpredictability. They didn't lend themselves as well to hypnotized teenage lust. Listen, listen, at sixteen, I overheard a man tell his friends that I was attractive as their group passed me by, and I *followed* them. Not far, just until they went into a bar whose bouncer was carding, but still. I don't think I even realized I was doing it. He'd responded to the heat emanating from my body in a way that was *almost* gratifying, and I ran with it as far as I could. But it was like watching a dog on a leash trying to chase a squirrel, which is to say, what are you even going to do with that thing if you catch it? What was I even going to do with John, twenty-nine, visiting for the week from the UK (because you'd better believe I tried to strike up a conversation, little slut that I was)? Thank God I didn't catch him.

But there was no bouncer at Under Armour. There was no ID check at Hot Topic. There was no danger of a potential target disappearing into a place where I could not follow.

Victor Gruen, the architect widely credited with the creation of the modern American shopping mall, intended the mall to resemble the wide, pedestrian-friendly plazas of cities like his hometown, Vienna. This was in the mid-'50s, when white Americans were fleeing city centers for far-flung suburbs where they couldn't get around without cars; Gruen hoped, maybe, to show them what they were missing. In his vision, malls weren't just the dense knots of consumerism that they'd ultimately become, piled high with stores to satiate every capitalist urge. Suburbanites who were otherwise disconnected from each other could gather there to eat, too, and to simply sit in the presence of other humans without being forced to spend money—how many other American spaces offered that?

The design of the mall is conducive to this lofty social goal. Gruen hoped to bring suburbanites into contact with each other on relatively flat ground (most malls are only two stories and feature deliberate swaths of open, plaza-like space). He envisioned something analogous to the Viennese Ringstrasse, where he'd passed so much time before the Holocaust

forced him out of Austria with eight dollars to his name. Except, where the Ringstrasse surrounded the entire city center so that Vienna dwellers could promenade around their town in each other's company, the mall would draw the city into its own interior. As far as he was concerned, his malls were the only rigorous planning to be found at all in American suburbs, which were otherwise sites of pure convenience. They sprang up around highways and shoehorned fast-food restaurants and dismal little shopping centers into any block with enough space. The mall was a place where suburbanites could be human, untethered from their cars and freed from the tyranny of the suburban six-lane mega-road.

In that regard, the mall is a success, even if it isn't a perfect socialist utopia. The malls of my youth certainly teemed with life. I walked the plaza-like corridors as if through a fog of pure pheromones, unable to stop looking at the people around me, especially other teenagers. Malls allowed me to drown myself in social energy. And what's more, I grew up in Washington, D.C.—all the museums are free! I could have just as easily walked the halls of the Hirshhorn or the Portrait Gallery, absorbing high culture like a good little citizen-to-be. Yet I chose the mall. Why?

Well, what teenager wants to while away the day at an art museum or maundering from one local monument to the next? The only thing that would have lured me into an art museum in those days was the possibility of encounters with cute art boys. I did go to shows regularly, especially at D.C.'s beloved Fort Reno, whose free outdoor all-ages concerts are a treasure. Still, I don't think nightlife is the fix that people have in mind when they bemoan their children's lack of culture. And even at those shows, in sweaty rooms full of strangers and with black X's on my hands warning bartenders not to sell me beer, all I wanted was for one of those strangers to pick me and . . . something. I didn't know exactly what I wanted, only that I wanted it.

So yes, at sixteen, I was a hormonal beast. I was single-minded and desperate, and while I did manage to absorb the odd piece of high culture, the

absorption wasn't noticeable until years later, when I'd remember some rogue piece of information from a teacher or docent that I didn't even realize I'd bothered to memorize. I'd remember those interminable school trips to Colonial Williamsburg and the Air and Space Museum with a start, shocked at the information that I was somehow able to amass despite my fixation on the newly triangular upper bodies of my male companions. How is it that I know the way butter is churned? I certainly made no effort to learn it. When we went to Colonial Williamsburg, all I could think about was how Adam Lehman's hair smelled when it brushed against my face on the bus—when did I have *time* to learn?

Weren't we cramming valuable cultural lessons in those bastardized malls, stripped free of Gruen's carefully planned green spaces to make more room for cheesesteak stands and Apple stores? We were learning something all right as we passed each other, looping around the building's terrazzo track, in packs of three or four, laughing together, a little too loudly, for the benefit of whoever might be watching. Because someone was always, always watching—we could count on that much, even if they never spoke to us. In fact, they probably wouldn't. What they'd do instead was ask their friend Rita's cousin's friend Mike to tell us they said what's up. I've developed crushes on less, even as an adult.

An example: At fifteen, I decided that I would kiss the counter boy at the Mrs. Fields cookie stand. I was a hormonal little tramp, and he was a year-ish older than me with a mop of fluffy black hair and, I don't know, broad shoulders maybe—something sexy, in any event, something over which to formulate obsessive stratagems, something that made me want to plot. Because I didn't know him, I first needed to seduce him. To that end, I parked in a chair opposite his counter, smiling and repeatedly crossing and uncrossing my legs at him. He smiled back but made no move to approach me. Finally, I could handle no more of this will-they-or-won't-they, Sam-and-Diane torment. I ambushed his counter and said, in what I imagined then to be a flirtatious way, that I'd been waiting for him to come talk to me for the better part of an hour. He looked pained. "I don't get a break

for another hour," he said, and, humiliated, I fled, never to enjoy another
Mrs. Fields cookie again.

At no point did it occur to me that he might have been interested in me
in his own right, though in retrospect, it certainly seems that way. Why else
would he have told me when his break was? But I believed then that every-
body else was as powerless over their hormonal surges as I was; that, upon
spotting a sexy body, everybody else's clock stopped ticking so that their
minds could home in on a single purpose, just as mine did. Put it this way:
I would have gladly gotten myself fired from a job if I'd caught a whiff of
an interested boy. Or actually, no, let me put it *this* way: I'm still wonder-
ing whether the Mrs. Fields guy really did want to fuck me almost fifteen
full years later, and he probably never thought about it again. To this day,
I remember the potency of his rejection more urgently than I remember
anything of Bach, or Aeschylus, or Descartes. That, unfortunately, is the
biggest point of conflict between the low social culture we create together
and the high culture we observe from a respectful distance: what's low may
drag out for years as slow and hideous as a funeral dirge, but it still hits
hardest, every time.

As children of the 2000s, we were building the culture that we'd even-
tually inhabit as adults, a culture of passive observation and active longing.
We refused to talk to each other but greedily formed impressions of one
another all the same. These are habits that we've replicated now—you only
need to visit a bar and see a row of six unrelated people, all reading books
or on their phones, all sitting alone, and all hungrily stealing glances at
each other every few minutes. Our inhibitions do tend to loosen once we've
had a few beers or a couple bumps of the bad coke that someone's friend
Rita's cousin's friend Mike brought, but we fear each other just as much
now as we did back then. We circle each other even now like lions whose
prey motive is stuck on "stalk," never to advance to "pounce." We claim
each other on dating apps from miles away and then disappear.

My visits to the mall were loosely, chaotically choreographed. I looped

through the junior sections of department stores, dragging my questing fingers along racks of silk blouses; I spritzed and decorated myself in Sephora. At Claire's, I might treat myself to a pair of novelty earrings from the sale section whose backings would turn my ears green and raw and bloody. I also loved Icing, trashy twin sister to Claire's, for occasions when I had exactly four dollars and simply needed to spend it on fingerless gloves. I steered clear of Abercrombie & Fitch, believing it to be a hub for the soulless and popular, and also frightened of smelling like the cologne they pumped liberally into the surrounding hallways. Hot Topic, as you may recall, was my favorite place of all and also the one I could afford the least, but oh, how I loved to look at the staff and fancy that our shallow conversations about Manic Panic would lead to a storybook wedding.

I trekked from store to store with no eye for one's distance from the next. Such planning would have defeated the purpose: the whole point of a trip to the mall, even absent any purchases, was to be seen as widely as possible. A trip to the mall was an occasion for my most daring outfit and my most questionable makeup look. It meant unsupervised encounters with other humans. In the mall, I could sniff the butts of strangers and convey to them, however ambiguously, that I was interested in what I was smelling. I couldn't do that on the street. My parents would have locked my ass up.

I preferred to visit the mall with friends, not because I enjoyed spending time with them there—I didn't—but because they provided a valuable buffer between me and my mission, which was the outmaneuvering and eventual capture of strange boys. I rarely bought anything other than food at the mall, unable to afford its expensive wares on the minimum wage that I earned at the frozen yogurt shop where I worked at that point. Instead, my friends and I would establish a headquarters in the food court, and raise hell over fries, our eyes constantly scouting the room for stubble, forearm muscles, T-shirts cresting over stomach fuzz.

As for the opera that I'd begun writing with Mitch, we were now firmly in the final act. Back at the mall, the gossip about our evening together

had followed me just as I'd hoped it would. Somehow, everybody knew. "Maybe your boyfriend wants to give us some free Frappuccinos," my friend suggested as we passed Mitch's Starbucks, her tone as suggestive as if she were recommending that my "boyfriend" insert his fists into our anuses sometime soon. Other boys pointed and whispered, and sent each other over to talk to me. I figured it was only a matter of time before the rumors paid off and I would be able to lure one of these pointing, whispering boys from his pack to be my steady source of sex. This was the most momentum that any of my trips to the mall had ever generated, and I hoped to capitalize on it, rounding out my slutty narrative to my advantage.

It never happened. I'd observed the rules of war brilliantly within the battlefield of the mall except for one thing: Mitch had a girlfriend who had factions of loyalists looking out for her interests, and as I later learned, he'd tearfully confessed everything to her when she found his texts to me. (Not innocuous enough, I suppose, or maybe she was just familiar with his tricks.) They were older, these friends of hers, most of them in college just like Mitch and his girlfriend were. They carried Coach purses and were sophisticated enough to use makeup that imitated their natural coloring, rather than blotching it around like clown paint. They wore identical skinny jeans and cardigans and had hair of uniform silk. They did not like me.

And when they called me a slut, it hurt in a way that it never did when my friends were the ones saying it with half-joking, half-jealous smiles on their faces. It was effective in a way that my friends' own gossip never was, too: nobody would touch me. Girls I'd known for years suddenly wouldn't "let" their boyfriends talk to me.

I'd made a tactical error. I'd punched above my weight. Perfectly average Mitch might have shown me nothing but a perfectly average time, but that didn't matter; what mattered was that I'd known he had a girlfriend and allowed myself to be conquered anyway. In the moment, with Mitch's head between my legs and my gaze fixed upon the faded glowing-star decals on

his ceiling, all I'd wanted was for it to be over. Not because it was painful or uncomfortable, but because it was dull.

Well, that was being a kid. I wanted the storybook ending but wasn't adequately familiar with the narrative rules I needed to follow to achieve it. I'd deliberately cultivated the impression that Mitch was one of many notches on my bedpost because I'd believed that it would be helpful to me; when it proved unhelpful, it was too late and I was no longer in a position to backpedal. I didn't yet believe in the permanence of the choices I made. I didn't believe that every door I opened would lead quite naturally to the closing of adjacent doors. That was the problem with the world-building that we did together in the mall, especially when comparing it to the world-observing of admiring a great painting or reading a great book: we only learned lessons from real life when the bad things happened to us, in real time. And those bad things were rarely dramatic in the satisfying way of history's greatest love stories. The lives they ruined were our own, and they did so in cruel increments, as we microdosed our own agony until we realized everything was ruined.

To the best of my knowledge, Mitch and that girlfriend are together to this day. How would I know otherwise? I never learned anything about her except that she left long yellow hairs on Mitch's pillow and existed on a particular evening in 2007. I certainly never met her, though whispers did circulate for a week that she planned to drive in from Towson University to kick my ass; I'm sure she did, but for whatever reason, the ass-kicking never happened and I remained free to pursue other people's boyfriends. Still, that encounter with Mitch did change one thing: I'd learned a valuable lesson about the quality of boy I could expect to ensnare over Frappuccinos at the Starbucks kiosk. These were not the heroes of stage and song who would sweep a woman off her feet and ravish her for the rest of her life.

Humiliated, I confronted Mitch one day at his Starbucks, my little face burning, my friends flanking me. We were nearing the end of our narrative arc, he and I. "Why did you rat me out?" I asked.

"I don't know what you're talking about," he said stiffly as his coworkers giggled. Word really had gotten around.

"Your girlfriend is threatening me, man. You gave her my phone number. Why would you do that to me?"

He ignored me in favor of pumping thick chocolate syrup into a cup. The customer whose drink he was making was eyeing me curiously.

"What'd he do?" the customer asked. Through my rage, I noticed that he was pretty cute.

"Yeah, Mitch," my friend piped up. "What did you do?"

"Grande mocha for Kyle," Mitch said, evidently committed to ignoring us, though his coworkers couldn't stop tittering at the spectacle.

"Hey," Grande Mocha Kyle said. "You want to talk about it? This guy seems awful."

And I found that, despite my betrayal, I did indeed want to talk about it with someone cute, right there in front of the last "someone cute" who had just fucked me over. That, too, was being a kid; the culture that we chose to engage with might have devastated us constantly, but we were resilient. Our dismal stories petered out and we swore off each other, swore we'd never again make such fools of ourselves, at least until the next promising opportunity to make even bigger fools of ourselves. We weren't telling stories with endings like the Shakespeare stories we were forced to read in class. Instead, we were knotting and unknotting the tissue of our lives, building up knobs of indestructible scar tissue as we went. Mitch might have been gone, but now Kyle was here, slightly cuter and in my presence as a direct result of what had befallen me with Mitch. A new plot was beginning.

Three Small Words

When I was a kid, Archie comics bored me terribly and I adored them. Not that I was an especially hard-core ten-year-old, but even by my virginal standards, the Riverdale where Archie comics all took place was eerily sexless. No, more to the point, it was missing any rock 'n' roll at all. The characters were polite, friendly, and seemed as if they did laundry once a week and never forgot to floss. They might have ribbed their parents just to get a rise out of them, but they loved their families and each other. Even Betty and Veronica's rivalry over Archie never felt like anything but low-stakes romantic minidrama, dragged out for way too many years despite its colorlessness. Will Archie pick Betty? Will he pick Veronica? I didn't care even then, and I was the perfect age for low-stakes romantic minidrama. The characters were teenagers, but at ten, I felt as if I were more mature than they were, somehow.

Still, for years I read Archie comics religiously. The mannered chipperness that characterized Riverdale had me under its spell. Reading Archie comics was like counting down from a hundred while waiting for the anesthesia to kick in. Though I knew it didn't matter what happened to Archie and the gang, I still enjoyed dropping in on their timeless city to see teenagers behaving like widowed churchgoers. Sure, the authors lunged clumsily at the zeitgeist once in a while, the most famous example being an ill-advised 1983 edition of *Jughead* in which the titular character gave himself a mohawk and changed his name to Captain Thrash. (To be clear, this is a Captain Thrash stan account—I love a poorly considered attempt to connect with the youths.) But for the most part, all Archie comics could have equally taken place in 1940, 1970, or 2000.

Not so with *Josie and the Pussycats*, the 2001 film that took all its charac-
ters and little else from the cheerful world of Archie comics. Look at the
movie poster, for example—the titular Pussycats suddenly look all grown
up. The kitty ears on their heads no longer resemble the ones from a child's
Halloween costume, which is what the Pussycats wore in the comics; now,
those ears are charged, and Pussycat no longer seems like such an innocent
name. Their outfits are child-friendly but suggestive in the perfect early-
'00s way: bare shoulders, hip-huggers paired with halter tops, tight leather
pants. It's turn-of-the-century eroticism, showing skin but not too much,
legs *or* cleavage, hips *or* breasts, and everything glittering metallic. Not to
put too fine a point on it, but these three women are stone-cold *sexy*. The
casting director could have just cast three nice-looking ladies as the Pussy-
cats, three churchgoers, three Girl Scouts, but no—they have the devilish
eyebrows and high cheekbones of hot, mean bitches.

I was too young to know exactly what sex entailed when *Josie and the
Pussycats* was released, but its images still struck me with their electrified
eroticism. I don't mean that I was tearing my clothes off and throwing
myself at my TV screen. Something subtler than that. I looked at the ears,
the outfits, my God, the lips, sticky with frosted lip gloss in every frame
of the movie, and I *responded*. Hairs stood up that had as yet never stood
up; neurons lit with the receipt of unfamiliar information. I wasn't comb-
ing the script for subtext, trying to understand why I felt what I felt. I was
instead inching out of my skin towards what I felt, magnetized somehow
by the art. Giving in to the feelings, trusting them. Is it even worth describ-
ing the movie's plot? The plot is not remotely the point of the movie's
position in my personal canon of effective artworks, and neither are the
characters, nor the script; rather, the thing is a neatly packed Pandora's box
of earthly sins, far more worthy as an experience than as a construction of
one-liners and plot devices.

The lens of *Josie and the Pussycats* was smeared unmistakably with the
Vaseline of millennial sexuality. Our generation has always been more bru-

tal than the boomers', less polite, more overt . . . and, for all that, less comfortable. Millennials have less sex than boomers did at the same age, even though we show a lot more skin, swear more, use sex-delivery services like Tinder more fluently. (Sidebar: I don't know how many readers out there have tried to order a hot older man from Tinder, but they're miserably inept at using it—no text etiquette at all! Two spaces between every sentence when they tweet!) *Josie and the Pussycats* is a prime example of that contrast, and I was the perfect age to notice it. Despite all that skin, those glistening gobs of frosted lip gloss on suck-me lips, that lingering shot of Gabriel Mann's fingers skating along the frozen honey surface of Rachael Leigh Cook's back, it's actually a pretty sexless movie. It contains the same amount of sex as Archie comics, which is none.

I didn't understand any of that at ten, though. What I understood was that certain intended-for-the-adults-in-the-room jokes were flying intolerably over my head; that I was in love with Rachael Leigh Cook; that I needed a tube of frosted lip gloss immediately. Which is to say, I absorbed all the important stuff without questioning it or dissecting it. I experienced the movie as a self-contained piece of entertainment rather than an avatar for some greater meaning. It rewards those who are more interested in experiences than interpretations; people who lean towards the latter are guaranteed to be frustrated by *Josie and the Pussycats*. A person who is not able to open that erotic aperture, naturally and nonjudgmentally, will find little of value in this movie.

Reviews of *Josie and the Pussycats* were mostly scathing upon its release, possibly because it resists the legitimizing act of criticism and is instead an object of love. When we criticize artworks, it's important to us that the works be worth the time and energy that we devote to critiquing them, and so we are offended by works that seem shallow or silly. The critics of the day took umbrage at the purity of the movie's goofiness. Per Roger Ebert, it's a "would-be comedy about prefab bands and commercial sponsorship" whose music is "pretty bad." (Its music is uniformly amazing, actually, and

I fully plan to insist on walking down the aisle to "Three Small Words" at my next wedding.) *Rolling Stone*'s Peter Travers called out the sardonic script as "a likely turnoff for preteen girls who don't like fluff balls laced with bile," an assessment that couldn't have been more incorrect for *this* preteen girl, but whatever. Even more recent reviewers who have hoped to rehabilitate the movie's reputation don't seem dialed in to the true magic of it—they all launch themselves straight at the satire and whether or not that satire works, and they miss the subtle *hotness* that had us preteen girls so spellbound in 2001. In other words, they interpret. They apply their dreary interpretive efforts to a script that, frankly, has little space for such business; it's too light to support the weight of everything critics have decided to retroactively attach to it so that they can feel comfortable liking it. But hell, personally, I was always comfortable liking it. I never needed it to be great just so I could dig it.

To be clear, it is worthwhile to ask ourselves whether a creation works on the level at which we imagine it's intended. If a satire doesn't work as a satire, that's more valuable information to its writers than whether the satire works as a piece of eroticism for children. But at ten, what did I know about satire? What did I know about punching up and irony and Jonathan Swift? For that matter, what claims would I dare to make about any of those things now? I'm a simple woman, and if I see a backless dress or a cobra armband squeezing an arm of tan velvet, I'll follow it to the ends of the earth. And it's not just sexy stuff that inspires such spirited loyalty, either. If I hear a great three-minute pop song with that 1-4-5 chord progression that sounds so fucking perfect, that Jesus and Mary Chain jingle-like magic, I'll replay the thing to death. If I read a tightly composed knot of a sentence, I'll highlight it, underline it, dog-ear the page, and never let it go. Life is short. It's important to attach oneself to the pieces that stick, regardless of whether somebody else believes the stuff is any good. And neat pop moments like these may not be good, but what they are is perfect: perfectly composed, perfectly arranged, perfectly produced, and gift-wrapped with a bow to land perfectly in our consciousnesses.

Susan Sontag wrote in her essay "Against Interpretation" that "in place of a hermeneutics we need an erotics of art." Meaning: the interpretation of art is a tiresome pseudoscience, and the magnetism of art is what has always saved it from becoming dull, weighted down. It's something we see and feel first and foremost, before we attempt to understand it. It's a pretty rich line of thinking for an *art critic*, no?

Still, I'll drink to it. As a people, we've toiled for too long at the heavy project of *understanding* individual works. Entire books are devoted to it. Entire academic disciplines. Entire careers. The important thing, it seems, is to develop tools with which to dissect art so that no piece of art need remain a mystery to its viewer. But . . . why? So few experiences have the ability to enrapture that art has, and I mean all kinds of art. The mystique of it is the point. To be arrested by a sentence, a key change, a flash of white sun poking through deep brown twigs in a landscape—that's why we keep making all this crap. It can be so insular to make art, and so lonely. Our projects consume us. What a sovereign bummer it must be to allow oneself to be obsessed by the project of creating something wonderful, only to turn around and read a piece of criticism bulleting out a hundred utterly boring theories describing what *really* makes it good.

To speak effectively about a piece of entertainment as seemingly goofy as *Josie and the Pussycats*, it's important to first distinguish between the good and the perfect. The good is tasteful. You can see that thought has gone into it. It is carefully layered, and so lends itself nicely to interpretation as a result: it wants, maybe, to be deconstructed, or else its constituent parts are so elaborate that it *must* be deconstructed. It impresses, but probably not in any unexpected way. Consider a film (a good film ought only be called a *film*, never a *movie*) like, I don't know, *Shoah*. Ponderously long? Check. Exhaustively researched? Check. Wrenching to the point of causing physical agony? Check. See also the gorgeous, tense work of Werner Herzog, or the poetry in the music of the National: these are good works, *which is fine*. Good work commands respect, even if it isn't to your personal

taste: you must respect the time and training that informed the people who have produced good work.

Not so with the perfect. A jangly, three-minute pop song with a hand-clapping section can be perfect in a way that a song with an unusual time signature cannot. The artifact, in this case, is its own packaging: the form and structure of a perfect thing are tricky because they need to look as if they don't exist. A perfect song should sound as if it were somehow already stuck in a first-time listener's head; a perfect movie should partake gleefully of tired old tropes and make them so much fun that a viewer doesn't care, maybe even delights in the familiar. As food writer Helen Rosner once wrote of her favorite, perfect food, the humble chicken tender, "Perfection is a precarious state. It occupies a narrow peak, the very pinnacle of the mountain. By its very nature, perfection leaves no room for wildness or risk."

It's not necessarily difficult to produce a perfect work, any more than it's difficult to produce a really fine chicken tender. But it is touchy, and requires the mind of a particular sort of savant—I don't think Werner Herzog could have written or directed *Josie and the Pussycats* to any viewer's satisfaction. His expertise in filmmaking would have gotten in the way. To make something perfect, you've got to want to be a little simple. Not simple as in stupid, but simple as in uncolored—the more educated you are, the more your learning will inform your work and force it off that narrow peak of perfection. The more you know, the more your work will know.

Most of the girls of my generation were predisposed in those adolescent days to what was perfect, more than we cared about what was good. You can't get more perfect than an early-2000s teen movie. You ever read a review that says an album "rewards repeated listenings" or that a film "deserves multiple viewings" or some such? That means the thing is good rather than perfect; a perfect object can be swallowed whole in a single sitting, and if its fans rewatch it or relisten to it, it's because they are addicted, not because they want to further unpack whatever they experienced the

first time. Our favorite creators already did the labor of packaging the thing up and tossing it onto our doorsteps. It couldn't have been easier to consume *Josie and the Pussycats*. You needed only be a sensual creature to do it. We showed our gratitude to the creators of such artworks with the sort of devotion most commonly associated with religious zealots and cult members. And we fondly remember our favorites, like *Josie and the Pussycats*, to this day. No critic could have ever turned us off from the perfect, and thank God for that, too.

Josie and the Pussycats shares a happy-go-lucky desire to skewer the pop industry with *Spice World*, another goofball comedy from approximately the same graduating class. Like *The Princess Diaries*, it tells an implausible story about obviously beautiful women who are seen by their peers as pitiful. It shares the music and, particularly, the voice of Kay Hanley with *10 Things I Hate About You*. Plus, it just looks like these movies, as well as *Save the Last Dance, Freaky Friday, 13 Going on 30*—all exposed midriffs and flared jeans and sarcastic, bitchy repartee between its protagonists. It exemplifies the style and behavior that would, over time, crystallize into my sexual aesthetics. But they weren't just my aesthetics. Other women grew up dreamy, isolated, and horny, and they have just as much of a stake in the slangy flirtations and overplucked eyebrows of our shared girlhood as I do. We spent so much time chasing the perfect in every aspect—aesthetic, interpersonal, sexual—that we never stopped to wonder what would happen if we did finally meet, for example, that perfect man.

To be a perfect man is also to be a whirlwind catastrophe. It's not their fault, really. They devote themselves so wholly to the tricky art of being perfect without seeming to try. They don't have much of themselves left to give to the lesser project of being kindhearted people, and why should they? Kind hearts don't pull in the ladies or make the money. Of course I have a guy in mind, and of course he's someone who once told me he thought kindness was overrated.

Travis Hart, Travis Hart . . . ! Even assigning him a pseudonym fills me with shivers that I should have outgrown by now. Travis Hart was early-'00s romcom-hero magic. His family was from the rightest possible side of the tracks. I can't reveal their actual surname, but it carries a similar weight to Astor or Rockefeller. Travis was the oldest son of the family, tall and soccer-player slender. He had the floppy blond hair that was so in vogue in our shared high school days, and he seemed to be having sex with everybody—and even if I correct for the exaggerated rumors to which teenagers are prone, it was incongruously dirty sex. These were not the halting missionary-position encounters to which I'd become accustomed with my first boyfriend. Travis partook of sex acts that struck me as impossibly arcane and referred to them by the same names by which videos of them were sorted on porn websites.

Travis Hart sold weed and Adderall and Xanax, and despite his pretty face, a vein of rich-boy ruin was beginning to wend its way through his body—you could tell just by looking at him that he'd already had a DUI. He had the same bags under his eyes that my father had only just begun to develop after forty years of heavy smoking. He was, in a word, perfect. Not good and not kind, but perfect like the catchiest of earworms or the most metrically tight poem can be perfect; a two-hundred-page beach read of a person. Gift-wrapped and mailed to my doorstep, so tempting a package that all I could do was unwrap it.

Travis and I were in Spanish class together, though in that class we'd been assigned the names Guillermo and Fabiana. One day, we were assigned to be each other's partners in conversation.

GUILLERMO: *¿Cómo estás hoy?*
FABIANA: *Muy bien. ¿Y tú?*
GUILLERMO. *¿Eres virgen?*
FABIANA: What?
GUILLERMO: *V-i-r-g-i-n.*
FABIANA: . . . No.

And he smiled. Every time he smiled at me, all I could feel like was prey.

I wish I could say that this didn't work on me, that I told him exactly what he could do with his "Eres virgen," that I never spoke to him again. Hell, I wish I could reliably say that my response would be any less enthusiastic now, if some charming guy with beaucoup family money tried that shit on me. But I was shy, and aroused, and flattered that my virginity should be a point of interest for Travis. Then as now, an easy target for a perfect monster. Again, the package had been delivered preassembled to my doorstep. What could I do?

We began meeting after school to have dull sex wherever we could. Anyplace that provided five minutes' privacy was suitable. It wasn't that Travis didn't care about my pleasure, because I'll give him that: he cared; he knew vaguely what buttons to push. But we never had time to do it enjoyably and had to settle for doing it at all. Why this felt like a reasonable compromise was a question that we weren't mature enough to answer for each other.

More thrilling than the sex itself was the act of molding myself into a sex object for him, which was a pleasure that I could drag out all day, unlike our frantic scrabbling in closets and on vacant, overgrown lots. I could turn myself into a *perfect* sex object. I had someone to preen for now. My first boyfriend had possessed a disappointing attitude towards the artifices of makeup, lingerie, and sexy clothing—his ideal was a naked girl with a naked face, which was a consummate drag, denying me as it did the right to play dress-up. Travis, though, loved the costuming. He loved the paint. He loved me—that is, *if* he loved me—in disguise.

Finally free to pursue the trappings of what I believed to be adult sexuality, I took my beloved romcoms for inspiration, which means that I went way overboard. I shoplifted the scented lip glosses that looked the most like the frosted lip gloss on Rachael Leigh Cook's mouth in *Josie and the Pussycats*—frosted lip gloss was already on its way out of fashion, but it remained a powerful emblem of sexuality for me, even as my lips stuck tackily against Travis's anytime he kissed me. I bought halter tops and lowriding jeans from Charlotte Russe, thongs from Wet Seal. I saved up the

money I made at Starbucks until I was able to buy a matching push-up bra
and thong set, both of which were spangled with sequins in the shape of
stars.

Travis ate this shit up, and even if I never did fully forgive him (it's
only to cover my ass legally that I even gave him a pseudonym here, for
example), I still appreciate how gratifying his responses to my over-the-
top imitation of adult womanhood were. In fact, if my imitation of adult
womanhood was over-the-top, his analogous imitation of adult manhood
was pure cartoon. When I remember the expression on his face anytime I
"accidentally" bent over too far to allow him a glimpse of my lace under-
wear under my skirt, what it matches most closely is the eye-bulging, foot-
stamping horniness of a cartoon character seeing a sexy girl cartoon. And
really, isn't that what we were?

Though we were the same age, he was a grade below me, which I now
suspect was due to his constant trouble with the law and his father's wealth
and influence: cops were regularly called to the Hart house but could do
little more than slap young Travis on the wrist if they wanted to keep
their jobs. If he'd had less money, he wouldn't have been in school at all.
He would have landed in one of those draconian prisons that gets endless
oversight over its young charges and the name "alternative school." I prob-
ably wouldn't know that except that Travis was often consumed by anguish
over the trouble he caused—not so consumed that he ever stopped causing
trouble, even to this day, but consumed enough to grab at his hair and
groan into my lap about it for hours at a time.

"You don't understand," he groaned one day while I stroked his hair,
secretly thrilled to have Travis Hart sobbing in my arms. "I could lose the
right to my inheritance. You have no idea the things I've done. I'm a bad
person."

That was my cue, and I said automatically, "You're not a bad person."

Then he sat upright, his cheeks suddenly dry. Whenever he became
angry at me, his teeth clenched so hard that I could see the knot in his jaw.
I saw the knot often. "What would you know about it? You don't know

the fucking pressure I'm under. It's different when you don't have a family like mine."

That, I hadn't dreamed of arguing. It *was* different when I didn't have a family like his. My parents and I enjoyed a congenial, egalitarian relationship. They knew I was having sex and had provided me with birth control. They didn't mind as long as I stayed on top of my schoolwork. When a friend of mine became homeless, they offered her our home; she stayed with us for a month and no questions were ever asked. The only thing they wouldn't tolerate was drug use, due to their twin histories with drug addiction; that was the one very-special-episode issue on which they remained totally conservative. But in general, their policy was to shrug off my half-assed gestures towards teenage rebellion, stepping in only if I was truly in trouble. I'd never considered that this might be because we were peasants with nothing to lose, but Travis made a convincing argument. He was so blond and so rich, after all, and his worldliness had led me to trust him more than once. His family had holiday homes in multiple countries I'd never heard of. His credit card was as thick and heavy as a compact mirror. I mostly assumed that Travis knew what he was talking about.

So I reached out for him. I didn't care if he insulted my family, insinuated that we were less important and our problems less real. But as I reached out for him, I fixed my lips so that my cheekbones looked extra sharp; I arched my back and tilted my head, conscious of my neck fat. Truth be told, I was bored of his complaining. I wanted to go back to the comforting, closer and more intimate. I wanted to look the part of the supportive lover without having to do more than strictly aesthetic work at it. My only leverage in that relationship was what I felt was my irresistibility. And, indeed, he melted into my arms, his tongue beelining for my mouth.

Despite all the secretive rutting in dark corners, Travis assured me that he was always on the lookout for ways that we could spend "real" time together. Even I wasn't naive enough to believe that we were boyfriend and

girlfriend, but I *was* naive enough to believe that I could pull off a liberated adult woman's sexual detachment with a boy that I was fully in love with, and I believed that his stated desire to spend real time together was itself real—I didn't recognize it as a ploy to keep spending as much, shall we say, "unreal" time with me as I'd allow. After all, I told myself, if all he wanted was to fuck me, I would have let him just fuck me. He had no reason to lie! I look back on that logic and long to beat some sense into my kid self, especially because I see the ghost of that self-delusion in so many romantic self-delusions that have plagued me since then—that tragic mix of overconfidence and self-hatred.

We did spend "real" time together twice, and the first time was when he came over to watch *Josie and the Pussycats*. I was excited, not because I thought he would like the movie—I didn't—but because I thought he'd recognize me in it. I'd cut and dyed my hair Manic Panic red to resemble Rachael Leigh Cook's. I wore the same low-riding pants that are hallmarks of the movie's wardrobe to my assignations with Travis. I felt as if I were sharing porn with him, showing him what turned me on. I thought it'd be effective. I didn't yet realize the perils of sharing a cherished artwork with another person: the other person may not feel the feelings you do about it.

My favorite scene in *Josie and the Pussycats* is set to one of the titular band's songs, written for the movie—not "Three Small Words," but "Pretend to Be Nice," which is almost as good. It's a vividly colored montage that hops between frames from the band's debut music video and shots of them accelerating towards stardom, buying better clothes, being recognized on the street, wearing knee-length lapis-toned leopard-print cardigans, etc. (That's the way all the clothes in this movie have to be described, by the way. No article of clothing is just one thing. If pants are snakeskin, they are also neon green and metallic-hued. As a writer, I'm stuck with these clunky constructions that read like garbage and fail to capture any of the magic of the movie's aesthetics.)

Anyway, we were watching, Travis and I, and during the montage he just

turned the TV off. I looked at him. He was toothache-faced, obviously miserable.

"What's wrong?" I asked, horrified. I hadn't expected that he'd like the movie all that much, but neither did I expect it to traumatize him.

"This is the worst movie I've ever seen," he said.

And then there was the other day that we were able to spend "real" time together.

A priori: I realize, of course, that my generation's particular romantic comedies were not entirely to blame for the problems in my sexual development. The poison was in the water, so to speak—I could have spent my whole life avoiding romcoms and still ingested plenty of that poison, and walked away with plenty of fucked-up ideas about what my role was as a woman with a sex drive. However, the *Josie and the Pussycats* aesthetics—what I internally call frosted-lip-gloss aesthetics—did some damage. If I'm honest with myself, I don't think I ever did move on from the deeply ingrained idea that the whole dance of sexuality amounts to little more than smacking your lips and showing a strategic plain of skin until, voilà!, your bed has someone else in it. And I took that thinking into emotional territory where it deserved to be even less. Hence the pouting of my lips and arching of my back while Travis complained to me that I could never understand the problems he was saddled with because of his family's wealth; hence my chilling delight at having him come to me for comfort despite knowing that I was totally unable to comfort him. Again, he was a perfect boy, delivered straight to me with a minimum of fuss. I thought I could mold myself into something that was more perfect than it was good, too.

The evening of "real" time that I spent at Travis's house was the crowning sexual achievement of my life at that point, meaning that he fingered me until I came and then proceeded the same way as he did when we only had a closet and five minutes. And in fairness to him, that's still more than

some adult men can make themselves do for me. But what I remember more than the sex itself was the lying next to each other afterwards, with only our pinkies touching, nothing else.

"I love that you always do, like, lingerie and makeup and stuff," he said. Then, his tone suggesting that he was gearing up for the confession of a lifetime: "I guess that's kind of my thing."

"Mine, too," I said. I wasn't sure it was my thing—I knew I enjoyed doing it, but it wasn't sexual gratification that I chased when I smeared on a second coat of vanilla-scented lip gloss. I wanted to *be* gratifying, and had never given much thought to what it would take for me to be gratified. But then, those were our roles. I had fun playing dress-up, and he had fun fucking the dressed-up thing. At the time, I believed it, I really did. I'd enjoyed pulling on my mother's stockings in the mirror that evening more than I'd enjoyed the ten minutes of robotic fingering that had led to my orgasm.

We saw each other plenty after that, but it wasn't the same. I could feel that his tectonic plate had shifted without me on it. To this day, I don't know why, any more than I know why men stop texting me after they seem to have had a great time with me, any more than I understand why I do the same thing to other men in turn—we all just get sick of each other, and as teenagers we weren't emotionally equipped to have respectful conversations about it. All we could do was ditch each other. His ignoble disappearance didn't stop him from telling everybody a heavily exaggerated version of what had happened between us. Too late, I realized the reason that I always seemed to hear gossip about his sexual exploits: he was spreading it.

I had never minded being called a slut. It struck me as a toothless word—why should I be insulted by the correct idea that I was having sex? But the whispers that now followed me around school were different. The idea wasn't that I was a slut this time, but that I'd been stupid enough to let a boy fuck me under false pretenses. To hear him tell it, I'd been madly in love with him and he'd been smart enough to take advantage. It was true, or at least true-ish, but I thought it was awfully mean for him to

tell everyone else—not only mean, in fact, but *unsporting*. Because I knew things about him, too, things he wouldn't have wanted his pals to know, crying-in-my-lap things, and I wouldn't have dreamed of revealing them in the locker room.

Travis might have been the first man to punish me for his attraction to me in this way, but he wouldn't be the last. I've noticed, though, that men only seem inclined to do this during periods of especially public slutty behavior on my part. I've never been shy about sex, which means that a lot of people have always known more or less what I was up to in bed. And men have always found it confusing. Talking about sex is uncouth for men and women alike, but especially unbecoming in women, who are supposed to enjoy sex only behind closed doors and pretend it doesn't exist the rest of the time. And men are of two minds about it: they want to take me for a spin, but they also don't want me getting any cockier than they think I already am. Travis was only exhibiting a crude early version of this double-think. He liked the makeup and lingerie but did not want to be the sort of guy who liked girls who knew to wear makeup and lingerie for him. That would have been letting me win, somehow.

In school, Travis and I had never been best buds, but neither had he treated me with the cool indifference that now characterized his attitude towards me. When he and his friends saw me in the hallway now, they fell silent until we passed each other, and then broke into titters and whispers. I was heartbroken and mystified. I couldn't imagine what I'd done wrong. It was a normal enough breakup between teenagers, meaning that it was half-assed and cruel, except that it's taken this long for me to stop repeating my mistakes, that there have been shades of this one-sided dumping in every disrespectful boyfriend and "boyfriend" since Travis. Actually, who knows if I've actually stopped repeating my mistakes or if I'm just taking a long lap? I know myself and I can see myself in the bed of another Travis, easily.

So yes, I put together that it was over, which naturally made me chase him harder, certain that I could put the pieces back together if he'd just let

me talk to him again. He'd liked my, like, lingerie and makeup and stuff once! He'd like them again!

He never did like them again, at least not while we were still in school together and in each other's company every day. His desire to consume me as an erotic object had been dashed. He'd had, perhaps, a little too much; no longer was there anything for him to seduce, since he'd completed the seduction already. There was no more of me to wash over him. Our relationship had been founded on the shallowest of sexual aesthetics, and once he'd gobbled them all up, seen all the lingerie, smelled all the perfume and tasted it on my neck, there was simply nothing else there. Which is the danger of treating experiences as mere experiences, whether art or sex: sometimes, if you can't force a deeper meaning onto the thing, it means there simply isn't one available. A bad movie can be just bad. An unkind lover can be just unkind.

Perhaps the appeal of interpretation is that only through interpretation can a person learn something substantive from an otherwise radically emotional experience. We post-Puritan Americans are always suspicious of art unless we think it can teach us something substantive. (Otherwise, you see, art is just frippery, and artists mere charlatans.) An erotics of art forces us to confront art on lower ground. It forces us to allow art to growl and bare its teeth at us, without allowing us the space to defend ourselves. Worse, it forces us to confront the possibility that this or that artwork that we love so much isn't "actually" "saying" anything. It can just be a thing that we enjoy on the hazy merits that it is, well, enjoyable.

My adversarial relationship with interpretation hasn't told me that *Josie and the Pussycats* is good, any more than it ever told me that Travis was a good person. It's told me something truer and closer: *Josie and the Pussycats* is perfect. It was perfect then, full of earworms and chirpy voices and an utterly holey plot and pastel-colored animal print as far as the eye could see. And because it's never been friendly to interpretation, it remains per-

fect. Untainted, unpoisoned. The package in which it arrives is as trite and appealing as it was the first day it arrived.

And Travis?

Travis still drunk-texts me sometimes, more than a decade later. Can you imagine? He got sucked into a predictable rich ne'er-do-well's downward spiral around the time that I got married, a spiral that spat him into a cushy job with a six-figure salary (or, as he might put it, "just" a six-figure salary). I could go on. Friends of mine have kept up with him and say he's learned nothing. Most of his drunk texts are nonsense, but one was interesting.

I don't suppose you remember what you wore that night at my parents' old house, he'd said, with a winking, tongue-stuck-out emoji for good measure.

Well, that did it. I remembered the heartbreak of the way he'd ditched me after that night. He remembered the sticky lips, the push-up bra, and the miniskirt. And frankly, I was glad he remembered that over my desperation to win him back over. Let my childish peacocking be the beacon in his night, the pretty signal that things weren't always so pathetic for him, the memory of an effortlessly flat stomach and an ability to feed off my girlish vanity until he'd swallowed it all. The dangers of perfect lovers aside, I guess I'm still more at ease with the idea that I can be consumed than I am with the idea that I should be understood.

To that end, I responded to him. *How could I forget?* I texted back. And it's true, even if I mean it with less fondness than he does. How could I?

The Burial of Samantha Jones

One day when I was a sophomore in high school, I went to my friend Maddie's house after school for the usual Thursday afternoon joint and sexually charged TV-watching session. Usually, we nodded towards our shared inability to just make out already by picking a TV show that we could ignore, while we stuck our feet in each other's laps, tickled each other's armpits, and engaged in other behaviors of plausible deniability. If a jury of our peers had wandered into the room and seen us together, they couldn't have identified us as gay beyond any reasonable doubt, or so we thought. "Your honor, the TV is clearly on and tuned to the Home and Garden network," I imagine myself saying now. "Were we pillow-fighting and comparing breast sizes? Certainly, but is that not our right as heterosexuals, as we enjoy a little hard-earned after-school entertainment?"

In any event, on this day, Maddie had other ideas. "Have you ever seen *Sex and the City*?" she asked, rolling a joint. (I could not, and still can't, roll a joint to save my life—when people ask me why, I mask my embarrassment at my own ineptitude by laughing and explaining that there are always men around.)

"I've heard of it," I said, though I knew nothing about it. In fact, I thought it was porn, given that it had the word *sex* in the title where anyone could see it.

"It's about four women in New York who have a lot of sex. You'll like it."

In these years, I had something of a reputation because I'd had sex, barely. Maddie was still an everything-but girl, and therefore looked to me as a font of sexual advice. She'd once asked me why I'd done it, and I had

told her, somewhat accurately, that I'd done it because I wanted to so badly. Which was technically true, but more to the point, I'd been in a relationship with Mark Friedman, who had done it before; I didn't like the idea of what it would say about me if he didn't do it with me, too. By this point, that relationship was over, but I'd deliberately developed experience in all the "main" sex positions, as if hoping to pad my résumé. Still, despite my reputation, nobody else had tried to have sex with me, no matter how much I flirted (by which I mean, no matter how often I put on my very shortest skirt and walked around the mall in front of boys).

What could I do? I had a reputation to uphold as the sex-haver in the friend group that Maddie and I shared. I took the completed joint from her and said, "Let's watch it."

I will always remember that the first episode of *Sex and the City* I ever saw was the one about frenemies, when uptight Charlotte and libertine Samantha each get a taste of their own neuroses and realize how much they need each other. It's a strong Samantha episode, and from that day forward, after watching Samantha squeal in glee over Charlotte's sexual triumph with her new husband, I had a new identity.

Samantha Jones vamped and innuendo'd across the screen, seducing men with compulsive sexual vigor. Nearly every week, she had sex with someone new. She worked hard and played hard, à la a mid-'80s finance yuppie; she was libidinous to the point of satyriasis; she was loyal to her friends and impossible to pin down romantically. Strong-willed and straightforward, she butted heads sometimes with her friends, particularly Charlotte, though all three of her besties expressed the wish that she'd tone it down a bit once in a while. Overall, though, she was critical to the group's dynamic. She could always be counted on to recommend that her friends look out for themselves and stop inconveniencing themselves for some guy who probably had a little dick anyway. She told her friends that they were fabulous, often and loudly and so enthusiastically that there was nothing to do but believe it.

She completed an evolution that I'd been trying to tie off for a while. People already thought I was a slut, but she taught me that I could be proud of it. She taught me that I didn't need to waste my time preening for boys who might never drum up the courage to speak to me. *I* could claim *them*; I was in charge. I'd never realized that all I needed to do when I was sexually interested in somebody was tell them so. But Samantha made it look so simple. She had sex "like a man," in the show's parlance, which is to say that she enjoyed dozens of partners' company for casual encounters and then moved on from each one seamlessly. That was who I wanted to be. Powerful, forward, and fundamentally unrejectable.

Part of the reason I was so desperate for a Samantha figure was that, simply put, my breakup had left me lonely. I call it a breakup because even now, it stings to use the more honest term: I was dumped, unilaterally and unkindly. It's one of those memories that lives in anxiety-inducing color to this day. I couldn't tell you my mother's cell phone number if you paid me, but do I remember what I was wearing and where I was sitting and, God help me, the little-girl way that my ass hung off the edge of the school bus seat because I hadn't taken my backpack off my back before sitting down on the day Mark Friedman dumped me? Yes, okay? Yes, I do, and when the bellows of my lungs expels its last gasp and the last of the color drains from my face, I'd wager that'll be the memory that God fires off in my brain before pulling the plug on the whole stupid mechanism.

I'm uneasy writing this breakup scene, which tells me that I must. So I was hunched over in my seat, fifteen years old as all get-out, flicking through *The Great Gatsby*, when Mark slid in next to me. He and I shared one of those excruciating erotic connections that's only possible before teenage hormones have settled into adult sexual patterns; we made out chronically, at length and with no regard for the world around us; his smell, a pungent workman's odor of unwashed flannel and greasy hair, makes me wet to this day, anytime I chance to smell it. So Mark tumbled into the seat next to me, legs akimbo, all teenage-boy swagger and gan-

gliness, and I perked up because I believed that we would make out as usual.

Not so. He said, "I want to break up."

Had I seen it coming? Had the flavor of our shared saliva soured of late; had I noticed him paying an untoward quantity of attention to his tomboyish friend Doreen? Yes, but also no, because I *had* seen it coming and therefore I'd asked him approximately twice a day for the entire month whether he planned to dump me. I didn't mind, I assured him; I just wanted to know. (I would have minded, obviously, but even then I was hip to the little subterfuges one must conduct in the pursuit of that rarest treasure, the honest answer.) Naturally, though, he said no every time. What was he going to say? "Yes, I'm planning to dump you, but until then we might as well fuck a few more times"?

So, he dumped me. And my heart shorted out for a moment, but I kept calm, and asked, "Can I kiss you goodbye?" Very adult, very comme ci, comme ça.

"Oh . . . no. No, we're done." And this is what kills me: we'd taken the same bus every day for the whole time that we'd attended the same school, but he *disembarked the bus*, and trotted off to do who knows what. Sure, he'd been unhappy, but did the breakup need to be effective immediately? Couldn't we let the air out of the relationship with a round of post-breakup making out on the way home? (Incidentally, Mark has since apologized for all this in a way that heavily suggests the presence of a twelve-step program in his life, which, mazel tov, I guess.)

I still had *The Great Gatsby* in my hands, and I remember thinking: *Drop the book dramatically to the floor.* So I let it tumble from my grip, believing that the desperation of this "involuntary" action would draw attention to me, which it didn't. And then I burst into tears, which *did* draw attention to me or, more specifically, whispers. Everybody knew that Mark and I had been having sex, which wasn't unheard of for a pair of fifteen-year-olds at our school, but was still unusual enough to put me on the social radar

now that I was crying over him. People's whispers were neither kind nor sympathetic. Whatever they said, they were really saying, *I told you she was a slut, I told you she was a slut.*

Fast-forward to that day on Maddie's couch, and I realized that an alternate path was available to me. I didn't need a boyfriend just for sex. Sex was all around me! It lived in every single person in the world, and could be wrangled with sitcommishly little effort. All Samantha had to do was cock an eyebrow the right way in a crowded bar and she'd be getting dicked down in the very next scene. I was a realistic little slut, and knew that I'd have to expend more effort than that, but in reality it was not a lot more effort. Men, I realized, liked me. And then I was upset, because who knows how long they'd liked me in the ten months that I'd wasted on Mark, who I wasn't going to marry after all. I had a lot of lost slutty time to make up for.

When I adopted this attitude that day, I didn't yet realize that one thing was missing from the show's vision of Samantha's sexuality. In order for the Samantha Jones lifestyle to be fun, the men I incorporated into its pursuit would have to care whether it was fun for me, too.

Vincent was thirty-four to my twenty. I picked him up at a show that I attended with a former high school teacher of mine. This might have been an alarming relationship for any other teacher-student combination, but I'd attended a high school for D.C.'s finest wealthy burnouts, where the teachers were the least of the troubled students' problems—it wasn't uncommon for him and me to meet at shows even before I turned eighteen.

The show ran late and I missed the last train home, and the teacher introduced me to his friend Vincent, who offered to give me a ride. He was so tall his pants didn't reach his ankles, which charmed me, as did his shock of red hair and the fact that he looked so much older than he was. There was something of the shabby, penniless royal to him; I could imagine that patrician face and those threadbare clothes fleeing from a siege somewhere.

He might have actually intended to give me a ride, but I launched into my Samantha shit as soon as we were in the car together. "Where am I taking you?" he asked.

"Your place," I said, clamping my hand to his thigh to make it extra obvious.

He studied me. "What are you, eighteen?"

"That's right," I said, even though it wasn't; I thought eighteen sounded hotter than twenty, though in retrospect I'm sure either would have been fine, and who knows, maybe seventeen or sixteen would have been acceptable, too.

At twenty, I was still checking off the occasional box, but was in what I believed to be my elder statesman phase, sex-wise. I'd entertained cocks in all three holes, from multiple people at once, from multiple people in the same day; I'd attended sex parties; I'd learned how to tie myself into a rope harness (rope bored me but was so tuned into the eroto-aesthetic sensibilities of the older men I liked that I felt I had no choice). I liked to casually reference one or two of these things when dealing with a man so that he could respond to me with the appropriate level of awe. I didn't think I would check off any boxes with Vincent; I thought he'd be purely recreational.

However, when he got me home, he had a lesson plan for me. "I'm going to teach you how to suck cock," he told me. "How to *really* suck cock."

After several minutes of profoundly unpleasant practice, I was able to hold the whole thing down the column of my throat for a few seconds at a time before gagging, which pleased him. By now, I'd learned many times over that not every sex act would feel good for me. Indeed, many men only seemed satisfied if I was in pain. When Vincent's face-fucking overwhelmed me, as it kept doing after I'd tolerated it for a few seconds, I tried to take control and bring the blow job back to a plane where I felt more comfortable. He never let me. But I figured that was okay. The discomfort

of the physical pain was nothing compared to the psychological torment I would have felt if I'd suspected he found me sexually unsatisfying.

My torso soaked in my own spit, I checked off another box in my head: deep-throating. He hadn't laid a finger on me yet, but surely that had to be coming after all I'd done for him. Surely it would be my turn soon. In the meantime, I'd learned a transferrable skill.

For the record, it wasn't my turn soon. I still hadn't put this together at twenty, but it was rarely my turn with these men.

"So hang on . . . you met this guy where?"

I was back on Maddie's couch, another joint, two more cans of Nestea, theoretically there to study for our eleventh grade exams but really hoping for another afternoon of *Sex and the City* and deconstructing my latest conquest from the world of strange men, still several men before Vincent. To that end, I was crowing about the guy in question, but she wasn't chiming in with the same ribald excitement that she'd done during previous iterations of this conversation; suddenly, she had questions, concerns. I was eager to paper over those concerns so that I could collect my encouragement.

"At the Wavves show."

"I wanted to go to that show," she said. "I thought it was twenty-one and up."

I explained that it was, but the guy working the door at the venue was a friend of mine. "Well, not a friend, exactly . . ."

"Okay," she said. "Got it. So he picked you up at the Rock & Roll Hotel."

"No, *I* picked *him* up at the Rock & Roll Hotel," I corrected her. Why wasn't this any fun this time? "His place was hilarious, dude. He had a motorcycle sitting on a bedsheet in the living room. The whole place was, like, motor-oil smell and shit."

"So you left?"

"No, I mean, I was already there. He was cute. So."

At this point, we'd had many variants on this conversation. We switched up storyteller-audience roles as needed, sharing data, tips for accommodating unusually large penises and then-unfamiliar fetishes, looking at the MySpace and Facebook profiles of the men we seduced and kvelling over their cuteness. And we stubbornly refused to acknowledge the flirtatious timbre of our giggles, the way I suddenly grabbed Maddie's arm or touched her thigh to emphasize a point after a few tokes. Before, our plausible heterosexuality had existed on the level of assumption alone: we could be two girls getting awfully cozy with one another, but people mostly didn't have a second thought about it. But now, we'd pegged that assumed heterosexuality to actual, real-world sex with men. We were two girls watching *Sex and the City* and talking at great, crass length about fucking men; what could have been straighter than that?

But something was off this time as Maddie licked the joint to seal it shut and handed it to me. "I'm glad you had fun," she finally said, in the tone of a mom who simply can't listen to one more fucking long-winded story about her kid's summer at sleepaway camp. And in a way, that's what I'd become: a long-winded, braggadocious kid, adopting the strangenesses of the men she fucked as her own. I lit the joint, wondering if Maddie was jealous, if she was jealous of me or of the men who were fucking me, if she felt left in the dust, if she was just bored of having this conversation with me. We smoked in silence for a few minutes.

She must have picked up on my woundedness because she went to the PC on the other side of the room and pulled up MySpace. "Come on," she said. "I wanna see the motorcycle. And then I wanna get caught up on *Sex and the City*."

I'm perfectly comfortable sharing my "body count" except for one problem: I no longer know what it is. For a while, I tracked my sex partners by means of a password-protected Microsoft Word document that listed each person's name and, ugh, score out of 10 (I know, I know). I stopped doing

this around partner #100, which was . . . seven years ago, eight? I don't remember who it was, only that it's been at least a hundred more partners since then, likely more.

What I can do is trace a couple zigzagging lines along the timeline of my sexual development, identify patterns, delineate eras. First came the Indiscriminate Era, full of mindless box-checking, back when I was an eager neophyte chasing experiences I hadn't had before. This was around the time I got a job at Starbucks, which put my horny behavior in the general public's eye where it could do unimaginable damage. I flirted so hard that my manager kept putting me on dish duty just to keep me out of sight, but it didn't stop me from collecting scores of phone numbers. I fucked lots of people solely because they were hot, sure, but also for several less coherent reasons, like "has a tongue ring" or "rides a motorcycle"— little not-quite-fetishes that I'd realize years later had been picked up from throwaway lines of dialogue on, you guessed it, *Sex and the City*.

Then there were the Early College Years, when I'd left home and was drunk on my own ability to have *anyone* over at *any* time without, e.g., waking my mother. My friends and I competed without admitting that we were competing over who could be the loudest, the most prolific, over who conducted herself with the most sexual abandon. Conversations about sex were less conversations than preening attestations to our lovers' incomparable skill and attentiveness. For some reason, we believed that whichever one of us bagged the best sex partner had won. One day in my freshman year of college, my friend Angie tossed a fifty-pack of condoms at me in the Family Planning aisle of our CVS. "Hey, Rax," she said, grinning. "I'll race ya." These were the sorts of games we played, games of deliberate and quantifiable excess, and who even cares who won? (I did, for the record, but of course it's all lost to the goldfish memory of time now; but yes, I did win, just so you know.)

And, of course, who could forget the Kink Era? Of all the epochs that comprise the history of my sexual follies, the Kink Era is the easiest

to put hard dates on: I made a FetLife account in my sophomore year of college, the week after being dumped by a guy who had mentioned his own account in passing. I figured he'd see me around and message me to ask how I'd been, and we'd fall back in love, etc. Many of FetLife's most visible users pretended that FetLife wasn't a sex website, calling it instead a social networking tool for kink-loving individuals. Perhaps they believed that this legitimized their communities more than would have been possible for communities that willingly admitted to being centered around sex. Still, from the first moment that I uploaded a photo of myself decked out in the Victoria's Secret clearance section's finest, I was inundated with messages from men, some friendly, some obscene. One of the friendly men invited me to a party in Baltimore, and thus began my Kink Era in earnest.

The members of these communities crowed about *enthusiastic consent* and *boundary-setting* and *communication*. Because these words were being bandied about by paternal, kind-seeming older men, I believed in their integrity and launched into the activities offered by my local kink community, imagining how proud Samantha would be of me. Here, I thought, was a place that I could check off boxes with abandon. I'd find partners who wanted to talk to me about what I wanted. I had a laboratory in which to experiment comfortably. It helped, too, that men fawned over me, the curves of my body in its tacky lingerie, the mewling noises I made when a paddle chanced to whack me on the ass. I was hardly the first *extremely* young woman to become *extremely* popular with a range of adult men at a kink event.

I met lots of people and had lots of sex, this time with accessories (rope! floggers! fetish wear!). But all the community fanfare about *enthusiastic consent* notwithstanding, I didn't find this sex to be meaningfully more enjoyable than the sex I'd been having before. More labor-intensive, yes. More expensive, certainly—all those butt plugs and thigh-highs didn't come cheap. But were these partners any more dialed in to what I wanted from them? No, not usually, despite all the *communication*. It seemed that the

communication they hoped to hear from me was Harder, Meaner, Don't Stop, More Rope. When I sought to communicate instead that I wanted them to Slow Down or Stop Mashing My Clit, it was a different story: they didn't love communication so much anymore.

Little of *Sex and the City*'s onscreen real estate was given over to such matters as *boundary-setting*, and when the writing addressed *communication*, it was mostly in the context of some man who wasn't doing it adequately—the girls were not available to answer my questions about how *I* should communicate what I needed during sex in such a seductive way as to actually encourage a man to do it. But one episode does come close. When Carrie is having bad sex with her latest crush Jack Berger, Samantha takes her lingerie shopping and lays down the law. "If the sex isn't great," she explains, "it doesn't help to say it's not great. That's usually a downer, and by that I mean . . ." And she imitates a drooping penis with her finger.

This advice is, of course, ridiculous, and Carrie ultimately ignores it. She and Berger mutually acknowledge that their sex has been bad, and then . . . it's fixed! It's an early-relationship miracle! So however unhelpful Samantha's advice was, seeing the onscreen solution to it was worse, another example of the letdown that *Sex and the City* inflicted on me time and again. Carrie has great sex! How? The bare minimum of communication! And then what? Great sex!

The genius of *Sex and the City* was that it could present me with four women solving problems in totally opaque ways, but because those women's internal landscapes were so realistic and relatable, I believed that I was the one doing something wrong when I failed to learn from them. The show was an unusable holy text. It refused to deal in anything as clear as fables or lessons. It assumed, perhaps, that it was nobody's instructional manual.

When I was nineteen, Kim and Barry messaged me on FetLife. Until I saw their message, it hadn't occurred to me to try a threesome. I wasn't repulsed by the idea, exactly; it was more that I believed threesomes occupied a simi-

lar space as, say, the music of Phish or the recreational use of Xanax. Go forth and enjoy it, I thought, if you're into that sort of thing.

But Kim and Barry were stunningly beautiful and so I reconsidered. I agreed to meet them at a party they were attending that evening, with the understanding that I'd go home with them afterwards. They were beautiful in person, too, though Kim was a foot taller than me and Barry a foot and a half taller. Normally, I enjoyed playing up my smallness for a tall partner, but two tall partners was a different story—when we walked together, they looked like two giants taking a human toddler for a stroll.

This wasn't a good enough reason to reject them, so I went home with them, as agreed. They both proceeded to do lots of things that they believed would make me feel good, things with mouths and fingers and pricey-looking toys, all in a mechanical order, as if giving me an orgasm was in the same class of actions as beating a video game. I had no reason to be bored. They'd clearly studied, just as I had. But at the end of the day, neither of them had that smell that made me growl and pulse; they didn't taste any particular way to me; the chemistry was incurably off. I faked my orgasm, believing that they'd earned at least an A for effort.

But annoyingly, the faking of the orgasm wasn't the guaranteed end-it-faster ploy that it was with only one person. Normally, I could cue my performance in such a way that it hastened the real orgasm of my partner. But with two partners, my rhythm wasn't so practiced. Sex continued after my "orgasm" as if nothing had happened, and I was left feeling dumb, like, great, it's business as usual *and* now they think that this is what makes me come. (The latter point was relevant because I'd already decided to sleep with them again. I'd gotten good at fucking one person, and Kim and Barry were my opportunity to do the same, but with two.)

It infuriated me that they bored me sexually, primarily because it wasn't their fault—they really were like statues of Greek deities, physically. And they were great fun, too, and knew all the hottest people and the best parties, and I'm sorry to say that they genuinely cared about me, even if

it rarely translated into decent sex. Fortunately, I'd given myself an Ivy League education in the art of sucking it up during sex. I endured the odd hour of tiresome orgasm hide-and-seek, and attended all those parties and kissed all those hotties, and kept dating Kim and Barry on and off until I married my husband at twenty-one. I prayed often to St. Samantha and studied her scriptures. The book of blow jobs. The book of anilingus. The book of sucking it up during a threesome that you'd rather not have.

Samantha Jones doesn't just love sex, of course. She's a creature driven by all sorts of appetites. She loves fashion, but not in the fangirl manner of her best friend, Carrie Bradshaw. Instead, Samantha's dual-pronged love of fashion targets it from two different angles: One, clothes are a powerful attention-grabber, and indeed her wardrobe throughout the show's run is all vivid colors, daring cuts, statement jewelry. And, two, haute couture is a status symbol. Samantha treats an old friend's funeral like a fashion show, gawking at the outfits and seeming genuinely surprised at her friends' disapproval; she obliterates a relationship with an important client in order to jump the line for a Birkin bag. In both cases, the message is clear. Samantha's unrestrained appetites put her at odds with others, and yet those appetites never diminish during the show's run.

I picked up on this, in the incomplete and optimistic manner of any child emulating an idol. I couldn't afford even one Jimmy Choo shoe on my Starbucks wages, of course, but I was able to cobble together some bootleg Samantha Jones outfits from the sale section at Forever 21. I refused to absorb any of the criticisms that *Sex and the City*'s shameless consumerism made it into basically one long ad for Fashion Week. Such criticism missed the point. If *Sex and the City* was one long ad for anything, it was the hedonism of refusing responsibilities greater than the right-fucking-now: this man, this night, this bar tab, this credit card debt to buy these shoes, all problems that could be solved some other time.

Criticism of *Sex and the City*'s flatness and whiteness hit closer to home. Occasionally, one of the girls will give in to the PC pressures of the world and date a nonwhite person. It happens three notable times in the show's entire run: one episode when Samantha dates Chivon Williams, a Black producer; a three-episode arc during which Samantha dates Brazilian artist Maria Diega Reyes; and an entire season when Miranda dates the Black Dr. Robert Leeds before ditching him for Steve. The show can't resist fetishizing the races of all three people in predictable ways, sighing over the preternatural sexual prowess of the two Black men and making a joke out of the Brazilian woman's fiery temper.

I didn't spot this in a complete, intelligent way when I was first watching *Sex and the City*. I did notice, though, that these women had a type, and that it had nothing in common with my own. They liked big balding foreheads, thin lips, big teeth—that WASP look. Occasionally, the show would bless us with a plotline in which one of the women decided to date a younger man, and we'd get a hottie. But at sixteen, I was not equipped to confront, for just one example, the attractiveness of Chris Noth's Mr. Big. Even now, when I can see with an adult's eyes how handsome he is, I'm a little pissed off that he was supposed to be the alpha and the omega, the emblematic sex interest of Carrie's life and therefore of the show's universe.

Such disparities between my world and the City of *Sex and the City* made my baby slut's apprenticeship difficult. My takeaway wasn't that it takes all kinds; it was that I needed to model my taste after the girls', which led, predictably, to missteps upon missteps. Several middle-aged men who definitely don't care about *Sex and the City* owe it more than they realize, because they wouldn't have had a chance in hell at seeing me naked without it. I chased big foreheads and thin lips for years, imagining myself at brunch with Samantha the next day, giving her my field report. My head slamming into some junior attorney's headboard, I'd imagine her pouring me a mimosa and grinning her fiendish grin. "So, honey," she'd say. "How *was* it?"

Well, it was mostly pretty bad, but that didn't seem worth worrying about. Bad sex, to me, was almost as important as good sex—it was all sex; it all boosted my numbers and experience and got me closer to the good sex that I thought would come after years of fumbling hideously in the dark. And it's still true that I'm glad to have practiced and learned what makes me feel good. I couldn't have gotten there without having a certain amount of boorish sex inflicted on me. Still, did I need to chase boorish sex in such great quantities?

I met Luis at twenty while I was on uppers and him, downers. He played bass in a band that I loved, and we made blitzed eye contact during their set. When the set was over, he sought me out. "I have to show you something backstage," he said, sounding amused by the lameness of his own come-on. It didn't matter. I was on board.

We made out backstage, and outside, and back in the venue, and in the bar of the venue, and chattered, too, laughed and play-shoved each other, trying to learn every single thing about each other in the three hours we had before his band had to hit the road. Our pants were miserably tight. I lived with my mother; I had nowhere to take him. Samantha Jones never suffered such indignity, I thought. We were so smitten with each other that night, despite the way that everyone around us rolled their eyes and tried to tune out our druggy nattering. I figured that it would work itself out.

Finally, Luis said, "I should fly you out to Austin."

"Sure," I said, assuming it was a joke.

"I'm serious. I'll roast you a duck. Mushroom risotto. Pills, beautiful weather, especially in the autumn. And I'll fuck you so hard you'll never walk again."

Eight years later, I saw Luis again. He'd gotten sober and looked beautiful; the deep lines that had crisscrossed his face when we'd met had smoothed themselves over, even though he was older. He guest-listed me for his band's show and hugged me like an old friend, long and close. We

talked all evening, as full of each other as we'd been the night that we'd met, albeit in a more subdued way. I was sleepy, he was sober, there was little danger of his bending me over a dumpster and spanking my ass black and blue like he'd done eight years before.

"Remember that trip you took to Austin?" he asked in a twinkly way. Flirting, but not.

"How could I forget?" I said.

"A lot of women I fucked, I don't remember anything about it," he said. "The drinking, you know. But I never could forget you."

"Thanks, man," I said, clapping him on the shoulder, and we both laughed at the ridiculousness of it all. We spoke like war buddies remembering our time in Desert Storm. The years had worked traumas on us both. But in truth, it was the most meaningful thing he could say to a lifelong Samantha. Fucking me was memorable; it was scar tissue in his memory that would never heal. That I only remembered the Austin trip in dim hazes was irrelevant. I still loved Luis, in my way, and he still loved me; he remembered every detail of me, for me, because I'd lost so many of them myself.

I devoured all six seasons of *Sex and the City* and both movies, even the dreadful second movie. I cherished all four women, but I loved Samantha most of all and studied her closely. I loved the story line in which Samantha is seduced by, and then falls for, rich playboy Richard Wright, only to be cheated on. I especially loved the revival of that story line, when Samantha is in a healthier relationship but has regrettable, humiliating sex with Richard anyway. These experiences of hers were the truest to my own experiences living the Samantha Jones life.

That story line notwithstanding, though, Samantha enjoyed a pretty carefree life for the first few seasons of *Sex and the City*. No, the men didn't care about her, but neither did she care about them. I kept getting stuck on that first part, though. My various practice guys didn't care about me, and

yet I kept wanting to see them again, despite my education at Samantha's altar. What was I doing wrong?

It wasn't until I had enjoyable sex for the first time that I realized what I'd been doing wrong. Regrettably, this enjoyable sex didn't happen until about fifteen partners in. The guy treated my body with the utmost respect, checked in with it at every stage, moved slowly and paid attention to what was working. I hadn't realized that sex didn't need to leave me feeling thwarted and underfed. When he left, I knew I'd never see him again, but it was fine this time—I'd gotten, for the first time ever, what I'd come for, and now I knew that it was what I had come for. I was satiated and content. My ability to wield power during a casual encounter didn't need to end at the moment my clothes came off. It could remain in effect the *entire time*. All my partner needed to do was care.

I wish I could say that the bad casual sex stopped right then, that I walked away from that encounter with a fully formed ability to demand what I wanted, that nobody ever overstepped my boundaries or ignored my body's signals again. I can't, and that isn't Samantha's fault, exactly, but I do blame somewhat her ability to exist, uncriticized, as the precise character she was. What did she want? Sex! How did she make it good for herself? She just did! I lost a lot of sexual ground to the show's refusal to answer that second question in more detail than the occasional winking "I like a big dick and when men can find my clit." We never saw any conversations between Samantha and one of her partners during which she told him that something was unpleasant and he stopped, and then switched to something she preferred. How I would have loved to see such a thing!

My hard-won familiarity with my body and its preferences developed by virtue of a ten-year trial-and-error process, and I am now comfortably on the other side of it, able to make most sex good for myself even with a partner whose body doesn't jibe with mine. Some partners are better than others, but my enjoyment is no longer dependent on their whims—if someone wants to be a selfish partner, I can usually turn it around so that

it's not a total loss for me. Is this what Samantha was doing the entire time? Engaging in sexual tug-of-war with a ceaseless parade of men who'd never learned how to make anybody but themselves come?

I return to the story line that comes the closest to showing a downside to Samantha's sexual instincts, when she's dating a young man who adores her but cheats on him with Richard, her cad of an ex-boyfriend. The reason she gives, inasmuch as she gives a reason, is that the young boyfriend isn't practiced enough, doesn't have any moves, doesn't operate with the charisma and ease that Richard oozes in spades. And yet when she's having sex with Richard, she's miserable, realizing what a shallow choice she's made even as Richard keeps drilling her and monologuing about what a rough few months he's had. Richard may have charisma and ease, but, crucially, he doesn't care about her pleasure, at least not then. He just cares about a hole and whether she has one.

It's easy to describe this situation and sound judgmental. I've heard variants on the argument for years: they just want to get laid, they don't care about you, you will never hear from them again. And on the one hand, it shouldn't matter, should it? If a man wants to get laid, and I want to get laid, and we have sex, that should be a slam dunk! If a man doesn't care about me, and I don't care about him, great! If I never hear from him again but he equally never hears from me, what's the problem?

The problem, annoyingly, is that even when I don't care about a man, I still hope that he walks away from an encounter with me having had a good time, whereas men who don't care about me often don't care whether I've had a good time with them, either. This isn't universally true, but it's impossible to control for, and I simply cannot tell from a distance whether a man is going to put the same amount of work into casual sex that I do. It's like moving into a new apartment and only realizing what's wrong with it once you're in it. You can spot a broken window or holes in a wall from a quick once-over, but not a clog-prone toilet, noise, bad insulation—the truly problematic stuff hides until it doesn't.

Surely a woman who fucked around as prolifically as Samantha Jones had plenty of dreadful sex stories—not just the cutesy B-plots when she dated men with gross-tasting come or an unsettling desire for sexy baby talk, but issues that indicated greater structural problems in the relationships she was pursuing. I've had great sex with men whose come could've used some sweetening, is what I'm saying, and that's not the sort of sex problem that a show of *Sex and the City*'s credentials should have been saddling its most sexually fluent character with. It never shied away from the real stuff, so why was it shy about this? Why didn't Samantha ever seem to have bad sex that wasn't bad for a jokey reason, sex with a man who staunchly refused to even try to make her come, something?

Such sex may have gone against one of the show's core commandments: thou shalt not suggest that casual sex is anything but perfectly liberatory for the women who have it. And that's fair enough, I suppose. To rewatch the show is to soak oneself in a peculiarly pre-third-wave-feminism conservatism for which I'm sure that edict was a welcome antidote. The four central characters aren't prudish by any stretch, even Charlotte, who was written as more romantic and traditional than the other three. But they do skew uncomfortable with practices like anal sex and threesomes. "Extras," in other words, are barely on the menu, even if penetrative heterosexual sex is no longer a huge deal. P-in-V is the final frontier for them, lots of it, deconstructed in painstaking detail the following day at brunch.

"Arch your back . . . a little more . . . good, now open your knees a bit . . . perfect, that's perfect! Stay just like that!"

My back all but spasming, my legs quaking in agony, I gamely hold the position into which I've been choreographed while my partner does what he has to do. A mirror is in front of me, so I can't make the pained faces that every neuron in my body is urging me to make. Instead, I maintain the classic fuck-me-like-a-dirty-slut expression that I learned from Samantha Jones: lips open, somewhere between a pant and a sneer; eyelids heavy;

periodic shifts into a pantomime of pure ecstasy. It doesn't matter if I come or not, as long as I look as if I'm credibly on the verge of it for a few moments here and there.

Who is my partner? Does it matter? He's any man who caught my fancy between 2007 and the present day. He's the married English professor who jerked his ring hand away in terror of getting caught when I dragged it between my legs at a student bar near his campus; or he's the bartender I can't even meet until four in the morning, when his shift is over, so I have to take a ten o'clock nap most nights; or he's the nurse who tends to my kidney infection in the emergency room and can't look me in the eye because he fucked me three months before. He's some hot palliative, drawn to me, maybe, but more likely drawn to the hint of ruin that twitches in my walk and wafts off my neck. My loneliness hasn't dissipated since Mark Friedman, even though he hasn't been its cause for over a decade. The more men I fuck, the more I realize that the loneliness lives in my marrow, that Mark's role was not to induce it but merely to awaken it. Some are able to stave it off for a while because they sincerely like me, at least before I turn on them. Most aren't, because they don't.

But back to the moment. The here and now. My partner, whoever he is, could be seconds from orgasm. He could be hideous minutes away. I won't know until I'm physically unable to hold this mannequin's pantomime of a hot slut and I'm forced to purr, "Get on your back, babe, I want to ride that cock."

What would happen if instead I said, "This is uncomfortable and I can't feel anything, so let's switch it up"? I'll tell you if I ever try it.

It didn't take long before my fascination with *Sex and the City* (and, too, my fascination with sex in my own city) had surpassed Maddie's, to the point that she was increasingly queasy in my company. She pulled away from me, and I tried not to be hurt by it. When she came back to me, it was because she'd begun having sex with Aaron Hazlitt, the drummer in

our high school's only band of note and a boy I'd been chasing for weeks. She wanted someone she knew she could gush to. I swallowed my jealousy, telling myself to do as Samantha would have done. I didn't relish the idea of honestly engaging my internal question of whether I was jealous of Maddie or of Aaron, so instead I poured her a glass of lemonade and said, in my best Samantha, "So, honey, tell me . . . how *is* it?" And I listened as she excitedly relayed the details of sex that sounded, frankly, pretty bad, even then, when I had so much less to compare it to than I have now. But I oohed and wow!'d at all the right moments and refrained from interrogating her about what her body was feeling—not what she'd done for him or what he liked about her tits, but what she'd felt.

Looking back, I can draw a line down the two phases of our friendship, the two sides of which are Before Samantha and After Samantha. Before Samantha, Maddie and I had been cozy, content to flirt without ever calling it flirting because we didn't think we had other options. But the more I absorbed Samantha, the more openly and clumsily I flirted with Maddie. I sat closer to her on the couch and refilled her lemonade for her and offered her shoulder rubs. It was tame stuff, but she wasn't there yet. When we eventually did have sex during my junior year of college, she admitted that she had been afraid I was trying to catch her out—my moves had been so ardent that they'd somehow abandoned the realm of flirtation and become sexual espionage.

We lay in bed together after that encounter, stunned by the anticlimax that was the sex we'd had after years of high school anxiety and flirtation. It was my first experience of a classic sexual lesson: the longer you spend fantasizing about a person, the more disappointing the immediate reality will be. In conversation, Maddie's and my chemistry was as potent as it had ever been. In bed, we fizzled. All those years of sexually charged dynamism had nowhere to go.

"I never actually did this with a girl before," she said after several minutes of quiet.

I wondered if we were still good enough friends that I could treat our unfortunate sex as a lighthearted joke, maybe apologize for what a letdown her first-ever sex with a woman had been. I decided we weren't.

"It's funny," she said. "Remember when we watched, like, all of *Sex and the City* back in the day? I think we even watched the whole thing twice. We could have been doing this the whole time."

"We could have," I said. "But then you would have been robbed of the years-long expectations buildup to the hangnail finger-blasting I just gave you."

She chuckled, and then laughed out loud, and then we were holding each other and cry-laughing, two fifteen-year-olds with a case of the giggles again, despite all the years and men that had passed, despite the fact that we were no longer kids but adult women with their legs wrapped around each other.

"I feel like you have to fuck me again, right? Like, that was so bad that we can't have that be the last time it happens."

"Oh, man," I said, and put a shy hand back on her leg before realizing there was no need to be shy anymore. "Twist my arm."

"I'm just thinking of your reputation, *Samantha*," she whispered as my fingers danced up her thigh. "You'll thank me later."

When critics revisit *Sex and the City*, they typically focus on Carrie, as did the show itself. She was the protagonist; her struggle to overcome her pathological insecurity long enough to settle into love was the central question that occupied the show. Given that so many of us could relate to Carrie's struggle, we remain invested in it, even though it's come to a close—Carrie has married Mr. Big, they've been together for years, they are together now. *Sex and the City* has ended and is therefore perfect in its conclusion. Never again will Mr. Big torment Carrie, withhold affection from her, or refuse to introduce her to his mother at church.

Samantha was a more dynamic character whose fate couldn't be tied up

so easily. Carrie might have been a narcissistic train wreck, stunning and seductive in her flailing, but things were always going to go one of two ways for her: one, happily ever after with Mr. Big; two, not. The particulars might have been less predictable, but those were her options and that was her arc. Samantha's story had no equally simple fork in the road. Especially after the end of her relationship with Smith, who was the only partner in her life that ever had staying power, the whole point of her was that she was a wild card. Samantha could have emigrated; she could have won the lottery and retired at fifty; she could have committed suicide. Throughout the show, her plots were always the best and her partners the most exciting because the show's writers knew they could throw anything at her and never lose the Samantha-ness that we knew and loved.

One thing was certain, though: there would be sex at the conclusion of Samantha's arc and, I'm sure, her life. Hot, loud, sweaty, breaking-the-tchotchkes-on-the-bedside-table sex. In Samantha's life, no force was more elemental. The writers said it time and again even though Samantha is rarely shown in the throes of sex acts more uncommon than the humble blow job. The main exception is when the show's writers have a funny bit about, say, BDSM that they need an avatar for. Who but Samantha would seduce her neighbor, only to see him arrested while she's got him handcuffed to her bed? Sure, this is mostly for the purpose of an easy C-plot and a cop uttering the zinger "Ma'am, can you undo your cuffs so we can use ours?" But the whole situation would have been impossible with Charlotte in Samantha's stead, and the writers knew it. Samantha might not have valued traditional womanhood, but she certainly had no issue with traditional fucking.

As a, shall we say, "extras-friendly" sex enthusiast in 2019, I admit that I find my former idol's behavior quaint now. Sure, she was a TV character, and each thirty-minute episode of *Sex and the City* only had enough time for so much of her dimensionality. Still, I think I can confidently say that I'm now having more enjoyable sex than my beloved fictional predecessor

was at my age, having put a great deal of work into it. She pointed my way towards a path that I have since made my own. And if I may borrow Samantha's own word, I bet she'd think that was fabulous. I bet she'd buy me a cosmo, hit me with that devilish grin, and say, "So, honey, tell me . . . how *is* it?"

Exactly as Much
Spinach-and-Cheese Dip

One night, I got into a car with a man named Richard who'd asked me on a date after an evening of exceptional sex. He must have believed that our extraordinary sexual conversation would translate with little fuss into an extraordinary interpersonal one; Lord knows I believed it. We'd planned to go to a fashionable local sushi place that we could have easily walked to, had he not wanted to show off his Lexus. There we would have been surrounded by the nervous chatter of other first dates. It would have been, ugh, cute.

At the last second, though, my date changed course. "We're going somewhere else. I don't feel like sushi," he told me as soon as my seat belt was fastened, and pulled out of the driveway that abutted my dorm building. Whether he'd intended it or not, his message was: *You're my captive now.* This was in the days before Uber and Lyft, and anyway I didn't have a dime with which to employ either service, had they existed. I was his for the taking.

Richard was much older than I was. I don't remember exactly how much older, but I know that he was the junior counsel on a case with my father as lead counsel, and I know that my father liked to torment him at work just for fun—the usual workplace stuff, pranks, offensive nicknames that I can't reveal without inadvertently outing my subject (but let's say it was something exactly as mean as, I don't know, Rot-Dick). To this day, I try not to think too much about whether my father's constant workplace japery was the reason that Richard wanted to fuck his daughter; I prefer to believe that it was my winning personality, or even my tits. Something pertaining to my own merit. On my end, I liked that Richard seemed confident and capable in my company, so unlike the guys my own age who could barely

string two words together in the presence of an attractive woman. And I liked that he lived alone, and not in a dorm.

Anyway, he peeled off campus, out of the downtown tourists' district on the confusing cobblestone streets that eventually led the patient driver to the highway. Needless, perhaps, to say, but I had no car of my own, and had suggested the sushi house precisely because I could have walked home from it, had the date been unsatisfactory. (I was nothing if not practical.) As we passed the landmarks I knew, then the landmarks I didn't, I mentally calculated how long it would take me to walk home from each unfamiliar strip mall that we passed. Thirty minutes. Forty. An hour.

I'd gotten into countless cars with countless boys at that point, and while I knew all the old tropes about stranger danger and serial killers luring innocent women into vans, I was still young enough to believe that I was immune to such cruelties. After all, no man who'd invited me into his car had hurt me yet, unless you count the guy who hot-boxed his Kia Sorento and then said, "Don't worry, I actually drive better when I'm stoned," just before sideswiping a parked car on the passenger's side.

I'd been hurt by men the entire time I'd been sleeping with them, of course, but the Kia Sorento guy's approach tended to rule the day; they wounded my spirit out of stupidity, not a desire to do evil. But Richard seemed different in these moments. He was increasingly quiet, and his face had an anxious set to it that I didn't like. The longer he drove, and the more time that passed without him bothering to maintain a line of small talk, the more uneasy I became. This, surely, was my punishment for being an arrogant slut all these years: I'd finally gotten into the car of the man who was going to murder me.

At length (worrisome, because at length in a car meant impossible on foot), we pulled into a strip mall identical to all the ones we'd just passed, save for one thing: a Cheesecake Factory lit up like Christmas Eve, anchoring the strip's less fearsomely lit businesses with magnanimous gravity. He asked, "Is this ridiculous? Am I ridiculous for taking you here?"

"Taking me where?" I asked, eyeing a rotisserie chicken spot a few doors down with an infomercial blasting on its hulking TV. But he pointed instead to the glowing Cheesecake Factory, and powered down his engine.

I wouldn't have thought it was ridiculous except that he seemed so certain that it was. I realized with disbelief that this was the source of his serial-killerish vibes in the car: he'd been nervous to bring me here. Me, I'd grown up in the Cheesecake Factory. It was my special-occasion spot, perfect for unobtrusively celebrating a birthday or bat mitzvah: noisy and anonymous enough to encourage party behavior, ornately decorated enough to feel special, and casual enough that nobody worried about fitting in there. Its founders had achieved a brilliant thing. The Cheesecake Factory straddled an impossible border between casual and fancy. Its servers wore crisp white shirts with black ties and slacks, and would not have looked out of place at fine steak houses or wine bars, but its menus were full of cringe-inducing names that stuck in the throat and emphasized the dishes' corporate origins, names like SkinnyLicious and Low-Licious (the Cheesecake Factory has always been big on the -licious). Regardless, Cheesecake Factories were all romantically lit, sit-down restaurants, which made them perfect for special occasions. Was the food good? Did it matter? Everything else was good, or at least fine.

The design principle of the place is courtesy of the Cheesecake Factory's founder, David Overton, who refers to his distinctive blending of casual and ornate as stemming from the "palate of the common man." As far as he's concerned, the common man loves fall-of-Rome opulence, *Penthouse* porno lighting, and heaping plates of unpredictable food—not unpredictable as in adventurous, but unpredictable as in these menus are biblically long and seem to contain absolutely everything. Moreover, he's right. The Cheesecake Factory remains successful because it's fancy enough to seem classy, but silly enough to seem comfortably trashy.

Overton's taste may be the linchpin to the Factory's success, but his mother Evelyn's cheesecake is the originator of the empire. Her story is

impressive—found a cheesecake recipe in the newspaper, futzed with it, turned that successful futzing into twenty-five years of selling cheesecakes out of her basement in Detroit. Eventually, Overton imported his parents to California, where the Cheesecake Factory dynasty began in earnest (and where the cheesecake itself was eventually deemphasized, since nobody could ever remember to save room for it when facing down their massive entrees). The restaurant was popular with Beverly Hills's rich and beautiful people and even gets a name-check in Kris Jenner's vanity song "I Love My Friends," cited in the middle of a list of activities and places that Jenner (then Kardashian) and the eponymous Friends love. But unlike other restaurants in its orbit, like Spago Beverly Hills, the Cheesecake Factory wasn't expressly *for* rich people. Its food could seem high-end without breaking the bank, or testing the palate. And the flip side of that was that a meal at the Cheesecake Factory could also seem casual without crossing the line into déclassé.

Plus, they served that brown bread, one of the emblematic pleasures of this world. It came in a baguette-shaped loaf, carved into slices; its surface was dotted with oats and it was invariably served warm, as all bread should be everywhere. Hard to explain the taste of that bread, though I've been chasing it for years in my own kitchen, testing out imitator recipes that contain cocoa, molasses, honey, coffee. What it tastes like, perfectly, Platonically, is the color brown. Slather it in butter and you can't beat it, and at our frequent Cheesecake Factory dates, my mother and I would do just that, putting away a basket or two before our massive entrees because the Cheesecake Factory is nothing if it's not excess.

My mother and I initially favored the Cheesecake Factory for the same reason that everyone at the surrounding tables seemed to: it was there, and it was pretty good. Our Cheesecake Factory lived in the same shopping mall as an equally popular California Pizza Kitchen, where we were also regulars, but CPK was no special occasion spot. California Pizza Kitchen was

fundamentally comfortable in our town, in our decade. The Cheesecake Factory could have been beamed into our shopping mall from a different planet. Its entrance cast haughty shadows over its entire corner of the mall, as if it were the opening to an ancient underground city that had somehow been excavated from the neighboring JCPenney. My mother and I were powerless to resist its neoclassical pull, just as its owner intended us to be.

We developed a routine sometime in my middle school years and fine-tuned it in the years leading up to my graduation from high school. She drove us both to the mall, where we accomplished whatever tasks needed accomplishing (the purchasing of new shoes, back-to-school jeans, whatever). Then we split up for an hour—"a *real* hour," she reminded me every time, ever since the day I blew our regrouping time by forty-five minutes because I believed I was truly developing a connection with the cashier at the Orange Julius every time I smiled at him, "not a Rax hour." She cruised around the mom-friendly parts of the mall, the Talbots, the Chico's, while I pocketed tchotchkes in Charlotte Russe and tried valiantly to identify my tones in the Sephora. (Some days I seemed to be a cool winter, others, a warm summer, and to this day I don't know my tones and purchase makeup on a trial-and-error basis.) Neither of us bought much. I couldn't afford to, and my mother preferred to save her money for our visit to the Cheesecake Factory, the lollipop reward that tempted us at the end of every shlep to the mall.

The typical public relations move for chain restaurants, it seems to me, is for them to emphasize their role in local communities, which they hope to convince us is legitimate. They want to de-chain themselves. They want to point to longtime regulars and say, *Look, we're not too big to know these people by name, they've been coming here for years, they have the same waitress every time, this is their order, these are the names of their grandchildren, and when they eventually die, we will feel it as community members, the same as you.* I believe this strategy is a fundamental betrayal of what's good about chain restaurants. To love them, as my mother and I did, you have to be . . . not antisocial, exactly,

but certainly subsocial. You have to crave the anonymity that's so difficult to find in an increasingly data- and service-oriented society. To be greeted by name, or offered the usual, should frighten you a little.

My mother and I were, and still are, like this. My closeness with both my parents has always hinged on our shared preference for silence. With my father, that took the shape of countless hours in front of the television, surfacing only at mealtimes or, more likely, muting the TV during a commercial break to hurriedly order a pizza and then play rock-paper-scissors to determine which unlucky soul had to claim the pizza once the delivery guy arrived. ("Goddammit, I can't get up now, they're about to shoot Sonny Corleone!" is a sentence that my father has actually said to me, his only child, when I dared to point out that he'd lost rock-paper-scissors fair and square, as the delivery person's doorbell-ringing hit an insistent crescendo.) But my mother and I like to recharge our social batteries by occupying the public sphere and observing our fellow humans in companionable quiet.

At the Cheesecake Factory, my mother and I could relax. Our server always greeted us with that not-unfriendly distance that characterizes the service at chain restaurants everywhere, and we were at ease with it as we ordered our two iced teas and a small mountain of food. (The Cheesecake Factory doesn't serve food in any quantities smaller than "small mountain.") The voluptuous columns, the frosted-glass dividers, the cousin-to-Formica tables, they're alien. No room really looks this way. But we'd long adapted all this lush strangeness into our ken. The plushness of the Cheesecake Factory was as integral to our shared landscape as the living room of our house.

My mother remains one of the most beautiful women I've ever seen, though as a selfish kid, I was ignorant to it. Inasmuch as I noticed my parents in those years, I acknowledged them as authorities to be obeyed, or opponents to be outfoxed; I loved them dearly but couldn't imagine myself sharing a plane with them. That would have required me to witness them as the lonely, ravenous people that had produced my own singularly lonely

ravenousness. But the more my face developed, the more I was forced to see it as a dilution of hers. The cheekbones were less pronounced, the smile was less well-sculpted due to years of refusing to wear my retainer, and the unruly black brows that beetled my face and bedeviled hair-removal specialists were not hers but my Jewish father's. Still, during those lunches at the Cheesecake Factory, we resembled each other so closely that strangers were always compelled to remark on it. Part of it was that I was growing into the features that she'd passed down to me, but mostly, we observed the world with identical intensity. As we judged everyone and everything we saw, quiet, mid-meal, polishing off basket after basket of brown bread, anyone would have said that we were communicating telepathically. We barely conversed, but energy passed relentlessly between us. Information was being exchanged.

To be clear, the Cheesecake Factory isn't responsible for this aspect of our relationship. How could it be? My mother and I had shared a house for the entire time that I'd been alive. Occupying that little space for that long with another person, it gets into your cells, bubbles up in your marrow; it hardly even mattered that we were related. The Cheesecake Factory was our place, sure, but we were capable of developing others. When my parents divorced and my mother and I downsized to a one-bedroom apartment down the street from a diner, that diner became our place, held just as much of our charged silence, listened as nonjudgmentally to it.

But only the Cheesecake Factory could be our place without our presence changing anything about its character. At the diner where we were regulars, the servers all knew us. They knew that my mother had been sober for two decades, that she took Equal in her iced tea, that she was a fussy eater, that my parents had just divorced, that I liked a chai latte and a chocolate croissant in the mornings before school but could only ever afford one of the two at a time and only a couple days a week. They saw my first tattoo before my mother did. The diner couldn't provide the warm anonymity that was the Cheesecake Factory's true signature dish,

cheesecake be damned. At the diner, my mother and I were a family with names and interests; at the Cheesecake Factory, no matter how many times we went, we were strangers. It never felt as if we occupied a lick of space there. Our servers never hustled, never dawdled; our fellow diners remained cocooned at their own tables, all the better for us to observe them. And when we left, a busser would swab the table with ruthless efficiency so that another pair of diners could immediately occupy the gap we'd left behind. We were no more loved by the Cheesecake Factory than we were by any assortment of perfect strangers.

My mother and I are both the sorts of people who prefer not to talk to taxi drivers or cashiers or even attractive strangers who might otherwise be enticing to us. The moment a stranger strikes up a conversation, we're already shrinking away. We're happy to witness the loopy rhythms of the world, but the minute one of its denizens reaches out a hand and asks us for a dance, makes it clear that we are being witnessed in turn, we crumple. That's the precise anonymity at which chain restaurants excel. They tell my mother and I that we're welcome, and that we will pass without being remembered. For her and me, two people who have spent far too much time being seen, nothing could be more of a relief.

Richard and I entered the restaurant and he told the hostess hello and that we were Two for Dinner. She led us to a table that was like any other table. That was part of the genius of the Cheesecake Factory and its ilk: its seating allowed for no real hierarchy. Due to the sheer strip-mall-mandated size of the places, they were always divvied up into partitioned-off sections, which had no corner tables and therefore sanctioned no power plays among its clientele. The Cheesecake Factory seemed to dare its clientele to bribe its maître d' (well, its hostess) with twenty-dollar bills. *To what end,* it taunted. *Every table here offers exactly as much spinach-and-cheese dip as every other table here.*

Richard was nervous that night, and that, more than anything else,

tricked me into thinking I didn't want to have sex with him again. I've attempted to Google him many times since that night, annoyed with myself that I didn't just fuck him again no matter how weird he was acting, given what a great time I had when we first had sex. I kept thinking I'd find him eventually, frustratingly un-Googleable name be damned (think John Smith, but Jewish), and I'd explain everything, my nerves, my childish anxieties, and we'd have a great laugh. But then again, was that realistic? He revealed something to me by taking me to the Cheesecake Factory and ordering a Glamburger that night, and it was something he probably hadn't meant to reveal, and now here he was, stuck with the cleanup while our server asked if we needed anything else, a signature cheesecake, a dessert cocktail, anything at all.

Hard to remember any of our conversation from that evening. Most of it is shrouded from my memory by a courtesy veil of embarrassment. We'd had a real rapport on the day that we'd met—we'd ended up locked in one of those utterly charming conversations into which nobody else can intrude, though my friends kept passing and giving me subtle thumbs-ups because I was hanging out with the hot older guy. But I had met him at a party full of people my own age, where he'd been cousins with one of the hosts. I had been on my own turf. And I have no doubt that we would have equally hit it off if we'd been at a party full of his friends.

The problem with the Cheesecake Factory in this scenario was that it could be nobody's turf. The warmth in its anonymity was attributable to the love between the people who ate there together; absent that love, it could only be alien and cold. I didn't know my date from Adam, and surrounded as we were by all this ersatz fanciness, all those avocado spring rolls arranged in pleasing diagonals on square plates the size of ceiling tiles, that wasn't going to change.

It's hard to love chain restaurants in America now. I try not to be a snob, but even so, I see little to recommend a perfectly solid chain restaurant in

this age of the Fresh and the Clean and the Seasonal. The trends simply don't support these places anymore. Now, it's all about showing off how much effort you made in the kitchen to produce a meal. The fussier the dish, and the more minute the quantities of obscure garnish, the more impressive the cook. Chicken is no longer supposed to taste like cream sauce; it's supposed to taste impossibly, ineffably, of chicken.

On one hand, I appreciate this. I'm a child of the imminent climate apocalypse, and one accommodation that's been proposed is for humans to return to a time of eating seasonally, rather than keep abusing our agricultural advancements so that nobody need yearn for strawberries in November, apples in March. We've forgotten how to preserve. We've forgotten how to be patient. Any efforts to reinstate these long-cultivated skills are, I think, good-hearted efforts.

At the same time, I feel fraught nostalgia for restaurants like the Cheesecake Factory that allow the masses to be *waited on*, to have *no cares in the world*, to eat a big meal and make a big mess that someone else would clean up for them. This matters! These restaurants gave unmoneyed people an experience that's hard to find on a budget. Fast food is one thing, but these establishments allowed one to approach a *hostess*. They allowed one to *sit with a menu* and *place an order*.

It's hard to describe how meaningful this is without sounding condescending. The implication isn't "you poor working class fools, with your uncultured inability to understand what a restaurant actually is." No, it's more "the experience of being cared for and waited upon was scaled down by the creators of the casual chain restaurant, and it's imperfect, but still readily achievable." No visitor to the Cheesecake Factory sincerely believes that his Glamburger and cheesecake are the same thing that some Rockefeller eats when he orders a tasting menu plus wine pairing at a restaurant with a secret phone number in the Hudson Valley. But the similarities in the two experiences are true, and real, and important. In an era when chain restaurants at a similar price point are gasping their last breaths, the

Cheesecake Factory remains relatively popular, which is perhaps attributable to its ability to lavish something like luxury on its diners. Its food costs approximately as much as that served at Applebee's or TGI Friday's, but it offers a far more sumptuous experience.

The Cheesecake Factory is a potent imitation of luxury, but impossible to mistake for the real thing. Nobody's arguing with that. What matters is that the imitation is available to us at all. The Cheesecake Factory, with its ornate columns and its ceiling murals and its rich mahogany palette, with everything the color of old money, made the effort to convince us that we weren't so different, us and the wealthy people eating at the Palm on the other side of town. It let us play dress-up.

That said, perhaps the very nature of a chain restaurant prevents it from feeling truly special. Are we meant to be comforted that the experience of the Cheesecake Factory is the same from location to location? Should it sadden us? Or do we just ignore it as best we can? On the one hand, it's distinctly creepy, this ability that chain restaurants have to occupy diverse spaces with such precise sameness; on the other hand, if I were a stranger in a strange land, I might well seek out a Cheesecake Factory in the hopes of reorienting myself. Plus, how many restaurants of the Cheesecake Factory's upscale caliber are there for low-earning people? We don't get many precious Michelin-star joints that only serve twenty-course tasting menus. This, for whatever reason, is what we get. And hell, if I like it (and I do!), then what does it matter that I know something finer is out there?

A sidebar: Servers often say that low-income people tip more generously on their bills than rich people do. And of course, it doesn't matter, because a 10 percent tip on a $600 bill will always go further than a 25 percent tip on a $40 bill, always, always, always. As long as this is true, our imitations of luxury experiences will remain pale and ghostly, no matter how much satisfaction we can still glean from them.

My date went poorly, and I know that the setting was one culprit. It seemed that there was no dish either of us could order whose name didn't stick

painfully to the roof of the mouth. For his part, he ordered a Glamburger, which proved an anxiety-inducingly massive feast. I ordered a raspberry iced tea, but he ordered a sugary signature cocktail, and that was a problem, too, speaking as it did to a fundamental mismatch. This was one of the perils of the Cheesecake Factory: the menu was so staggering in its scope, it was easy to stumble into discord. How could you have an easygoing evening with your date when he was eating a quarter of an entire cow and you were ordering from the Salads and Soups section of the menu? And why did salads and soups always pair off on casual chain restaurants' menus, anyhow? What did they have in common aside from being barely enough food? I tried this quip on my date, and he barely nodded, chugging his -tini. The evening was ruined as soon as he took me where he took me.

We tried to engage in the small talk that we'd initially expected from ourselves, but the Cheesecake Factory laid bare all our insecurities about spending time together in public. I was nineteen, and he was, who knows, thirtyish, maybe older—old enough to be a lawyer with his own apartment, heights to which I didn't dare aspire at that point. Old enough for a receding hairline and a fine landscape of forehead wrinkles, old enough to stick out next to me. He wore a freshly pressed button-down and khakis, and I was still young enough to believe that the only appropriate clothes to wear on a date were the sluttiest ones. We made an awkward impression on the world. We'd had something in common the night that we'd met, but that second night crisply extinguished the spark; it turned out that whatever special thing we'd shared could be tied off in the basin of a used condom and flushed down the toilet. By the time our check arrived, we were both fidgety, ready to go home separately. I wondered many times that night, and have wondered many times over the years, if things would have gone differently had we gone to the sushi house as planned.

But what would have been different? What would have changed? We still would have bumped up against our incompatibility eventually, though we might have successfully pushed it off had we gone to the sushi place—he would have impressed me with his familiarity with dishes I'd never tried,

and I would have impressed him by blending in with the disarmingly hip waitstaff. At the Cheesecake Factory, neither of us was the hipper, nor the wiser, nor the better. We faced down that menu in states of equal discomfort, both of us uneasy, both of us longing for the comforts of home. And perhaps that was the ultimate genius of the Cheesecake Factory and its casual ilk: that everybody could be comfortable there, and that under minimally tweaked circumstances, nobody could.

With all this in mind, I wonder why my date did what he did. He knew I was DTF; we'd already F'd. He needed to do so little in order to maintain momentum with me, and still he couldn't manage it. It's impressive, in a way, how badly he loused this up. I wonder if he looked at the evening that lay ahead of him, with a teenager he barely knew, a hot teenager, sure, but a child in a push-up bra nevertheless, and realized he needed to claim a little comfort. I recall the euphonious coziness of my afternoons at the Cheesecake Factory with my mother and wonder if Richard had similar memories, a similarly recalled warmth that he'd hoped to shoehorn me into. From any angle, it looks like he attempted an intimate gesture with me that night, eerie in its familiarity. He tried to impose the intimacy of a chain restaurant on me, only to be thwarted by the nontransferable nature of that intimacy. It was a naive move. I never would have attempted to recast my Cheesecake Factory lunches with him in my mother's role.

But as naive as it might have been, I understand it. He got spooked. In my own times of grievous discomfort, when I've lost jobs or lovers or looked at my bank balance and found single digits, I've felt his pain. I've longed for the Cheesecake Factory myself, because it is the precise same experience everywhere, and because I could go there today or next year or in 2009 or in Oregon or San Juan and find absolutely zero surprises.

On Sexting

My parents bought me my first cell phone reluctantly, and only because I'd joined my middle school's drama club (shut up) and needed the phone to coordinate my ride home with another mom on Tuesdays and Thursdays. I was in eighth grade and so it was an ancient model, roughly the size and weight of a laptop, capable of making calls and sending texts but permitted to do only the former. Each text cost money. "If I catch you *text messaging* on this thing," my mom warned me, "so help me. This is only so you can call Mrs. Hertz after your club lets out."

At first, I didn't think I was missing out on much by not texting, but then I realized that all those other kids around me with their noses buried in their flip phones, painstakingly clicking out each individual word on their keypads, they weren't just dicking around. They were *flirting*, under the adults' radar. Adults discouraged texting at every turn, but if they'd known precisely what obscenities their students were tapping out to each other, they'd have thrown our phones onto the nearest pyre. What could I do? Not texting in 2007 was, I decided, like not being allowed to go to prom in 1965: it quarantined a girl sexually.

I don't remember the content of the first sext I ever sent, but I remember that it was to Mrs. Hertz's son Jacob in the back seat of her car as she drove us both home from our drama club meeting. And it wasn't like trying to talk to boys in person. He responded, instantly and enthusiastically. I no longer needed to prove that I was game through hours of excruciating flirtation. I could just be explicitly game, and the fact that it was all confined to our phones lent it an unusual air of decency. Little Rax might have been loath to say words like *fuck, pound, spank, suck* out loud, but this

was practically Morse code. Adults weren't privy to it and nobody could overhear it.

It was different then, in those years when I desired confirmation that people wanted to have sex with me. Back then, the interesting thing was neither sex itself nor the dancing tension that leads up to it, but rather the gloating knowledge that someone wanted to *fuck-pound-spank-suck* me, which I believed meant that he also wanted to love me, even after I asked Jacob Hertz to homecoming and he said absolutely not and went with Lindsay Mueller instead. It wouldn't have lasted with Jacob anyway—not after my mother saw her phone bill that month, though thankfully she declined to look into the content of my texts. But it was too late. I'd glimpsed the power of the sext and wasn't yet savvy enough to recognize it as false.

I met Paul at his band's show one night when I was sixteen. That was how I met everybody, since I wasn't invited to my classmates' red Solo cup parties and had unceremoniously ditched drama club the day that Lindsay Mueller joined Jacob Hertz there. I had black X's Sharpied onto the backs of my hands, which warned bartenders that I wasn't yet twenty-one and should not be served alcohol. Paul didn't. But he took my number anyway, which was a thrill. He had long hair and played an instrument and used terms like *polyamory* and *MDMA* in conversation with me, leaning his long body against a monitor as he spoke. We were a long way from Mrs. Hertz's back seat and its empty Happy Meal cartons.

My mom had eventually sprung for a more text-friendly phone plan, her texting ban having proven as effective as an umbrella in a Category 5 hurricane. But Paul pushed the limit of the two hundred texts I was allotted per month. He'd use the T9 keyboard on his flip phone to tap out these florid, implausible paragraphs—I couldn't imagine how he planned, for example, to have his mouth between my legs *and* his dick in his hand *and* the fingers of his other hand in my mouth *while* massaging my breasts? How many hands was I supposed to believe he had? He often proposed the

introduction of toys and practices with which I was unfamiliar, which was a plus as I was eager to learn. I discovered later that he was twenty-four at the time, and once I was twenty-four myself and more learned in the ways of twenty-four-year-old lovers, I thought, *Yeah, that's about right.*

I hadn't had much sex at this point and therefore I couldn't turn a realistic eye to the encounters he was proposing. I wasn't yet suspicious of the claims that men made in their sexts about their stamina or skill. When Paul told me everything he planned to do to me all night, I was thrilled: surely he wouldn't say it if he wasn't going to do it. Of course, I was padding my sexts to him with references to things I'd never actually done and didn't yet know if I would like, but that was different. I was young and inexperienced and wanted him to believe otherwise. It hadn't dawned on me that there were also things he wanted me to believe about him that weren't *strictly* accurate.

I was sixteen and lived with my mother; Paul believed I was eighteen, possibly because I'd explicitly told him I was eighteen, and didn't understand why it was so hard for me to get away from my roommate for sex with him. I explained that my roommate, who was definitely my age and in no way the person who'd given birth to me, was terribly protective of me after I'd had my heart broken by my twenty-*six*-year-old ex-boyfriend Miles (I had a whole backstory going that also included both height and dick size, a story that I'd employed to make Paul jealous but that in retrospect just made me sound insane). But one night, my mother had to attend an event after work and I saw my chance. I visited Paul's apartment wearing all the sexiest garments I owned at the same time: the ratty Victoria's Secret push-up bra *and* the fishnets I'd shoplifted from Charlotte Russe.

He invited me inside and offered me a beer. I was surprised that he was being so polite when he'd just texted me that he didn't even plan to greet me when he saw me, just tear my clothes off. But then I saw the other guy in the living room, hunched over the computer.

"This is my boy Mike," Paul said. Mike didn't look up, only chuckled at something onscreen. "He's been showing me YouTube videos."

What followed was an excruciating hour of clips by sketch comedy troupe the Whitest Kids U' Know, a group of people who couldn't pick me out of a police lineup but who collectively owe me millions in psychological damages for the misery I suffered on this evening. And to be clear: in retrospect, I don't think Paul had anything to offer me that I especially needed in my life. But at the time, I believed that I was being cockblocked from the best night of my life by Mike and the Whitest Kids U' Know, and I didn't understand why Paul was laughing at these sketches when he could have been tearing my clothes off like he'd promised.

Finally, I could take no more. "I'd better get going," I said, standing.

"You sure?" Paul said. "Okay, I'll walk you out."

He kissed me on my cheek. As I walked to the bus stop, I felt my phone vibrate. It was Paul. *Mike is jealous, he thinks you're sooooo hot lol.*

College held no shortage of guys who wanted to have sex with me, especially appealing because they were *college boys*—it hadn't yet registered that I was a college girl in my own right, and pulling these college boys still felt pleasantly like punching above my weight. I was now responsible for my own phone bill, unlimited texting very much included, which I paid for with shifts at the Hard Bean Café between classes. Between school and work, I was free from my parents and, critically, surrounded on all sides by horny young men who wanted my phone number.

At first, I sexted with enthusiasm, glad as ever for the warmth of male attention. I learned that if I sent twenty sexts and received twenty excited responses, that was twenty perfect little buzzes that would leave me feeling pretty good. Even then, I was beginning to recognize that these buzzes lasted only as long as it took me to read a text. They offered exponentially diminishing returns with each reread until I was left a day later staring at my phone and wondering why I no longer cared that this or that man did

indeed want to fuck me. But the buzzes were still gloriously self-contained and impossible to disrupt in a way that was hard to imitate with other pleasures at the time. I could luxuriate unquestioningly in the fact of my fuckability for as long as my texts were getting responses, and if Eric stopped responding, well, all I had to do was hit up Matt, and when Matt turned off his phone for his three o'clock class, there was Tom, and when Tom went to bed, wouldn't you know it, there was Eric again, ready to pick up where we'd left off. I could keep topping off my validation levels indefinitely as long as I had a willing source.

But when I'd assembled a comfortable stable of sexting partners, I realized that it was hard to keep them straight. Eric and Matt and Tom all referred equally to *fucking, pounding, spanking, sucking,* just like Paul before them, and Jacob Hertz before him. And whenever one of them landed in my bed, their behavior never matched up with the acts they'd described, for better or for worse. Sometimes, it was a relief: I didn't always want to be *pounded* or *spanked,* and I didn't want to implicitly sign a contract to engage in such activities by submitting to hours of back-and-forth about them.

But more often, these guys had written checks with their sexting that they then refused to cash. They didn't care about making me feel good like they'd promised they would. They couldn't last all night. Acts that I'd been assured would be performed for hours were reduced, in practice, to minutes. All this left me feeling thwarted and unsatisfied in a worse way than the bad sex that was preceded by no sexting at all: at least those guys hadn't promised anything. I realized that it was more painful to be promised something and cheated out of it than to not expect it at all.

I never confronted any of these young men with the vast discrepancies between what they'd promised me and what they'd delivered, and they never seemed troubled by it themselves. I never expected or heard any apologies. And for that matter, I'm sure I disappointed my share of men with

similar discrepancies myself, men who never confronted me in turn. If I'm coming down hard on the men I knew in this era, it's because it's easier to look at myself as the subject of all those disappointing sexual encounters, and them as the objects. But I suppose the fact remains that there were at least two people having unsatisfactory sex in all those beds.

It makes sense. When sexting, we forget our own limitations, or agree to abandon them. It's pure salesmanship. We want the mark to buy the car; it's no time to admit that the car needs a hard-to-find fuel in order to run. Perhaps the issue isn't that sexting is bad, but rather that sexting is performance freed from the constraints of reality (where lingerie doesn't always match and people's limbs don't always bend the way we want them to). But if that's true, then why do so many of us seem tied to the same script? If all we're doing when we sext is performing for each other, then it seems especially sad for us to be bound within such limited parameters. I once told a man I liked that I wanted to be his cat, to rub up against his legs until he had no choice but to stroke my back. And his bewildered response made it clear that I was inadequately fluent in the language that was expected of me; I was not performing to the expected standard.

I asked several men if they'd be willing to have their sexts to me quoted here, and every one said no. I assured them that I wouldn't reveal names. I was simply eager to examine the speech patterns of these conversations, but nobody would budge. They all consider this the most private and sacrosanct of communications. Fair enough.

They needn't have worried about being identified from the content of their messages. Sexting is always the same. Absent the smells, tastes, viscosities, absent the precise and irreplaceable feel of Person A's skin against Person B's and every other bodily particular of sex, what are you left with? Only a stark description of the acts. My old friends *fuck*, *pound*, *spank*, and *suck* are perennially popular, as are slimy adjectives intended to inspire themselves in the text's recipient (by which I mean, when a man texts you

about "wet" and "horny," what appropriate response can there be except to be wet, to be horny?).

The sameness of sexting, I noticed, flattened my own needs with most partners. It was mechanistic, a soulless call (*my cock is so hard right now*) and response (*I wish it was in my mouth*). At its worst, sexting makes me feel like my body is intended to plug some hole in my partner's existing desires, a hole that may not even be shaped like me. This oddity of mine gets mistaken for prudishness, which makes sense. I'm uninterested in the IKEA instructions booklet formula, the screw-rod-C-into-slot-D; therefore, I must be uninterested in sex itself. All I can do is laugh and let it be known that I actually enjoy the screwing of rod C into slot D as long as it's performed artfully. And this seems important, too: even when sexting artfully, you're still typically stuck with the instructions booklet, whereas when you have artful sex, your task is something greater. Sex can be elevated beyond the primal act of procreation by virtue of raw human chemistry, but sexting rarely follows.

The interesting thing is not sex but the question of sex in the air. It's hard to explore this through services like Tinder and other apps designed to answer the question of sex with an emphatic "Yes!" It's hard to sext someone and still maintain the credible illusion that you're deciding whether you want them, that you need to be convinced. And yet I'm tempted even now to wrap up my own point in some way that defends sexting—I'm hesitant to disown the act publicly because I recognize that it's integral to most current interpretations of presex flirtation. As much as I usually dislike it, not doing it seems worse. In that sense I'm my teenage self again, scared to get locked out of sex. I worry about showing this essay to anyone I've enthusiastically sexted and having them misunderstand what the problem is.

Sexting extinguishes all the most tempting elements of the tease. That's why I deliberately delay it as long as I can with any new potential partner, ignoring their cues that they're ready to take a conversation in a sexual

direction until I decide I'm ready to pounce. Is it so wrong to love those hours when the prospect of sex is bright and alive, an unanswered question buzzing electrically along the wire between two people? Is it so wrong to want my partners to feel like they may have to beg a little?

One such partner told me, "I was surprised that you even wanted to have sex. I was starting to think you weren't feeling it."

It was true that I'd put him through something of a wringer. I'd sat on his lap and then scuttled off "for another glass of water" when he'd put his hand on my leg; I'd coquettishly batted him away at every turn, laughing. As a teenager, I would've looked at a person behaving that way with the greatest disdain, wondering why things had to be so fussy, wondering when adult Rax had stopped grabbing people by the front of the shirt and asking if they wanted to make out. It would have looked puritanical to the frustrated kid who found herself in Paul's apartment with a cornucopia of cleavage spilling out of her shirt, not understanding the discrepancies between what he'd said and what he did. That kid wanted men to like her so that she could say men liked her; she'd skipped the study of erotic artfulness in favor of treating sex like a hunt. She still believed in sexting. She wouldn't understand.

I wondered, though, whether my partner that day would have been more satisfied if things had been more straightforward and transactional: *I find you attractive, you find me attractive, let's get this done.* Because that's what sexting does, especially when it's done poorly. Unfriendly to subtlety or flirtation, it mechanizes sex so that when you meet your sexting partner to do all the things you've talked about, you have a detailed blueprint. When I do sext, it's common for me to tell men that I am, for example, masturbating wildly even if I'm doing nothing more exciting than sitting on the couch. And I've always assumed that my partners do the same. But is it possible that they're out there on the other side of a sexting dialogue feeling actually, erotically fulfilled? Is that all some people need, the basic transaction of sex and the shadow of it that sexting allows people to re-create?

I said none of this to my partner, of course. Too much to explain, and he was ready for a little hard-earned validation out of me. Instead, I just said, "Isn't that uncertainty what makes all this fun?"—"all this" being sex, romance, flirting, dating, love.

I'll spare you the vulgar details; suffice it to say, he disagreed.

Whatever It Takes, I Know I Can Make It Through

In December, he invited me to New Jersey with him, where he was scheduled to speak at a conference. We'd take New Jersey Transit, and I could spend the night with him in his hotel room. Did I want to join him?

I sure did. I met him at Penn Station, where he was buying a couple tallboys for us at the Shake Shack. I lightly whacked him in the hip with my purse by way of greeting. He turned and smiled. I loved the way he had to look down the entire length of himself in order to make eye contact with me, the little-boy-in-a-treehouse cast that it lent his face, even though all it meant was that he was tall and I wasn't.

"Hey, you," he said.

We boarded our NJ Transit train and suffered our two-hour ride valiantly, sometimes talking, sometimes lost in our respective phones. I drank as much of my tallboy as I could before the urge to pee became too ruinous. The lights on our train kept blacking out, and he playacted a vaudevillian train conductor who couldn't work his controls, a bit that made us both laugh until we were flicking tears from our eyes. He put an arm around me, took it away to type something with two hands. He told me about his conference, and I feigned supreme disinterest in it—the default position that I now took in our banter was playfully uninterested in him, which he seemed to find endearing. I wisecracked that it must have been blowing his mind to ride a train that didn't have a steam engine, part of my running joke that he was the oldest man in the world. He was really forty-five, and a criminally sexy forty-five at that, attractive enough that he liked the joke more than he was made insecure by it. He responded that he planned to give me a Werther's "for being so sweet."

I tweeted about the woman sitting across from us on NJ Transit, didn't mention that I was with him. I knew he'd see the tweet later and hoped he'd feel the way I did about it. I wanted him to see this tweet in which his presence was camouflaged—the tweet now had a second meaning that only we knew, which was that we were together and, in my opinion, in love.

Later, we had to transfer trains, and I bobbed up and down with urinary discomfort while our old train idled on the platform.

"They should put a damn bathroom in this station," I said.

"Couldn't agree more."

"This is anti-Semitism."

He laughed. The platform was frigid, and I was wearing only lingerie under my coat. I'd been enjoying his eyes on my body as I innocently unzipped and adjusted my coat on the train, but I was enjoying it much less now that we were stuck outside and I had to watch him carefully donning a scarf, gloves, a hat.

As if he'd asked, I said, "I tend to run hot. But this is freezing!"

He agreed but didn't put his arms around me to warm me.

In the taxi to the hotel, he made an honest effort to finger me, but between his gloves and my coat he could only paw at my thigh.

At the hotel, he took the bucket to get ice and I stripped off my coat and climbed onto the bed, surfing my phone but really waiting for him in perfect hot-girl pantomime, on my side, toes pointed, stockings on, the whole enchilada. When he got back, he growled, "I like what I'm seeing here."

"I'd love a drink," I said coquettishly, and he slopped a generous portion of whiskey and ice into one of the Styrofoam cups that was next to the coffee maker. He handed it to me and then kissed me.

I luxuriated in the smell of his moisturizer and his sour breath while we kissed until his phone rang. "Shit! Fuck! Shh!" he said, and then he answered it. "Hey, baby!"

In the moment, I wasn't surprised. I hadn't realized that his wife didn't

know I was joining him, but it didn't surprise me, either. In the moment, all I wished was that he'd given me a heads-up. I didn't hate him for what he'd done to his wife, or even what he'd done to me; I wanted to be his co-conspirator. When he hung up, he collapsed backwards onto the bed, no longer touching me. Then he sat up, forlorn.

"She saw your tweet about NJ Transit," he said.

And I said, "I'm sorry."

"I was barely able to cover that," he said. "She's suspicious. God, I feel like such an asshole."

I was immediately hyperconscious of my lingerie, which felt like a ridiculous costume under the circumstances. Of course we weren't going to fuck. No attire could have been more inappropriate.

I stood and went to my bag to change into the pajamas I'd also brought with me. I was wearing a corset that hooked all the way up the back, and couldn't reach several of the hooks on my own.

"I can give you a hand," he said, watching me fumble. Any other time, it would have been a come-on.

"If you don't mind."

He approached and unhooked all thirty hooks with two swift motions of his massive hands. I thanked him and began pulling my Bruce Springsteen T-shirt over my head, but he stopped me, still behind me, his hands on my back. I kept waiting for him to say something, to acknowledge any part of what had just happened even if only to say that he didn't care that it had, but he only stroked my back as if hypnotized. He took the shirt from my hands and tossed it to the floor. Then he bent me over.

Back in the days of Xanga and LiveJournal, before any of us had ever been kissed, my friend Steph made a post on her LiveJournal identifying her friends as different characters from a show called *Degrassi: The Next Generation*. She labeled me as "Ashley: the cool punk chick who doesn't put up with any crap from anybody!"

I'd never seen the show, but knew enough about cool punk chicks who don't put up with any crap from anybody to know that I was being paid a hell of a compliment. But *Degrassi* was Canadian, and I didn't get the channel that showed it at home. So the next time I slept over at Steph's house, I asked if we could watch it.

"This is a great one," Steph said, as the show's theme song began. "This is the one where Craig starts to cheat on Ashley with this slutty chick named Manny."

I was twelve, and taken aback; infidelity wasn't on my radar in the least. As far as I was concerned, the acquisition of a boyfriend or girlfriend would have been so miraculous as to utterly obviate any desire to cheat. If I'd already found a person to kiss, my thinking went, why would I jeopardize that by trying to kiss another person against the first person's will? Intrigued, I watched on.

Steph had once described *Degrassi* to me as a soap opera, and that description stuck, so that to this day I call it a soap opera even though many of the show's fans insist that it's a *drama*. The difference, to my eyes, is that a drama is a respectable exploration into the chaos of the human heart, while a soap opera is a sentimental feinting towards the same. A drama and a soap opera both could have tackled the Manny-Craig-Ashley love triangle, but perhaps only a soap opera would have used that love triangle to inflict both an unwanted pregnancy and a coke-addled boyfriend on poor Manny. *Degrassi*'s devotion to aggressive plot development was second to none. Its long-term story arcs could have been generated by Mad Libs in which every blank was "a terrible thing that could happen to someone."

Yet there was that theme song, incongruous in its perkiness, a chorus of prepubescent-sounding kids chirping, "Whatever it takes, I know I can make it through!" The exclamation point might as well be written into the lyrics. It always startled me, the contrast between the cheer of the song and the unrelenting anguish of the show. *Degrassi*'s thesis was very nearly that

its characters would *not* make it through. These people suffered a ceaseless barrage of tests that would have broken even Job, and they did not all survive. How could it be said that they knew they would make it through? From every story line's start through its finish, the kids of Degrassi High knew no such thing.

The suite of episodes in which Craig is eventually caught cheating on Ashley with Manny is still particularly hard for me to watch. I'm not the only one who feels that way about some *Degrassi* subplot or other, either. All of *Degrassi*'s long-term plotlines include heavy-handed attempts to address the Issues of Today, which means that each of those plotlines are hard for someone to watch. If infidelity isn't the reason that you struggle with this particular love triangle, then, brother, keep on watching and you'll stumble ass-over-elbow into unplanned pregnancy, abortion, and drug abuse. Not enough trauma for you? That's okay. No matter what your buttons are, *Degrassi* will find a way to push them.

Me, though, I struggle plenty with the infidelity alone. As these episodes begin, Ashley and Craig are presented as a loving couple. Craig wants to have sex; Ashley isn't ready. Then Manny comes into the picture, with her newly developed body and her propensity for showing it off and, worst of all, her crush on Craig. She and Craig have sex. God! Even typing out this basic summary is filling me with agony. Why?

At the time, I would have said Manny was a slut, and I would have meant it in the truest and cruelest sense of the word. I knew girls who had "done things." Parties were beginning to happen in basements during which pants were occasionally unbuckled, shirts hitched up, bras undone. I was not on the invite list for these basement parties and my bra (cupless, racerback) remained firmly on my chest. I was curious about the girls who'd done more, and my curiosity made me jealous, and my jealousy made me mean. After all, I was a cool punk chick who didn't put up with crap from anybody. Why should I let just any horny boy kiss me, I thought, while longing for literally any horny boy to kiss me.

Watching Manny kiss Craig for the first time, then watching them lose

themselves to a feeling of exceptional urgency that I'd never felt before, I was equally dishonest with myself. These two were evil! Weren't they capable of thinking about anyone but themselves? When the time came to make the right decision in a similar situation, I wouldn't struggle a bit. I'd stand up and walk out and no innocent person would ever feel pain because of something I'd done.

Describing him still shoots lightning bolts of longing from my stomach into my heart and groin. Allow me to rush it a bit. He was impossibly tall and broad and big *everywhere*. He had already warned me before we met in person that he was so huge he tended to turn heads in crowded rooms, and it was true. He was a perfect forty-five; his body was younger, but his face and hairline, older. Later, I'd realize that the face suffered the consequences of his dedicated self-ruination in a way that the body (protected as it was by his daily pilgrimages to the gym) did not.

I'd arrived early, and so he was the one to approach me. He'd spent months patiently securing my attention via Twitter DMs, and I'd already decided that, while he was funny and friendly, I didn't like him: his arrogance, his stubborn lack of interest in anything other than himself. Then he tapped me on the shoulder and I turned to look at him for the first time, and my body pissed me right off by telling me, *Actually, we do like him, we really, really do.* And I realized in a prescient moment that it was always going to be that way, and that he probably knew it. He was counting on the force of my attraction to him outweighing the red flags.

We drank together and shared in slangy, rapid-fire banter that felt like playing Ping-Pong with someone who's really good at Ping-Pong. I wondered whether his students or his heavy social media use was more responsible for keeping him so young. I wondered whether he fucked his students. I realized that I liked him when it occurred to me that it was hurting my feelings whenever he didn't ask me the same questions I was asking him. He told me about his wife.

"She caught me cheating on her a few years back," he said, as neutrally

as if he were saying that she'd caught him cheating on his diet. "Nearly ended our marriage. Now we both see other people sometimes."

His breath soured worse with every drink he ordered. He showed his intoxication by raising his voice to a friendly boom and unbuttoning a couple buttons on his shirt. We were not touching. I swung my legs into his lap, and he set two fingers on my shin. Now we were touching. He said, "I think I'll switch to beer." Then he received his beer and pointed to the foam on top.

"Back home in Britain, you'd send that back," he said, in earshot of the bartender. "Americans don't take their beer so seriously."

When it was time for him to catch his train home to his wife, I walked him to his platform. It annoyed me that women all turned to look at him, and that he obviously knew it—I kept wanting to tell them to stop boosting his ego, even though I was surely boosting it much worse than they were. My attraction to him was dishonest like that. I wanted to be one of the undignified women fawning over him and yet I refused to admit it to myself, preferring instead to treat him with eroticized detachment that I fancied made me special.

At the platform, we made out. It pleased me that his breath was bad and that he wasn't a great kisser. I was possessed by the childish urge to track down every person who had just checked him out in Grand Central and tell them he wasn't all that, not really.

It was late, but I didn't go home. I joined my best friend, Trixie, in a bar and told her all about the man I'd just met. She listened with the tired, subdued ear that all my friends develop after enough years of listening to me gush about some man.

"I don't like this guy for you," she said. "This seems messy."

If Trixie warned me that a man seemed messy, it meant he was a looming apocalypse. But I ignored her.

"Let's take a picture together," I said, and I posted it on Instagram just to see if he'd respond to it. He liked it but said nothing. His own Insta-

gram, of course, was all his wife. Pictures of her sad smile when they went on dates. Praise for her writing and promotion for the events where she was slated to appear. I could have looked at her beautiful face forever. I'd lose myself for a moment in her big dark heartbreak eyes, the slouch in her back that I recognized with a pang as a more developed mirror of my own, and I'd think, *In another life, you might have been me.*

Watching the kickoff episode of Manny and Craig's affair, one thing strikes me. Manny doesn't seduce Craig with her beauty or her willingness to put out. She chases him down the sidewalk right after he and Ashley have a fight, and she tells him how much she loved the song that he wrote for Ashley a few days ago. Speaking of the song, she says, "If it was for me, I'd be happy for months." Then she corrects herself. "Forever."

Manny Santos is a gentle spirit. She's one of the show's more promiscuous characters, but she's promiscuous because she's a trusting romantic—it's rare to see her have sex for sex's sake. She doesn't bad-mouth Ashley in this moment, though she could. She has no quarrel with Ashley, in fact, except her naive belief that Ashley should love Craig more. She is propelled by the purity of her love for Craig, and that unadulterated love is so potent as to get her in quite a bit of trouble indeed.

I've been the other woman in other men's lives. I've been the cruel hypotenuse of a love triangle many times, sometimes knowingly, sometimes not. What's always struck me about men who are cheating on their women is that they love those women fiercely. A man's wife has perhaps "abandoned" him for her work or their child or her own understanding that her sexual desire for him is experiencing a lull. He becomes lonely for her. Unable or unwilling to do the hard, thankless work of trudging through his relationship's low points as they come, he starts craving a fix.

The men I've known have wanted to be appreciated so badly, and I have appreciated them, and that's when the trouble always starts. Manny was a

goner the moment she dared to admit that Craig's song would have made her happy, if only he'd thought to write it about her.

He asked me, "Is it safe for me to come in your pussy?"
 "Yes," I lied.

His wife and I were friendly on social media but never met in person. I admired her art, her writing, and especially her beauty. If Joey Ramone had had the good fortune to be born a woman, she would have been that woman. I wasn't jealous of her at first, at least not consciously. I wanted to do this thing with the right attitude so badly that I almost managed it. She and I played different roles, I reminded myself often. Did I want to be the one whose marriage had nearly collapsed due to my husband's infidelity? Did I want to be the one who now waited for him to come home from dates with someone like me? No, I did not.

 He and I weren't able to see each other often. Once a month or so. I was never as clear as I should have been on how much his wife knew. Two of our assignations were definitely on her radar. I know because those were the only two days when she tried to out-slut me on Instagram, and I assumed it was an effort to remind herself of her own erotic power, an effort I understood and respected. One afternoon that he and I spent together had not been cleared with her ahead of time, but he said so to me in such a breezy way that I, too, felt breezy about it, decided it must not have mattered. And then, she knew about one meeting, but I found out later that he hadn't told her it would be in his office and that she wouldn't like it if she knew. The longer he and I knew each other, the more I heard him admit to half-truths like this: that she knew we were meeting, but not where; that she knew we were close, but not that we gazed into each other's eyes and plaintively asked each other what we were doing.

 "She's insecure about you," he admitted to me one night after several minutes of that gazing and plaintive asking.

I didn't like the elation I felt at hearing this and tried to swallow it. "What? Me? Why?"

He did not hesitate to reveal that his wife was troubled by my youth, my popularity, my success, my youth, my beauty, my youth. I wondered what he'd told her about me in similar conversations, what humiliations he hadn't hesitated to unleash in the other direction. I imagined him painting me to her as a silly little girl with a crush. I didn't stop to consider whether he would have been correct.

The day after losing her virginity to Craig, Manny is walking on clouds at school. To her, her night with Craig was a milestone in her romance with him, one they'd surely look back on for decades, reminisce about with their children, then their grandchildren. He walks by her, and she jumps up to greet him. And of course, we, the viewers, already know what she doesn't: nothing between the two of them has changed. He's cool to her, and within seconds, Ashley comes out and politely asks Manny for a moment alone with her boyfriend. That's the end of the episode. Manny's disbelieving face, fade to credits, and if you're watching a marathon, then the next thing you hear is that eerie chorus: "Whatever it takes, I know I can make it through!"

We are sensitive animals indeed, we the other women. Sensitive in the way that turtles or armadillos are sensitive—balls of organ and mush inside our protective armor. Human sympathy is not with us, nor should it be: we are firmly on the side of evil when we encourage these men to stray. When girlfriends and wives find out about us, often as not, their response is to express their hate to us. We may be cool enough to jeer at that hate or even mock the woman's inability to satisfy her man, but it hurts us every time, doesn't it?

When one guy cheated on his girlfriend with me in college, I brazenly told anyone who would listen that I didn't care. Their relationship was their business, I claimed, and if he wasn't invested enough in his relation-

ship to stop himself from fucking me, then why should *I* stop him? I held fast to this line of thinking as we spent more and more time together over the course of several months, increasingly sexless time, intimate time, holding hands over cups of hot chocolate in a part of town where neither of us knew anyone, him tentatively resting his head on my shoulder just to see what it was like, developing inside jokes, a couple's language of our own. He gave me one of his T-shirts and told me I could never wear it in his part of town, and I never did—I hardly wore it at all, preferring to smell it, worrying that if I wore it then it would smell like me instead. And of course she found out, and he disappeared from my life the second she did, and all that was left was a voicemail box full of her calling me a whore one second and begging to know why I'd done it the next.

"Not my problem," I said, often. I played that poor girl's voicemails at parties for laughs and missed her boyfriend, who I never heard from again. I wore his T-shirt in any part of town I wanted and told myself I had come through it just fine.

Now, of course, I know that the things I do are my fault, that just as I'm not able to steal a man who doesn't want to be stolen, a man can't conscript me into psychosexual warfare against his girlfriend or wife if I don't enlist. In some cases, that makes it easier to say no. Other times, though, it's all the more difficult to resist if I am consciously aware that it's my task to resist.

It must seem backwards that a man can love and yearn for his wife, and that this can somehow be the reason that he's suddenly enamored with me. It makes a lot more sense on the other side, after he's gotten me out of his system. He uses me to spice up his wife a bit, remind him of how much he loves her. Once my spice is spent—once he's caught his first glimpse of my period panties, once he's felt me between waxes, once we've had our first unsexy fight that isn't just "What are we going to do?" over and over in the most erotically abject way—he realizes what he's done. He feels ten pounds lighter and ten years younger. He realizes that it was a close shave and vows, probably, never to do it again.

I do think Craig loved Manny, even before they dated, when they were still just fooling around behind Ashley's back. That Manny loved Craig is undeniable; that Craig loved her takes some defending, and I'm up to the task.

I believe it because I believe that these men love me. (No eye-rolling, now!) And fine, I still believe he loved me most of all. Every time he picked a fight with me of the "What are we going to do?" variety, he really hoped I'd have an answer. What a sweet little boy he could be, looking at me with wide eyes as if he'd just been caught smashing a piece of the good china, hoping that I was yet another woman who could fix it all. I wanted to be that woman for him, too. I tried like Manny before me had tried to take this troubled man and smooth all his worry lines away.

He loved me because I reminded him of who his wife had been before they'd learned each other by heart. I reminded him of what it's like to have a crush, the fluttering uncertainty of it, the boyish way you have to be in order to engage those feelings of joyful interest in another person. Having been locked into his family life for decades, he might have believed that those feelings were behind him, or he might have felt the classic stirrings of a midlife crisis instead, those urgent pricklings that tell people that the outsized feelings of their youth must be revisited at all costs—I don't know. But I do know that he loved me, and that who I was as a person was only minimally relevant to that love.

Craig is the same way about Manny. He loves her not for her sweetness and light, but because that sweetness and light is not Ashley; he loves her because she reminds him of what it's like to have the upper hand in a relationship. Look, it's not a good reason. It wasn't a good reason in my case, either, and it never has been. Not to be trite, but I can't imagine falling in love for some good reason. A person's smell or taste gets in your head, and the next thing you know, you're ten months into the open water of your own recklessness, the shore invisible behind you.

After that night in New Jersey, the poor dear got so confused. Lying to his wife about me made me extra special to him: now we shared a secret, and the sexiest kind of secret, too. He claimed it had been years since he'd lied to his wife. Maybe it had.

The problem was that I did not particularly want to share a sexy secret with him. I'd shared enough sexy secrets with enough other men. I knew what fruit they bore. The entire point of his arrangement with his wife was that it allowed me to be a sexy *known* variable. It was, theoretically, the best of both worlds: the thrill that can only accompany sex with someone who is not your wife, but untainted by guilt and therefore free of drama. But of course some people like the guilt and drama, don't they? No, it's not that anybody likes it; it's that some of us are helplessly compelled by it. He wanted to ruin his dinner with an illicit afternoon snack, convinced that the treat he'd been offered wasn't half as tasty as the one he hadn't.

I say "us" because, of course, I, too, am helplessly compelled by anything that feels doomed. And nothing could have been more doomed than my love for him. I know it's hard to sympathize with someone who says overwrought things like this, who uses words like *doomed* and talks about how hideously she was in love once as if the significance of the pain translates into any other kind of significance. I read advice columns, too, and roll my eyes at my fellow romantics. I don't like most stories of infidelity. They hit all the same beats, tug all the same heartstrings. The whole thing is endlessly predictable. What's to like?

The path out of doomed love is just so *visible*, even when you're in it. I told him that night that I was staying in New Jersey with him because it was too late for me to get home, and he agreed, said it wouldn't be safe for me to leave, and we were both sort of right. But that wasn't the real reason we both wanted me to stay, and we knew it. I stayed because despite how visible the path away from him was, neither of us was ready for me to take it.

I woke up before he did in that hotel room and I wrapped my arms

around him, a foot and a half shorter than him, a comically implausible big spoon. Still mostly asleep, he grabbed my forearms and pulled them tighter around him. His chest was so broad that this nearly popped my arms out of their sockets, but I didn't mind. I mouthed *I love you* into his shoulder blade, because I meant it when I said that I am helplessly compelled by anything that feels doomed. And, fine, because I did love him, because neither of us had allowed me to flee New Jersey like I should have and that meant we were in this wretched thing together.

We didn't say good morning. We never did. Instead, he rolled onto his back and I rolled on top of him in one fluid motion, a motion at which we'd always excelled. When it was over, I slid back off him again. It was a clumsy dismount. He was so big that I had some distance to fall.

"Good morning," I said then.

"Same to you." He checked his phone. We still had some time before the alarm he'd set to remind himself to call his wife again.

Our tones were as cheerful and casual as ever. We thought we could paint right over what we'd done. When he said he felt racked with guilt, he said it brightly and followed it with a sharp laugh. Then he hopped out of bed and strolled into the bathroom to brush his teeth.

I futzed around on my phone like I'd been doing the night before when he had gone to get ice, except I was no longer in perfect hot-girl pantomime. I was naked, feeling him ooze out of me. Lost in Twitter, I coughed a couple times to clear my throat, and he appeared, rabies-mouthed with toothpaste foam.

"No coughing, you," he said, grinning but not joking. "I have to call her soon."

I must have looked more wounded than he was expecting, because his face softened. He disappeared for a moment and I heard him hawking his toothpaste into the sink, gargling with sink water. He reemerged with open arms and folded me into them.

"I'm sorry I fucked this night up so bad," he said into my hair. "You

know how much I always look forward to seeing you, don't you? Like, the sex, obviously, but also just how much I love being with you."

I was mollified, because I *didn't* know. I mean, I knew how I looked forward to seeing him, and I knew he looked forward to fucking me. But it was the first time he'd ever even gestured towards the idea that maybe we were doing something more. As a rule, he and I kept things deliberately light, which was why we were so good at banter: it was the level on which we knew we were permitted to connect, and as time went on, we poured all of our longing for each other into it. When he made me laugh until my cheeks were sore, was it because he really was that funny? Or was it because "joking" was the way he was allowed to express himself to me and "laughing" was the way I could show I was listening?

I remembered that first boy I "stole" from his girlfriend, the way that we were so confident we could just fuck, as if people who like each other that much can ever really just fuck. It was ten years later, now, and I had a different set of loving hands on my back, a different smell flooding my nose with pheromonal agony, but nothing had meaningfully changed. I thought of Manny, months into her affair with Craig, telling him that Ashley may have loved him, but "not as much as I do." If only it were that easy, even on TV! In reality, I loved him one way and his wife loved him another, and there were many differences, but none so potent as the fact that I knew what he was doing and she didn't. It didn't mean I loved him more, and it certainly didn't make me more deserving of the love that he was trying so hard to dole out to both of us. It only meant that I had a little more information than she had.

"Are we going to have to stop seeing each other?" I asked him, knowing the answer.

"I don't know. I hope not," he said, knowing the answer.

Then his phone rang, and when he held a finger to his lips before answering, I knew who it was. He'd told her he would be the one to call her, but she always seemed to beat him to the punch. I couldn't blame her.

If it were me, I would never be able to trust that he'd call when he said he would, either.

"Hey!" he said. Then, in response to what she'd said: "Oh, baby, it's okay. Please don't apologize for being paranoid about that, I understand."

Lying in a bed that I wasn't supposed to be in, his come still seeping out of me, I didn't think I could feel worse than I felt listening to that. And of course I was wrong.

Doomed love is always closely attended by hope. Of course I knew that we'd have to stop seeing each other, but I also didn't. I believed in him. Believed he could fix it all, believed it till the very end. I asked him if it was over that day fully convinced that he had a Hail Mary for us. And he told me that maybe the Hail Mary was coming because he wanted so badly to produce one. It wouldn't have been doomed if we hadn't both believed in it so fervently.

In the days that followed the New Jersey trip, we played house as much as we could via email and text, cramming the love of many years into a span of less than a week. We had lost time to make up for. We were euphoric at our realization that we'd both wanted to be together for so long. We both gave in to crush impulses that we'd been suppressing for months. I texted him good morning and good night; he started calling me baby. He referred to me, cautiously, as his lover and then started signing his emails that way, too: with *love*. It couldn't last, any more than any blissful beginning can last.

One week after our night in New Jersey, we'd arranged to meet for a drink to hash out the terms of our relationship. Once things were hashed out, we'd agreed that he would tell his wife some version of what had happened that night. I never knew what version, and he never told me. I wanted him to come clean to her entirely, but what I wanted more was for him to tell her something that would allow me to keep him.

I planned to ask him a number of questions at our meeting, which I still have saved in my Notes app:

- *would we ever get to like go away together for a weekend, would we ever be able to do normal couple stuff*
- *we've been at it for six months, what do you want it to look like in six more months*
- *do you want things to be more committed between you and me? in your ideal world, do we both stop sleeping with other people?*

And, most painful of all to reread:

- *what kind of relationship can we have?*

The morning when we were supposed to meet, I woke up an hour early to wash, dry, and flat-iron my hair in the style I knew he liked best. I trimmed my bangs so that he'd be able to look into my eyes. I decided that my look should be sexy but haughty. All-black everything, black boots with spike heels, deep cleavage. I imagined him arriving at the bar where we were meeting to the sight of me flirting with some hot man, my back ramrod-straight, my skin glowing. I added four extra steps to my usual skin-care routine and wore my grandmother's fur coat for the occasion.

As I was commuting to work, I texted him to confirm the location. An hour passed, then two. Then he texted me that he'd confessed to his wife and that he and I could never see each other again.

The love triangle on *Degrassi* ends at Craig's expense, the way these things always seem to end at one person's expense. *Degrassi* is, at the end of the day, a traditional show and punished Craig accordingly for his cruelty and duplicity. Manny and Ashley catch him lying to them both. They both leave him. We, the viewers, are even led to see it as a moment of empowerment for the girls. Of course they're both sad to have lost a meaningful romantic relationship, but they're angry enough at Craig that the pain of the loss is numbed.

Even Manny, Craig's most devoted advocate, has had enough. When he asks how this could have happened to him, she coldly tells him, "Because you were stupid, Craig." It's the first thing she says to him that isn't loving or supportive. It's a clean break of a sentence, one with the power to insulate months of agonizing history so that the wires are no longer exposed. Manny is sad, but the moment she says that to him, she's already healing. Why? Because Craig was stupid. Easy as that.

My own love triangle should have ended after that text. I should have blocked him everywhere. But this is doomed love we're talking about and I couldn't be as disciplined as all that. Something needled at me then, something he'd danced around but never actually said. I texted:

please tell me you love me once

I'd felt things, but suppressed them. He'd felt things, but suppressed them. We couldn't seem to catch each other; one of us was always passing the other. So it was over. Fine. Let it be over. But we had a piece of unfinished business.

He didn't respond, and my heart didn't stop thrashing in my chest. I believed that if I could just make him say it, then it wouldn't all have been such a vile mistake. We would have hurt other people, we would have hurt ourselves, but it would have counted for something. If his wife did leave him like he'd said she might in his text, he'd have to say that it was because he'd fallen in love with someone he could never see again. It would be a weightier reason than "because I couldn't stop fucking someone twenty years my junior," more meaningful than "because I was stupid, like Craig from *Degrassi*." I would have something to look at, a souvenir, a tangible piece of documentation telling me that I'd mattered to him. I had worked so hard to be pleasing to him, and I'd thought I would have more time to collect the reward of his affection. Increasingly frightened, I texted him:

please, i know i'm being ridiculous, but i'll live on it forever—
please tell me you love me

God, I believed in him! Even Craig never had a more dedicated co-
conspirator. Not only did I believe he loved me, but I believed he had the
power to instantly heal the blisters that had sprung up all over my poor
heart, just by saying so. They were magic words. They could have erased,
immediately and completely, my fear that it had all been in my head after
all. It would have meant so much.

He'd been willing enough to love me when it had looked for a stupid,
optimistic moment as if things might work out. Now we knew that things
wouldn't work out, and all I could hope was that he'd see me, small and
alone, with my Notes app full of self-important questions for him and my
eye makeup weeping down my face at my desk, and not just that he'd see
me, but that he'd embrace me one last time, make the whole thing real for
me, tell me it had all been for a reason. He could have been my shrieking
children's chorus, reminding me that "whatever it takes, I know I can make
it through." It was the only gift I ever asked him to give me.

He never did.

So, why did it end? Because he was stupid. And who am I? Hard to say,
but certainly not the cool punk chick who doesn't put up with any crap
from anybody.

The Sims and the Heart-Shaped Bed

One day when I was nine, I dragged out my Barbies, fully intending to play. I had several story lines in progress with my Barbies, and can't recall which was my favorite that year. Technically, most of these story lines didn't involve Barbie at all, but rather Barbie's doll-friend Teresa. I could pretend Teresa was me, if I squinted. She had dark hair and the same big tits I hoped one day to have, so it was easy to imagine elaborate scenarios in which Teresa seduced the kids I had crushes on. She was as shy as I was, but she always overcame her shyness when she realized that handsome Adam (played by a Ken doll whose blond hair I'd Sharpied to better resemble my real-life handsome Adam's) loved the music of *NSYNC as much as she did.

Anyway, I took out my Barbies as usual, but immediately realized that something was wrong. My Teresa doll was sharply dressed as ever, but the fun wasn't coming. It was as if I'd forgotten to plug my dolls in overnight so they could charge. I usually played with my beloved Barbies until my mother burst into my bedroom, irritated because she'd been calling me for several minutes with no response. Today, I answered my mother on the first try, grateful for the interruption.

I'd never known a life when I didn't love my Barbies, and I kept playing with them for a few months after that first dismal revelation, believing that the fun would return. It never happened. That wasn't the exact moment I outgrew my childhood toys, of course—that slope began with practice kissing and books about puberty, and it didn't hit its lowest point until high school—but in that moment, the magic was officially gone. Whatever fairy dust had coated my Barbies for so many years, it had worn away.

That was the same year that *The Sims* first came out, and it was a phenomenon that easily could have bypassed me. At nine years old, I was no gamer. I had no consoles other than our PC, which in 2000 was already ancient. In my friends' living rooms, I warmed the bench during *Mario Kart* tournaments. I burned in agony every time my inexperienced fingers fumbled a control on the joystick. My preferred role in these early video game sessions was that of cheerleader.

But *The Sims* was a runaway success like few other games ever had been, and even I couldn't resist its pull. It was initially intended as the architectural companion to *SimCity*'s city-planning simulation, but its dark horse superstars were the Sims themselves. The pixelated people who populated the game were infinitely customizable. You could dress a Sim just like you or, more likely, like a slightly hipper and sexier version of yourself. You could pick from an astonishing array of hairstyles, skin tones, weights, ages. You could, if you so desired, stick your Sims in a pool and then remove the ladder that had granted them access to that pool and watch them drown. You could play with them like Barbies, but the Sims were better than Barbies: they played back, just like a real human would if you stuck him in a pool and watched him drown. They were your Barbies, and you were their god.

I was nineteen years old when I first met the man who would become my husband, on OkCupid. OkCupid was distinctive among online dating services of the day for its youthfulness and for how relatively cumbersome it was to use. It asked for lots of biographical details and required its users to answer "match questions," questions whose answers were supposedly indicative of compatibility between two strangers. The questions were just fun enough that answering them didn't feel too much like homework. Are you more horny or more lonely? (Husband-to-be's answer: horny.) What do you think of genital piercings? (Husband-to-be: they make me hot.) Which is bigger, the earth or the sun? (Husband-to-be, fortunately: the sun.)

When I met him, though, I had no intention of making him my husband. We exchanged straightforwardly flirtatious messages on OkCupid's proprietary messaging service before exchanging phone numbers, at which point the straightforward flirtatiousness became sexually explicit. All was proceeding on schedule until he mentioned that he had a girlfriend. Loath to find myself in a compromising situation with an unavailable man yet again, I backed off and we stopped talking, at least for the rest of the week. But a few days later, when another man I'd been dating told me he didn't want to see me anymore, I decided I needed a pick-me-up. And the only balm I'd ever found effective against a wounded ego caused by a man was another man.

That weekend, I waited at the appointed meeting spot just outside the Woodley Park Metro station, a few minutes away from the apartment I was sharing with my mother that year. I forget exactly what I was wearing. Something skintight, or too short, or both; something that said, loudly, *Pick me.* He ascended the escalator, riding, not walking, and greeted me with a hug that felt eerily intimate. He had picked me.

I took him to the diner a block away, where I hated myself for being too nervous to eat. (The whole point of the evening was to serve as a pick-me-up to *my* confidence; nerves were decidedly against protocol.) He ordered a scotch and offered me an orange pill out of the wrong day's slot on a large-print pill organizer.

"What's that?"

"Adderall," he said, amused that I didn't recognize it.

I'd used Adderall in occasional times of desperation, to finish term papers and cram for tests, but had never considered its recreational potential. I remembered the last time I had taken it, hoping that it would make me focus on Aristotle's *Rhetoric*; when it kicked in, I happened to be focusing on folding my laundry instead, and it drove me to fold my laundry with greater intensity than I'd ever done before, to reorder my shirts and pants drawers, in fact to tear down all my assumptions about the very concept

of laundry and start fresh. I could imagine no recreational version of the experience.

"Is it fun?" I asked him. He was twenty-six to my nineteen, but I could see years of partying on his face and in his hairline; he could have been thirty-five.

"Tell you what." He placed the pill in front of me, between my fork and knife. "Take it in an hour and I'll show you how fun it can be."

An hour after that, we'd found the hotel across the street, where neither of us was a guest. But it had what we realized was a gloriously underused stairwell, where he pushed me against the door that commanded passersby not to open it except in cases of emergency. The door's push bar began to give, but no alarm sounded.

"Still got that pill?" he asked into my neck, and I remembered that I did. I produced it from inside the bottle of Motrin that I always carried. "Take it now. We'll have to get a room here or somewhere. I can't take you to my place."

I realized that I'd forgotten about his girlfriend, the guy who had just dumped me, everything. All I'd remembered to do all night was be hypnotized by this man. Full to its limits with this mission, my psyche had abandoned responsibility for anything else. So what could I do? I took the pill as he pushed into me harder and the door's alarm began to sound.

When *The Sims* was released, I was a scant few years too young for it. It turns out that "a scant few years too young" is the most tantalizing age to be anytime a game includes sensitive content like violence or sex. Luckily, my parents weren't wise to the particulars of the game, and were simply grateful for this latest hobby that kept me quiet and accounted for. The game was rated T for Teen, but my parents were oblivious to what that meant—later, my father admitted that he'd believed the T stood for Terrific.

So I started playing *The Sims* just as I stopped playing with my Barbies,

and the transition was seamless. As with my Barbies, I could play different ways based on my mercurial preteen moods. Feeling vengeful towards Charlotte Pajeska for that snide comment she'd made about my book report presentation? Easy—stick a Charlotte Pajeska into my game. Specifically, stick her in a one-by-one room lined with sad-clown paintings, a room from which I could promptly remove the door and watch her starve to death, her sanity crumbling the entire time. Or was I perhaps possessed by the same designer's mood that had once led me to rearrange my Barbie DreamHouse for hours? Easy—just use that famous "rosebud" cheat to snag myself a few million Simoleons, and build the castle of my wildest dreams.

The Sims allowed me to work out anxieties that I didn't even realize I had. As a little kid, I was heartbreakingly shy, which I tried to disguise with the sarcastic shield of humor that I'd cannily noticed my father using to mask his shyness. But my own humor was a poorly developed facsimile of his, and the jokes that had my father's friends in stitches never landed with nine-year-old girls asking if I wanted to join their four square group at recess. "Smooth move, Ex-Lax" was big in those years, but as hilarious as I thought it was to say, I never hit the proper tone and always trailed off with an audible ellipsis followed by an audible question mark, so that the perpetrator of the smooth move in question was never sure whether he or I was the Ex-Lax. In short, I never felt in control during social interactions. I never had the upper hand.

The Sims obliterated those concerns and more. I was not only my Sims' god; I was their social director. A player who wants their Sim to make a friend must interact with another Sim repeatedly (using commands such as Talk, Tell Joke, and, amusingly, Fight). Each interaction raises or lowers the two Sims' relationship's "score" depending on how successful it is, an action with a corresponding graphic: if the score goes up, a little green plus sign appears over both Sims' heads; if it goes down, a little red minus sign appears instead. How much time had I wasted searching my own con-

versational interlocutors' faces for cues like those? How hard had I Talked and Tell Joke'd, to no avail?

The Sims was, it seemed, endlessly sympathetic to the anxieties that might plague a socially awkward fourth grader. It invited me into its world, with all those clear and obvious cues, and put me in charge. I might have little facility with friendships in the real world, but in Sims world, I had friendship and love down to a science. Friendship: talk, tell a couple jokes, and wait for green plus signs. Love: flirt and flirt some more until it's time to buy a heart-shaped bed to fuck in.

My husband-to-be texted me two years after our first "date" that his girl-friend was out of the picture. He furnished no further details than that and, exhilarated beyond the point of self-control that he was once again texting me, I didn't ask for any. He invited me over to celebrate, promising drugs, sex, a hot tub. I put on a bathing suit under my pick-me outfit and then took it off, wanting to look extra *pick me* without any bra or underwear on.

I didn't need a bathing suit anyway. The "hot tub" turned out to be the bathtub in his apartment, which was itself a freshly built suburban town house divided into different tenants' bedrooms, with a common kitchen. He'd snagged what was supposed to be the master bedroom and promptly trashed it. The bones of the room were still clearly intended for the matri-arch and patriarch of an upwardly mobile suburban family, but its guts were all poorly assembled IKEA furniture and mirrors gummed up with the ghosts of lines past. I moved to sit on a futon when I arrived and, mid-sit, was cautioned against it. "It's broken," he said in a hazy voice. His eyes looked far away and out of focus. "I haven't had a chance to throw it out yet." As he spoke, I noticed that the futon was not only broken, but badly stained with markings of unclear provenance. I hastily joined him on his bed instead.

It had been two years, but he'd aged ten. The charming, chatty racon-

teur from the diner was nowhere to be found. His body hadn't changed in shape, but his skin was now the beige, flat color of a cheap carpet. I assumed, not yet knowing what drug habits he'd adopted since I'd last seen him, that the breakup had aged him. I assumed that my task tonight was to help some of the years fall away from his face. I kissed him.

Hard to overemphasize how beatific I was to have him, even in this diminished form. Despite the beginnings of the fall to come that were evident in his face, he was still a beauty beyond compare. Walking down the street with him even made me hotter, so gorgeous and confident was he. And he was sharp, and listened to every word I said with great, firm-jawed intensity. I was pleased to learn that my body was inclined to come more than once every time he had sex with it—a fortunate accident of our chemistry, since he never tried very hard to make sex feel good for me, but of course I didn't notice that part until it was much too late.

I had never been so eager to relinquish control within a relationship. He made submission to him seem like the only natural choice—not just sexual submission, either, although that was an important source of his power. Mostly, I was eager to quickly lose the arguments he picked with me, just so they'd be off my plate. I asked questions about the end of his last relationship that he consistently parried, and then, when he asked me invasive questions of his own, he used the fact that I'd been asking similar questions to get me to answer him—even though he never answered me. Our sex exhilarated me even as it left me covered in bruises I'd repeatedly asked him to stop leaving in plain sight. He listened to just enough of the requests I made of him to make me think of myself as an equal partner to him, ignored the rest.

After meeting him, my father immediately disliked him, even though my husband-to-be had been on his best parent-pleasing behavior and wearing a sweater vest whose task was to neuter his virility a little. I knew my father disliked him because, when I asked what he thought, he said, "He's awfully charming, isn't he?"

Charming was one of my father's warning words. It was a trait he didn't trust. But I was in too deep by then.

"Of course he's charming," I said. "He's in sales."

My father nodded slowly, dragging on his cigarette. I could tell he was trying to think of a way to share his misgivings with me without inadvertently making the object of those misgivings more attractive by virtue of his disapproval.

"Just don't lose control over this one," he finally said. "You know how things get when you lose control."

But he said it hopelessly, like he knew that if he had to warn me, I was already losing control. And even though I chuckled and nodded and promised I wouldn't lose control, it was true. I had.

Sure, your Sim could climb the career ladder, upgrade every appliance, add a second floor, a pool, a heart-shaped bed from which the most devious seductions could be performed, but it could all be undone if only you forgot to install a smoke detector. Even the wealthiest Sims were not immune from burning to death. I especially enjoyed deactivating "free will," a gameplay state that would have allowed my Sims to make basic life-or-death decisions themselves. *Too bad*, I thought, watching them weep from the pain of needing to use a toilet until, eventually, they'd have an accident, having spent two Sim-hours screaming at me to please let them pee. *The Sims* told us all terrible things about ourselves.

Two months into the relationship, my husband-to-be and I took acid together, and he asked me to marry him. We were having sex for the second minute or the fourth hour (when acid is involved, who knows?). It was Christmas Day.

"Hell yeah," I said, and then launched into one of those giggle fits that's native to an acid trip.

The next day, we went to the courthouse, high on Adderall since the

previous day's acid trip had left us too enervated to leave the house without a boost. We did not take this as an indicator that it wasn't a good idea to get married right then.

D.C. had a legally mandated three-day waiting period between the issuing of a marriage license and the ability to use it to actually get married. We spent those three days shopping for rings at a flea market and taking more drugs, some to put ourselves to sleep, some to wake ourselves up. It was funny: between the uppers and the downers, we were going to bed at ten p.m. every night and waking up at six the next morning, a lifestyle we could have achieved with less effort if we'd just stayed sober.

The ring he chose was a gold-colored band with a skull on it; I skipped the flea market and used a silver ring shaped like a snake that my mother had worn in the '70s. By the time we rendezvoused with our justice of the peace, we looked very strung out indeed, but he was mercifully silent on the matter. The "ceremony," such as it was, happened in D.C.'s Malcolm X Park, which was frigid and December-empty but for our little party.

As soon as it was over and our marriage official, I called my dad. When he picked up, I said, "Guess what I just did?"

It's hard to tell the story of my marriage without appalling and frustrating listeners. For them, it's like watching a horror movie: they long to grab the story's main character by the shoulders and give her a good shake for acting like such a dumbass. I get it. They know trouble is coming and they want to take control of the story's characters like a player with a family of struggling Sims.

It's hard, too, to avoid letting people think that my husband was a wicked Svengali controlling my every move—hard because sometimes even I still believe that. When I remember my husband, it's as an unvanquished enemy. He kept me docile and obedient with drugs, but also with his own extraordinary instincts for pushing my buttons, for reducing me to tears with half a sentence. It was a finicky dance that required the total

concentration of both partners to go off as gracefully as it did every day. When my father tried to advise me on how to survive my husband until I could leave him, his most repeated piece of advice was to stop dancing. To be a less rewarding partner, to trip him up on his own too-practiced choreography.

"He needs you to respond to him in order for this to have any payoff for him," my father would remind me yet again, as I complained of another lie I'd caught my husband in, another three-hour fight he'd picked with me. "He needs you to care if he lies or if he's nice to you. But you're at an advantage. Because you already know he's going to lie and you know he's going to be mean to you. You don't have to respond at all."

Listening to this advice felt backwards. I already knew he was going to lie and I already knew he was going to be mean to me, it was true—so the advice was to do nothing? Refuse to escalate to the level of my own defense?

Now, of course, I know that my father was right. I couldn't afford to leave my husband and didn't yet have anywhere I could go. The point of anything I did before either of those factors changed should not have been to defeat my husband, but to survive him. If my best chances at that survival meant keeping my head down and letting my opponent tire himself out, that's what I should have done. But my father was only telling me to do what would work, not what I was able to do.

Because the infuriating truth was that every time my husband pressed one of my psychological buttons, he had no trouble activating the power supply of the button's corresponding instinct. Machinelike, I could respond to a request only by fulfilling it precisely. If the request was that I scream and beg him to leave me alone and cry, then nothing would do but for me to scream, beg him to leave me alone, cry. Trying to convince me to give him any other reaction, even when it was manifestly for my own good, was like trying to turn on a TV with an air conditioner's remote control: it simply wasn't what that device did. If I still wasted a lot of time and effort

on screaming, begging, crying, and the like, it was a sign of my instinctive backdoor optimism. I still thought I could beat my husband at his game, playing by rules that only he knew.

For the first time, I notice how hard it is for me to avoid mixing my metaphors when I talk about my relationship with my ex-husband. Whether I'm being led in a dance or having my buttons pushed or losing at a game whose rules I don't know, the premise remains the same: one of us is confident and in charge, and one of us is a fool.

My relationship with the Sims is characterized by bursts of intense devotion followed by years-long stretches when I forget about the game entirely. I broke my final years-long stretch of my Sims-free existence in 2013 when my husband asked what I wanted for my birthday.

"The latest *Sims* game," I immediately said. "I think they're on *Sims 3* now."

"Really? *The Sims*? Isn't that for, like, little girls?" He wasn't mocking me; he was genuinely puzzled.

"Kind of," I admitted. "But I feel like I want to play it."

He didn't push the issue, and when my birthday rolled around the following week, he pirated and installed the latest *Sims* on my computer.

I fell back into it effortlessly. The game had evolved quite a bit since I'd last abandoned it in high school. No longer content to amble aimlessly about their properties fulfilling the occasional item from the lowest tier of Maslow's hierarchy of needs, Sims now had aspirations. They had careers that could alternately fulfill or depress them, just like their real-world counterparts. They sang in the shower. Their homes looked better than ever, and they could now hang out outside them, too: their little Sim-towns had bars, restaurants, gyms.

I realized, as I took one of my husband's Adderall and designed a mansion for my Rax-Sim in exacting detail, that these virtual people had surpassed me. In 2013, I weighed ninety-eight pounds. Under my eyes were

pouched gray canopies of exhaustion. My teeth, despite the Adderall focus that I paid to the act of brushing them, were yellowing and thinning. I was still taking classes and working two jobs, one on campus, one off, but the combination of the three activities plus the fourth mandatory activity of fighting with my husband all left me too exhausted to pay attention to any of them. More than once, I fell asleep in the middle of one of my husband's tirades, which only enraged him further.

But the Sim who bore my name still looked the way I'd looked two years before. She went to work on time in the mornings and did well enough there to advance quickly. She ate healthy, worked out for an hour every day. She was the life of the party. Amused, my husband watched as I directed my Sim to befriend every other Sim in the neighborhood.

"You should have her fuck all their husbands next," he said, without a trace of irony. So I did. And for whatever reason, as much as it enraged him to see me talking to attractive men in real life, he cheered my Sim on in doing the same. From then on, whenever he entered the room to find me focused on my Sim's life, he asked me how many husbands I'd stolen. Not how many husbands my Sim had stolen—how many I'd stolen.

Years later, I still prefer to look back on my marriage as a period of evil that descended upon me, to look at my husband as a hypercontrolling puppet master. I don't like to focus too tightly on the unkindnesses that I, in turn, cast upon him—times I cheated on him, lies I told to cover it. These are choices that no omnipotent player would have permitted his in-game avatar to make. If he'd known, the resulting pain would have compromised the fun of the game. He could only enjoy toying with me if I responded the way I was supposed to respond.

And didn't I understand that perfectly well? I behaved with my husband like a Sim or a Barbie, compliant and responsive because it was how I was designed. Even when I left him, I never bothered twisting the knife, revealing everything I'd done to hurt him that he never knew about. When I left him, I cried so that he could see. I let him tell me I was making the

worst mistake of my life. I behaved, even in my moment of freedom, like the little wife I was becoming more and more every day. I wasn't making a conscious choice to behave this way. I was reacting, unconsciously and obediently as ever, to the pressing of my buttons.

It was only after I'd been gone for about a month that I stopped feeling like a doll. Color came back into my face and fat back onto my bones. I'd been wearing my hair dyed an unflattering red color that he had always loved, and I realized that no harm would befall me if I dyed it back to its natural brown. Reclaiming myself from my husband's grip was (and, really, still is) an ongoing process of noticing ways that I'd changed to accommodate him, and changing them all back. Noticing shirts I wore regularly that I'd never actually liked, and giving them away. Realizing that I could call my father whenever I wanted, or see my friends, or go on dates. Remembering to do things according to my own rules this time.

The trouble with my marriage was not only my husband's desire for an underling to rule but also my own tendency to behave like a ruled-over underling. Of the two of us, he was clearly the more damaging partner, but he couldn't have damaged me half as much without my cooperation. That was the hardest thing about leaving him: unlearning my instinct to behave at all times like harm was approaching. My marriage was an ongoing drill during which I proved my constant readiness to deflect attack and shield myself from pain. Even now, I catch myself trying to prove that I'm still ready to show how good I am at being hurt.

As silly as it may be, I remind myself often that I am not a Sim. However predictable my responses to my husband were for so long, they can be eliminated from my repertoire of instincts now, along with the costumes I wore to gain his favor and the complicated dishes he preferred me to cook. I'm not a video game character, confined to a set number of obvious responses because it's the way I was designed. I'm not a dance partner, a subservient machine, the losing player in a game. I can grow. I can stop dancing, as my father would have said, and be any sort of person I want.

Love, Peace, and Taco Grease

One night in 2012, two years before I dared to leave, I made a meal for my husband and me. At the heart of this meal was a pair of frozen Texas Toasts, which I'd heated in the oven—inadequately, as it happens. The edges of these Toasts were crisp and hot, but the middles were still damp; the frost on them had melted and left them chilly.

It was rarely my husband's style to hit or scream. Instead, he said, "Your carelessness is unfortunate." He then interrogated me for three hours about why I'd prepared these Toasts the way I had, the mistakes I had made. Why must all my cooking be so sloppy? Did I intend to poison him? No? Then why did I insist on disappointing him?

I was still in college and had an evening class I needed to catch, but now I had a crime to answer for. My husband, a finicky eater, might not have liked frozen Texas Toast no matter what I'd done. He preferred rare steak, caviar; could never resist a menu item whose cost was "Market Price." In bars, he ordered top-shelf liquors, neat. But he resisted my claims that this made him a snob. He simply preferred everything, including food, to be done *correctly*.

Finally, I had to beg him to let me attend my class. I'd already missed it four times that month and was in danger of being kicked out of school, which would have forced us into a move we couldn't afford. He extracted from me the promise that I'd never ruin a meal like that again and, unsatisfied by my delivery, extracted it several more times, once while holding a fistful of my hair. Not pulling it, just reminding me with his grip that it was his to pull if he needed to.

His movie-villain behavior embarrasses me now. How dull, to be mis-

treated in so predictable a way; how dull I must have been to fall for it. But at the time, as I squirmed and sobbed and begged him to please-please-please drop it, as I tried to walk away only to have my exit blocked at every turn, he was all I could see. He'd reduced the dimensions of my world to his height and weight. I had no room for anything else.

The same year, Pete Wells's famous *New York Times* review of Guy Fieri's Times Square restaurant, Guy's American, was published. This review raised valid concerns about the restaurant's poor quality and overambitious size, but what stuck with me was the sneer of it. It was less a review than a series of mean, pointed questions directed to the man himself:

> *When you cruise around the country for your show "Diners, Drive-Ins and Dives," rasping out slangy odes to the unfancy places where Americans like to get down and greasy, do you really mean it?*

And:

> *Hey, did you try that blue drink, the one that glows like nuclear waste? . . . Any idea why it tastes like some combination of radiator fluid and formaldehyde?*

And worst of all:

> *Is the entire restaurant a very expensive piece of conceptual art? Is the shapeless, structureless baked alaska that droops and slumps and collapses while you eat it, or don't eat it, supposed to be a representation in sugar and eggs of the experience of going insane?*

In 2012, while I was supposedly poisoning my husband, Guy Fieri was doing the same to the husbands of Times Square. I read this review

the same night I stormed out of my husband's house in tears, unable to pinpoint how, exactly, a box of fucking Texas Toasts had undone years of therapy, unable even to slam the door behind me, unable, really, to speak.

The day I left my husband, I devoted myself, with the single-minded purpose of a Talmud scholar, to the show that made Guy Fieri famous: *Diners, Drive-Ins, and Dives.*

The world of the show is Technicolor majesty. Big, splashy primary colors abound; the host drives a Camaro whose red is the reason that color TV exists. His hair is canary fluff. The premise is that Fieri is on an endless, nationwide restaurant crawl. No town is too small. In fact, the more obscure the site, the happier he is. One restaurant, Hillbilly Hot Dogs, comprises two remodeled school buses in Lesage, West Virginia. And Guy Fieri boards one of those buses without reservation.

Fieri's voice is a constant, low-grade bark that lies somewhere between a boom and a screech. His guests, all owners of locally appreciated restaurants that are not famous (yet), seem cowed by him. Their quietness only has the effect of amplifying him further.

He is uncool. Does anyone dispute this? The bowling shirts, the Camaro, that incredible hair—he's the concierge of Margaritaville. His hugs look like they hurt. His palette is all reds and oranges. When he's sunburnt, the camera doubles down on that crisped-up skin as if he's a particularly tempting chicken tender. He's often sunburnt. His Oakleys tattoo a white raccoon's mask across the top of his face. The sound editing is generous; the sizzle of any pan is extra bacony. Flavortown, the mythical province from which Fieri claims all great food comes, is butter crackling in a pan. Flavortown is a red Camaro painting a gray hamlet pink.

At home, in my dirty sweatpants and a threadbare sports bra, I unwrap my burger and enter my sixth hour of a marathon of Triple-D (as the insiders call it). There is so much that I love. There is so much that I would be afraid of if it were anybody else, but it's Guy Fieri; there is so much that I love.

In 2019, I avoid arguments, I avoid cooking, I avoid loud voices. I especially avoid those roundtable shows where feisty pundits interrupt each other. I eat heaps of greasy food; I eat no food at all. I shower twice-ish a week and never shave. I seethe in a terrible rage that drives me to snarl at my loved ones, sneer in their faces, insult them in someone else's voice. I don't know where the rage comes from, and I cry when it's gone, tears like the breaking of a great fever. I still watch Triple-D for hours at every opportunity.

Guy Fieri beguiles survivors other than just me. Why? We hate shouting but not his shouting; we fear the loudest, biggest man in the room unless it's him. Many of us have forgotten how to eat properly, how to feel the simple joy of food, swallow it and keep it down. But when he gobbles his beloved fried chicken sandwiches, his oxtails, his waffles, the pleasure evident on his face, we're hypnotized. We hear the road-trippish wailing of the electric guitar that plays over the show's B-roll. We nod.

People are most comfortable encountering the illness first and symptoms second. "You may have PTSD if you experience constant irritability, anxiety, self-destructive tendencies, emotional detachment"—something like that, didactic and medical. It's comforting to demystify any diagnosis with a list. But when it's you, you look like your illness long before you ever know it by name. I'd already spent months on a Triple-D bender by the time I understood what I needed Guy Fieri to protect me from.

My husband must have been feeling flush the day he took me to dinner. I wore a dress with cutouts in the sides, a good deal of makeup, a hairless lower half. I blow-dried my hair, but the humidity wrought it into steel wool within minutes of my stepping outside.

At the restaurant, I ordered a burger. My husband caught the server's eye. "Actually, can you give us another couple minutes?" When she obliged, he looked at me as if I'd just lied about an empty cookie jar. "Do you really

need a burger when everyone in this restaurant can see your disgusting body spilling out of your dress?"

I instinctively pressed my arms over the cutouts. During one of our phone calls, my father had begged me to stop apologizing to my husband when he said things like this, so I said, "Excuse me."

I cried for a prim few seconds in the bathroom. When I returned, I ordered a salad. The server brought it with the dressing on the side, unasked. I used just enough to make the curly kale palatable and left half of the leaves on my plate.

Leaning on scenes like this is easy. I could write whole gratuitous novels' worth of behavior like this, enraging people on my behalf. But looking back, what angers me isn't what he said. It's that I didn't just get a burger anyway, a double, with extra cheese.

The *New York Times* food critic rates restaurants on a scale of zero to four stars, and positive ratings begin at one. Guy's American received a predictable zero. If zero stars is for any place that's "poor, fair, or satisfactory," then who gets to be "extraordinary"?

Only five restaurants have four stars: Del Posto, Eleven Madison Park, Jean-Georges, Le Bernardin, and Sushi Nakazawa. The most affordable of these will set back a thrifty dinner-seeker no less than $138. At least, I think that's the case—their websites are cagey, burying the prix fixe cost in the small print if they mention it at all, giving the impression that it's gauche to inquire about money when art is on the line.

My ex-husband championed these experiences, though he could never afford them. One night, he made me dine-and-dash a local restaurant to which the *Times* might have awarded two stars ("very good"), so desperate was he for a fancy night out—or at least three-quarters of one, minus dessert. "Go warm up the car," he told me and, unaware of his plan, I did. Then, "Go! Go! Go!" as he jogged to the car. Even though I only had a learner's permit, I took off as soon as he was in the passenger's seat.

Sometimes, I imagine the way Guy Fieri would guffaw if I told him this story, throwing his head back, slapping his thighs. He'd hear it from me at a crab boil, maybe, or in a greasy spoon. Someplace loud, where the melted butter flows like river rapids and every voice is jolly.

I did not initially believe that my love for Triple-D stemmed from my history with my husband. Here was a man whose speaking voice was a low shout, and yet here I was, someone who cried whenever anybody yelled. Guy Fieri's whole project was to adore food, and I was reduced to rubble by a box of Texas Toasts and a burger that I never got to eat. Even I believed I watched the show as a joke.

But loving Guy Fieri was a safe, simple rebellion against the memory of my husband. My husband, the preppy man-boy in Sperrys, who never saw a bleached-blond man he didn't sneer at, who pruned at my too-soft body like it was a troublesome topiary, who only believed in loudness when he was employing it against me. On the other hand, Guy Fieri, uncool and bold and tacky as hell, offered such generosity and praise to the restaurant owners on his show. He was uncouth for a cause. The timbre of his voice was the exact opposite of a disappointed murmur and a handful of my hair.

Guy Fieri allowed me to ask: Who do I fear noise and brightness for? Who do I fear food for? And he gave me the answer: I fear it for myself, and yet someday, I'm going to need to take those parts of me back.

He takes the burger in his hands. A gargantuan thing, more sculpture than sandwich; a behemoth of glittering brioche, patties, slab bacon, palm-sized lettuce leaves, Edenfruit tomatoes. No toothpick could hold it together. A sword might stand a chance.

It's a beautiful moment whenever he takes a bite. I love to watch cheese, sauce, and blood congeal on the hairs of his beard, to see his chin weeping the juice of the food he loves best, to hear the slobbering sounds of his triumph. Who knows how long he chews, but after a respectful few

moments, the camera cuts away and now he's wiping his face. After that one bite, maybe half the burger is left.

"Wow," Guy Fieri says, expertly speaking around the sides of his mouth so that he can finish chewing. "That is *money*."

"It *is* money," I say to nobody, and I raise my own burger to the screen.

It's Time to Let Meat Loaf into Your Embarrassing Little Heart

Within ten minutes of opening his 1977 album, *Bat Out of Hell*, here are the feelings that performer Meat Loaf has already felt to completion:

- Desire
- Anguish
- Desperation
- Perfect, adolescent faith in the attachments of the flesh
- Motorcycle—not classically a feeling, no, but what else can be said about the lyric "I'm gonna hit the highway like a battering ram / on a silver-black phantom bike" except that it encapsulates the feeling of Motorcycle— that is to say, motorcycle qua motorcycle, the Springsteenian motorcycle, the emblem of masculine longing to *get out*?

That's five feelings, more than I allow myself to feel on a good day, and he cranks them out one after another in the span of a single song! And as if that weren't a severe enough display of emotional generosity, he's still got six songs to go! This is the way Meat Loaf drives me to speak: in exclamations, in exhortations, with my hands full of my interlocutor's shoulders, because nothing on the planet is more important or destructive than human sentiment. Walk with me now, please. No, rather than walk, straddle me on my chopper. Take a chance on the silver-black phantom world of Meat Loaf, Jim Steinman, Todd Rundgren, and the chaos orchestra that is 1977's *Bat Out of Hell*.

Once, I was languishing on a fellow writer's lap, his hand high on my thigh, the two of us nearing the end of the mating dance that introduces sex. I'd spent the day noticing his petty meannesses. When he showed me snatches of poems he'd written for me, they were brutal verses, meaner and shallower than any other words I'd ever read about love. He always spoke as if through a smirk, and when he told me I was gorgeous or that he liked me, I couldn't quite believe it: everything he said felt as if he were cueing a laugh track.

This was a brush with an "irony guy," though I didn't know it then. We weren't calling them that yet, but the signs were there. For example, all his tattoos were jokes (I vividly recall a Garfield stick-and-poke). He dressed, as a joke, like a kid on his first day of school, all oversized sweaters and threadbare corduroy pants. He once texted me a video of him mocking his weed dealer to his face, expecting that I'd respond with mockery of my own, and deflating when I asked instead what the weed dealer had done that was so mockable. "He's never heard of Merzbow," my proto-irony guy explained. "*Merzbow.*"

"What do you want to do?" said my irony guy into my neck now.

High off his coke, I wanted to do a thousand things, only one of which was the thing I'd come here for. I said brightly, "I want to listen to Meat Loaf!"

We'd been listening either to one sixteen-minute chillwave song, or several identical chillwave songs. But I was hungering now, as I always do in the presence of irony, for something sincere. And so I was determined to mainline Meat Loaf's human agony into my veins, cherishing him as the father of all feeling.

Meat Loaf's *Bat Out of Hell* still sells approximately two hundred thousand copies every year, forty-two years after its release. He's retained the popularity that every creator dreams of, with one hitch: no creator wants to be popular in the exact way that Meat Loaf is popular. When we think of

Meat Loaf, we imagine Broadway-loving aunties and dads who don't have time to "get into" "real music," and other people we fancifully imagine to have worse taste than ours. These are not the people that we want to appeal to, inasmuch as we're conscious of the people whose opinions matter. Upon its release, *Bat Out of Hell* received iffy reviews, most of which pointed to its overwrought arrangements and sprawling song lengths and, frankly, its silliness. This was an album whose lyrics were about macking in back seats, yet its arrangements all spoke to apocalyptic self-importance.

When reading reviews and retrospectives about *Bat Out of Hell*, you'll often see the word "uncool." Chief songwriter Jim Steinman's lyrics were uncool, as were producer Todd Rundgren's neo-wall-of-sound arrangements, as were Meat Loaf's operatic vocals, as was that inimitable album cover. The whole thing reeked of squirming, slimy sincerity. The album spoke to passions that were simultaneously too deep and too shallow: too deep because the entire record was about capital-*L* Love; too shallow because it was a love that groped over a girl's bra and left hickeys on her neck, a kid's love. Meat Loaf offered his slobbering heart on a silver tray, and so did we all before we knew better, and thus did he violate one of the cardinal covenants of artistic maturity: as adult creators, we are never again to partake of the gasping desperation of those teenage years once they pass us by. If we only wrote what we felt, we'd be teen idols forever, enslaved and enfeebled by our emotions. If we said what we felt as soon as we felt it, what havoc we would wreak!

People are generally uneasy around their own emotions, and writers in particular cope with this by introducing a level of intellectual distance that actually makes feelings *uneasier*—squirmier, crueler, never allowed to just exist but always analyzed and turned into content. Does it infect us? Do we open a wound when we write about each other, forever injecting poison into it, until the inherent self-consciousness in the act of mining our human feelings for creative material becomes all we are? I don't know for sure, but what I know is that literary Twitter is an insecure and insulting

place where we blast each other's innocuous behaviors for our little audiences all day long in a poisonous, mocking drawl. The tone is singular: aggressively modern, to the point that I can hear people's vocal fry in their tweets, and yet timelessly bitter. Editors roast writers' flakiness. Writers rail against their icy, remote editors. Publishers demand that both parties shut the fuck up and admit how easy they've got it. Agents, presumably, watch.

I'm as guilty of the poisonous, mocking drawl as anyone else, lest this sound preachy (or, worse, lest it enter into the Twitter discourse as its own stance to be mocked). I've dunked on strangers when I could just as easily ignore them—as an active Twitter user, my days are consumed with little else. I want to be cool, too. I want to sit on the irony guy's lap without wishing we were listening to Meat Loaf. When I lash out in cruelty, what I'm really doing—what we're all really doing—is trying to stay ahead of the cruelty. As long as I'm in charge of it, aiming it at somebody else, it isn't being aimed at me.

As Jim Steinman once said, *Bat Out of Hell* is timeless precisely because it's so uncool. It was not ahead of or indeed behind its time; it would have been equally uncool no matter what cultural epoch it landed in.

In an oral history of *Bat Out of Hell* that appeared in *Classic Rock* magazine, Meat Loaf has claimed that two Ivy League professors performed a "psychological test" in the "U.S. Medical Journal" (all quotations *sic*) to determine the subjects' state of mind, using the album as a litmus test. Per Meat Loaf's interpretation of this test, any listener who doesn't like *Bat Out of Hell* is psychologically unsound. This sounds exceptionally incorrect, but as a lover of this album, I agree that its emotional highs and lows *feel* informative. I trust people more when they admit that they love this album as I love it; I trust them less when they offer the same old critiques of it, the predictable way my proto-irony guy did. "Meat Loaf?" he said doubtfully when I made my suggestion. "I can't have that in my Spotify history."

Regardless of whether this psychological test ever happened in the way that Meat Loaf believes it happened, its existence is true to the spirit of *Bat Out of Hell*. A team of scientists heard this album and believed it was not only worthy, but declarative: that an hour of Meat Loaf's music has legitimate claims to make about a listener's brain. Sure!

I agree, for the record. A person who believes this album is too cheesy must also believe that all-consuming eros is too cheesy. And if you can't love the poetics of loving, failing, itching, abjection, yearning, beating your chest, kissing your girlfriend, starving, fleeing, bawling, Motorcycle—if you can't love every open wound on the skin of humanity—then, my God, what *do* you love?

I don't mean to be the sort of wet blanket who gets classified as a "scold" on Twitter, but when we write into one another's cruelest tendencies, when we roast each other on social media and publish thinly veiled prose about each other written in a perfect flat affect, we resist the hostile invasion of feeling that Meat Loaf represents. We hold honesty at arm's length so that none of us has to face the humiliation of weeping on another's shoulder, dying in another's arms. Fuck that, I say. We have limited time to explore the glittering fascinations that live within other humans; before long, we'll all be dead, and the flat affect will have done us little good.

No other experience is like listening to *Bat Out of Hell*. Every comparison of Meat Loaf to other artists is lacking. Nobody does what he does. The closest comparison is probably to a Broadway musical (and indeed, there is now a musical based on this album), but that doesn't do justice to Meat Loaf's earnestness; actors in a musical are acting, and Meat Loaf is proselytizing. Listening to *Bat Out of Hell* means sitting in the front pew and absorbing the spirit with every inhalation.

For all that he tried to pass himself off as a different kind of man, in his little boy's outfit and his arty haircut, my proto-irony guy was as conventional as they come. Born, probably, with the same willingness to

bleed as the rest of us, but self-cauterized, he was now roundly, wholly unavailable. Meanwhile, Meat Loaf has been riding flying motorcycles and wailing in multiple octaves. How have we forsaken him so? Why don't we creators want him on our team? Depressingly easy to say: we still think we're too good for him.

Well, I'm not too good for Meat Loaf, any more than I'm too good for the truly elemental experiences of the earth, the orgasm or the slashing of an artery or the blissful thrill of Motorcycle. No writer is; no artist should be. The more willing we are to inhabit agony and ecstasy and the rest of it, the more popular we become! How magical is that? All we have to do to appeal to humans is feel the feelings of humans. It's simple, and yet if the writer's goal is not to get hurt, it's the most impossible thing in the world. Already too susceptible to feelings, we believe we avoid them with good reason.

It's a reasonable strategy, but I don't approve of it. Surely we all remember when "baby, you're the only thing in this whole world / that's pure and good and right" was a way we were willing to feel about someone. I think that we should all aim to hit the highway like a battering ram on a silver-black phantom bike; to tell our loved ones that they're the only thing in the whole world that's pure and good and right; to occupy the human spirit utterly, with all the messiness that entails, and all the pain.

Like Meat Loaf, I don't like anybody or anything unkind, even unkind as a joke, and so my yearning for irony is an act of profound self-sabotage designed to leave me unhappy. Because an ironic writer is, above all else, an armed writer. Free from the expectation that his work passes any emotional smell test, he is shielded from too much feeling, any kind of feeling, even love. Even Motorcycle.

When people call Meat Loaf uncool, they're saying that he is irony-proof. And they're right. The sheer scale of his songs leaves no room for tittering. When you listen to the self-titled opening track on *Bat Out of Hell*, with Todd Rundgren's ululating guitars and Max Weinberg's deafen-

ing drums, a gauntlet is immediately thrown down: either you can hang or you can't. And Meat Loaf has no time for you if you can't hang, or if you need to pretend you're spending time in his universe as a joke. There's work to be done. Throw open the doors to the castle instead, and walk through his towering hallways with him, and allow yourself to feel every feeling in its highest degree.

Acknowledgments

Thank you to my mom and dad for handling their pain-in-the-ass loud-mouth with grace and aplomb.

Thank you to my editor, Vanessa Haughton, and my agent, Sarah Bolling, for essentially the same reason.

Thanks are also due, in no particular order, to Katya, Cory, Tony, Eve, Tommy, Sean, Neil, Amber, Noor, Jamie, Alina, the members of my writing group, and Jackie the bartender at Birdy's, who always gives me free shots, all of whom provide this anxious writer with lots of much-needed care and support, particularly Jackie.

I can thank whomever I want in this thing, right? Thank you so much to the staff of BK Jani for making one dynamite burger. I think I ate like seventy of them while I was writing this book, and I am in no way too proud to admit that.

Finally, thanks to all the people who appear in this book for messing me up so bad I had to write sixty-nine thousand words about it. Nice!